INTERSTELLAR

T0323181

INTERSTELLAR

Written by
JONATHAN NOLAN *and* CHRISTOPHER NOLAN

Storyboards drawn by
GABRIEL HARDMAN

FABER & FABER

First published in 2014
by Faber & Faber Limited
The Bindery, 51 Hatton Garden
London ECIN 8HN

Typeset by Country Setting, Kingsdown, Kent CT14 8ES
Printed in the UK by CPI Group (UK) Ltd, Croydon CRO 4YY

Lines from 'Do Not Go Gentle into That Good Night' by Dylan Thomas
from *The Collected Poems of Dylan Thomas: The Centenary Edition*,
published by Orion, are reproduced with permission

The rights of Jonathan Nolan and Christopher Nolan to be identified
as authors of this work have been asserted in accordance with
Section 77 of the Copyright, Designs and Patents Act 1988

Storyboards drawn by Gabriel Hardman

A CIP record for this book is available from the British Library

ISBN 978-0-571-31439-3

Printed and bound in the UK on FSC® certified paper in line with our continuing
commitment to ethical business practices, sustainability and the environment.
For further information see faber.co.uk/environmental-policy

Our authorised representative in the EU for product safety is
Easy Access System Europe, Mustamäe tee 50, 10621 Tallinn, Estonia
gpsr.requests@easproject.com

Contents

Introduction

JONATHAN NOLAN AND CHRISTOPHER NOLAN
INTERVIEWED BY JORDAN GOLDBERG

JG Walter Donohue [*Editor at Faber & Faber*] wanted me to start off with a question about the term *science fiction*. He's never liked the term *science fiction*; he prefers the term *speculative fiction*. He believes speculating about the future is a way of revealing the way we live now and providing some kind of order in the way of understanding the chaos of contemporary life.

JN For me, that was the whole jumping off point. Originally, Steven Spielberg wanted to do a contemporary space adventure. I pitched him instead something set fifty years into the future. The reason was that – in the tradition of *MASH* being set in the Korean War but really being about the Vietnam War – I wanted to do something that reflected what I thought was the current state of human ambition. Which it is to say we congratulate ourselves every day on living in this spectacular moment of technological advancement and progress; we've invented the internet and a variety of ways we can buy stuff online, but we're not going into space. Measured purely by altitude, the human race peaked fifty years ago.

CN But Walter's question is about the value of speculative fiction – he's not asking about futurism per se. Science fiction can be contemporary, speculative fiction can be contemporary as well. You set the story in the future so you could address the underlining problems and ideas that are going on in society right now the way the best speculative fiction does. And this project has always been in that tradition. What's interesting is that when we came to shoot the film, we went exactly in the opposite direction. So we didn't allow for any kind of futurism or any kind of difference from contemporary technology and contemporary society. The reason for that is it is more speculative fiction than science fiction. You choose what your speculations are about. And I didn't want to speculate about the color of people's trousers in the future or what kind of computer screens they'd be using. I think that

vii

speaks to the difference between science fiction and speculative fiction just as terminology.

JG Where did the specific speculations in *Interstellar* come from? Like the dust situation?

CN For me, the whole dust situation came from looking at Jonah's original draft and focusing in on the idea of a return to an agrarian society. An agrarian society has a utopian aspect – there's a simplicity and a kind of wholesomeness associated with it – and I think Jonah's goal was to stop it from feeling dystopian. I really liked that. But what I found interesting was the idea that when you research the kind of farming community that existed in the past, they're very subject to the elements, they're subject to the natural disasters. And whilst I think the blight idea was always extremely compelling as a device, it was inherently not very visual because you're talking about things not growing or dying. We found ways to dramatize it by setting fire to the fields and the like. But I really wanted to get across two ideas with the dust situation. One was a simple way of visualizing the decay of a farming community or the ability to be able to farm. And the other key point is from watching Ken Burns's documentary *The Dust Bowl*, which is incredible if you haven't seen it because *it is* science fiction. It seems like science fiction. You cannot believe the images you're seeing, the real images. The descriptions are heartbreaking and amazing, but you're looking at pictures and film of things that if you put them in a movie, directly, people wouldn't believe it. When we do the dust clouds and the dust storms in the film they are toned down from the real imagery because the real imagery would never be believed. And that really happened.

JN That's amazing.

CN And I really like the idea of trying to dramatize your inherent blight situation in a sort of disaster movie mode and make it bit more visceral. But do it in a way that has already happened on our planet, for real, that has been documented. And that eventually led us to actually incorporate some of Ken's footage in the film as the real voices talking about the dust with the older Murph. I really like the idea of saying that the most threatening and outlandish visual idea of the first act has already happened in real life. It's not even under question.

JN We're sort of in this moment in which humans are obsessed that we'll prove our own undoing – that we'll poison the planet, we'll destroy ourselves, and all these things. But I thought it would be more interesting to find a slightly less personal Armageddon, or the idea that the universe obliterates you or the planet turns itself toxic because it doesn't care about you and me because we're an accident in outer space. The blight and the dust provided what I thought was a great, impersonal way for the planet to sort of gently suggest that our time here was over. That it was the moment to move on, rather than being something that we had brought on ourselves which, in its own way, feels anthropocentric.

JG Jonah, in a story like this, there needs to be a certain amount of scientific research. In the beginning when you were talking to Kip Thorne, you were in immersed in a slew of complex concepts and ideas. Where did the science end and the imagination begin?

JN Well, Kip is simultaneously a brilliant, brilliant scientist, but also a very kindly and patient explainer of science. He's of the philosophy that all these grand discoveries that he and his mates have come up with, if they can't be articulated back to regular people – people like me – then of what use are they? If you can't share them with the rest of humanity, then have you really discovered anything at all? And so Kip has devoted an enormous amount of his career and his time to trying to make these ideas accessible as his great friend Stephen Hawking has – and to a degree as Albert Einstein did - trying to make sure that these things are things you can hang onto. And in the manner of Einstein – you know, Einstein's thought experiments ultimately always involved two people on a train, or twin brothers with one headed into space – any attempt to understand general relativity seems to come back to this personal scale because it's how we see the universe. We are our own instrument for measuring the universe – ourselves, our life spans, our senses, and our relationships. And our understanding of our mortality is built through those relationships. So Kip – in his books, in his work – has concentrated on finding ways to relate these things on a human scale. And that inevitably brings you to this view of natural events as they relate to us and our families and our relationships. In terms of principles guiding us, there are a number of ideas that are common to lots and lots of speculative fiction. Wormholes being one of them. But the main thing here was to try to get all the way

underneath the rule-set sufficiently that the experience becomes kind of a tactile one that you feel. I mean, a wormhole is kind of an inherently alien concept, right? We know nothing in the universe that would allow one to develop naturally. The idea of a wormhole pre-supposes the idea of a higher order of intelligence, so there's a certain amount of speculation just in that.

CN There are several key narrative ideas that I put into the script based on passages that Kip had led me to in his book. Those then turned out to be the things that he argued with me the most about whether they would really happen.

Laughter.

But I found that fascinating because it meant to me that even though he'd written it in a book ten years ago, he was still completely prepared to take it as a fresh story element, and argue about whether or not it could really be.

JN Sure.

CN And I found that surprising and a little frustrating at first, and then the more I talked to him I realized that he approaches these things from a very pure point of view. So it's not about whether he said it ten years ago or not, it's about what does he believe now. What does the science tell him. And very often it was about whether he could make the numbers work. Literally. So I would say, 'Can this happen?' And he'd say, 'Well, I'll do some calculations.' And when he did the calculations it allowed him to understand that mathematically it was possible, which I guess is kind of the genesis of the whole idea of wormholes because he doesn't believe they can be naturally occurring, but he believes them as a mathematical possibility based on Einstein's equations. But I did find that when I came to the project, there was a very, very dense amount of science that he was quite keen on that I had to (*laughs*) gently pry him away from.

JN (*laughs*) Yeah, sure.

CN And we were able to address some very sophisticated scientific concepts in the movie by just simplifying – just having fewer elements. I think there were so many things crammed into the original, so many scientific ideas that Kip wanted or that you wanted –

JN Yeah, there was an awful lot of stuff that we were trying to cover. Kind of everything . . . Well, the film's called *Interstellar*!

Laughter.

CN Relative to the original question, though, I definitely tried to not go too far and try to understand the complexities of science because I felt that the audience won't be able to. I have to understand it a little bit better than the audience does, but you have to be one of them . . .

JN You and I are not terribly keen on research. You do just enough so that you see the possibilities and not the constraints. This was a very different experience for me because I spent so long talking with Kip and reading books. Sometimes these projects go quickly, sometimes they drag on, but this one lasted a bit. I became friends with Kip – we sort of kept talking – and I think all of that helps. There was about a two-month period in 2008 in which I felt confident to say that I felt like I truly understood both special relativity and the theory of general relativity, right? And then the writers' strike happened and I've never understood it since. (*Laughs.*) Some of these things you can understand on an intellectual level, and then hanging out with Kip long enough there are some of these things that you just start to feel are more instinctual.

CN And the instinctual ones are the worthwhile ones because the actual ones don't play for an audience at all, unless they can be summarized as a simple rule that you oppose – like you can't go faster than the speed of light, or whatever.

JG Explain the significance of Murphy's Law.

JN Murphy's Law is not quite as scientific as – (*To CN.*) I can't remember if you and I ever talked about it . . .

CN Well, the way you explain it in the draft – it actually is pretty scientific, funnily enough.

JN Yeah, it's kind of a lot of my speculative bullshit. What was interesting about Murphy's Law was that I thought it was a fascinating jumping-off point for a theme –

CN Well, it's not speculative bullshit! You mean in terms of it meaning whatever can happen, will happen?

xi

JN No, that's not speculative bullshit.

CN The other end of it is complete bullshit, and Kip has explained that to me. I left it in the film because I thought it was really good.

JN What's that?

CN The scientific idea that Brand expounds that because Miller's and Mann's planets orbit a black hole that not enough elements are able to reach them. Kip went with it at first, but then he talked to some of his colleagues, and he's fairly confident that, in fact, the opposite would be true. But he was okay with me leaving it there because I'm like, 'Well, first off, she could be wrong.' And I think, interestingly for Kip, that was a major breakthrough because of his understanding of the science –

JN (*laughing*) That the scientist could be wrong! Yeah, totally.

CN Yeah, that you can have a character who spouts bullshit, or speculation, or whatever – that that's okay. Once he got his head around it, he was very comfortable with it. Where we got into a certain amount of trouble and where we really tried to skirt the truth is with the gravitational pull of the black hole, because this orbital angular momentum stuff that it gets into, the way that a black hole would really attract a body, and the way that you wouldn't fall into it, you would orbit it – they're just not things that the audience is ever going to be able to understand. That was one of those early things that we said, 'The way this story is going to work, we're going to have to view gravity as a stronger force than it really is.' Or, stronger in its early stages.

JN But in turn, when you'd talk to Kip you'd realize that relativity is such an odd thing. The shape of our universe is so bizarre that at certain speeds and locations, time and space do become very unusual. The idea that I was really trying to get to with Murphy's Law was just that we live in a space in which things are permitted to happen, right? And those are good things or bad things. Death, destruction, but also life. The idea that we're here on this ball of mud hurtling through space seems to have something to do with our interactions with extra-planetary bodies and cosmic rings –

CN I think biologically and historically it's a very interesting idea, and I do think it's scientific because it actually relates to osmosis, as simply

as that; it's like, a body in motion with particles going through a membrane because they just will.

JN Right. They'll find a way.

CN Exactly.

JG Talk about making abstract, complex concepts understandable by finding a way to make them emotional.

CN You do have to personalize it. Even if the audience understands it, they aren't going to care about it. There were two things that really hooked me on the project after reading the early drafts. I mean, I loved the characters. I loved the setting of the first act. But I really loved the moment where Cooper catches up with the messages he's missed. And I always felt that if you could make that the centerpiece of everything that happens in the second act – it just is such a powerful thing that anyone could relate to. And there is science behind it, but you're not thinking about the science at all. You're actually thinking about your own mortality. You're thinking about living life as a human being. And that was attractive to me.

If you look at what I did with the draft, mostly what I did was take out all of the other stuff in the second act and just have that scene. I always found that moment to be the most ambitious thing in the project, and the most sort of . . . extraordinary.

JG Walter brought up an interesting point. He said that Flannery O'Connor always said that the most important word when writing is concrete. And for him the concrete thing in this script was the emotional core between the parent and the children.

CN Yeah. Well, I always felt that was at the heart of the project. My feeling on the development process – which you (*JN*) were engaged in for many years – is that it doesn't necessarily allow for choices; that is to say, the stripping down of choices. The development process inherently adds things – adds potential choices – but it's not a very good process for making the ultimate choices you have to make in terms of what to take out. And ultimately, in any moviemaking process, at some stage somebody has to come along – usually it winds up being a director, if somebody's a writer-director they've got a better chance of doing it – and going, 'Okay, yes you could make this whole other movie. You could make ten other movies, but you can't make those

movies. You've got to choose one and follow that line very strongly.' So what I found in your drafts was this family. And to me, that's the thing that you follow the whole way. And ultimately what I wound up doing – and I told you after I'd done it because I did not do it on purpose – but I wound up eliminating any kind of alien life from the project. For me, that happened for two reasons. I mean, one was just me following my natural instinct about what I loved about the characters, and the story that I thought was important. The other reason has to do with the problems I have with a lot of popular science fiction films over the years, which is that they don't necessarily focus in on a momentous event to the degree that they should, and the only way to do that is with the exclusion of other momentous events.

JN Sure.

CN So, to me the idea that you could find a planet that you could walk around on and talk about living on is so extreme, that to then also have a scene where somebody encounters alien life – that to me is the next momentous event . . .

JN A whole other movie!

CN It's the difference between screenplays and then the screenplay that you go, 'Okay now we turn the cameras over on Monday.' It's not about taking out things that you think are good – it's just about a choice of going, 'You could make any movie out of this. What is it?' And I talked to you a lot, I remember, about genre very inarticulately for a very long period of time. Like years. Because I would say I don't want it to be an adventure story, but it was very difficult to figure out. I think ultimately it was about moving away from it being an action film and going more to – I don't even know what genre you call, like, *Treasure of the Sierra Madre* or *Greed*, or these films that are very much about human beings, and they tend to be quite simple stories.

JN A disaster morality tale, or something. Something in that space.

CN Yeah, I suppose you do call them adventure movies, but it's different. It's different from action-adventure.

JN Absolutely. Because *Interstellar* isn't about an antagonist. The antagonist is the universe.

CN Exactly.

JN The antagonist is the void of the vacuum that we live in.

CN Yeah. Which is about focus. I mean, one of the things that we did very early on – well, we really did it in the shooting, but when we came to edit, we do the first docking scene on the Endurance, which in all the scripts had been fairly much a throwaway. In my draft, it was one line. But the action takes up a lot of screen time. And I think, without even really talking about it with Lee (*Lee Smith, Editor*), we realized that if you make that moment important, and difficult, and dangerous, you're setting the tone in terms of just how difficult space is. If you turn the volume down you can put the focus on the mechanics of 'how do you live in space?' One of the things we talked a lot about in the sound design is not having sound effects in space. We thought that was going to be this very risky and daring thing to do, but what we discovered was that as soon as you just did it and looked at the film that way, you realized that silence is extremely threatening. It really reminds you at every stage that you just shouldn't be there.

JN You're automatically reminded of the uninhabitable aspect of that environment. It's very powerful.

JG By no means is this a message film, but it does emphasize the importance of the human impulse to explore, and it hits it pretty hard, particularly in the first act.

CN Well, I think that's a very positive message to have in the first act because it keeps an optimism to things, even though there's a negative view of 'where are we now?' But there's a real optimism to exploration. It's like in *Star Wars*, Luke Skywalker sitting there on Tatooine trying to see what's out there and eventually he gets his chance. So, it's an incredibly optimistic thing at the beginning of the film. What I brought to it, which actually wasn't even that fresh an idea because it was something which you talked about years before trying to get it in yourself, was the idea of looping it back in on itself. So the journey returns to where it starts. Because that always seemed the appropriate journey, and I think I tried very hard to make that very literal – very mechanical almost. We loop it back in on itself, and we see the dangers of that kind of exploration. I don't just mean physically, but emotionally. I mean, you go all the way out there, and then you have to come back.

JN But you return to find the world has changed. That was the most important thing for me. I think where I began my journey with this film was really with the end. The idea of a man out of his own time. Sort of a time traveller. On some instinctual level we feel that time travel is not possible backwards. The universe forbids it. You feel that once events move from right to left and we progress forwards in time, there's no going back. And there's something very tragic and sad about that. You can move only in the tragic direction – tragic in the sense that you have to leave people behind, optimistic in the sense that you can glimpse the future.

CN Right.

JN And as you get older, and certainly as I've become a parent, which is this transformative moment and somewhat meaningful for me with this project, because when I started it the relationships between what was then father and son were purely speculative – Chris then changed Murph to a little girl, and then in the interim I had a little girl of my own. So now the emotional wallop of the film is completely different. But even in the short few months since I've become a parent, you begin to realize that, as you get older, you become a bit of a passenger in the universe. And I imagine I will probably get to a moment in my life shortly towards the end of it where you just want to keep living because you want to see what happens. What do our children become? What is my little girl going to be doing in forty or fifty years? I mean, the possibilities of that are staggering. And the idea – a very provocative one – that you'd be able to glimpse that on some level, that you'd be able to glimpse where all that is going, is very sad and very alluring all at once.

CN It is, but there's another factor that really feeds into that, which is that pop culture relentlessly speculates about the negative aspects of the continuing human story. So there are all these ideas of apocalyptic thinking. Every generation believes they're the last generation on Earth. Maybe one generation will eventually be right. I certainly hope it's not ours. But everyone has always believed that, so there has always been this apocalyptic mode to storytelling. What I really loved about what you'd done with the central concept is that it transcends that. It's about the way in which human beings adapt and transcend natural move-ments – apocalyptic-type movements. And that is where the optimism comes in. That's also where the excitement comes in. Yes, the sadness

of leaving Earth is very analogous to the sadness of leaving home. But then you go somewhere and that's exciting and fascinating. I was just struck by how it had been a long time since I saw movies like the ones that Spielberg was making in the early eighties, late seventies, where you presented a sort of inevitability in life or human evolution or whatever – something that the filmmakers really believed in. Like, if you look at *Close Encounters* or *E.T.*, or whatever – stuff where you go, 'Okay, these things are going to happen. What if it happened now? Or what if we could see it happening now? What if we knew it?' And I just thought that original concept you had that the Earth is the nest and you leave the nest – I'd never seen that presented as positive. I'd never seen that presented as a simple, evolutionary sort of inevitability. Which, to me, the best science fiction films do, or the best speculative fiction films do – they present it as, 'Yes, this is going to happen. Isn't it interesting to think about what that would be like?' It's actually a lot harder to imagine something positive – a lot harder to imagine what if we have to go beyond where we are?

JN That's the fascinating question of why is it that humans are so obsessed with not just the idea of their own Armageddon, but their own culpability in it.

CN Well, I think it's actually easier to imagine hell than it is to imagine heaven, and I think if you look at paintings or anything else, the descriptions of hell are always more convincing and relatable because they're exaggerations of human suffering, which is quite tactile. But there's also massive importance to a generation that is the last human generation. I think every generation has that sort of ego to them – if you could ascribe an ego to an entire species. But there's that idea that we might be the last, and therefore we are the most important.

JN The film might be guilty of that, but ultimately not.

CN I don't think it is at all because there's nobody sitting there going, 'Yeah, we messed up; this is the end of things.' They're all sitting there kind of going, 'Yeah, we'll figure it out.' Part of the problem of where the negativity comes from has happened in the last twenty years with people trying to look in a more cynical way under the surface about motivations for why things happen. So, there's a very, very powerful belief that innovation comes from war, or human conflict. You know, we only went into space to mess with the Russians or whatever it is.

And you go, 'Okay. There are interesting theories behind that. There are interesting undercurrents that, yes, in the past, might have been overlooked.' But now people aren't seeing the wood for the trees. We went to space because it was a cool thing to do. Kennedy sat there and said, 'Yeah. We should go to the moon.' I had a very interesting conversation with my friend David Lloyd years ago. We were talking about, in human history who of our times will be remembered? And who will be the most prominent person to be remembered for the last hundred years in the way that historical figures are? And if you ask people that question, you know, they'll say things like Steve Jobs, or whatever. And then you go, no, it's Neil Armstrong!

JN Right.

CN And how can it not be Neil Armstrong? If you look five hundred years in the future, it's like, the first guy who left the earth and landed somewhere else.

JN He's Christopher Columbus minus all the slavery.

CN Yes. And whatever things sort of hover around, that stop us from being able to see, will fall away over time, the same way they did for Columbus.

JN And that's how I got the job in the first place. At that moment it absolutely felt – this was my pitch – that the safe bet was in a million years that alien anthropologists would come to Earth and they would find a stick with a piece of polyester on the moon, and they would say, 'Wow, they almost made it. They got that far.' So, you wash away all the day-to-day stuff that we get caught up in – this invention or that invention. And it's like, 'No.' That drive to get out, to explore the universe, will be the residue that's left behind. Armstrong will be the person that people talk about.

This is what connects it back, for me, to Murphy's Law. Murphy's Law popularly is: if something could go wrong, it will go wrong. The eponymous Murphy was one of a group of rocket engineers working for the Air Force. And he was a grumpy guy, and the rest of the people on the team didn't like him very much because he was constantly ragging on people. And one day he came back and said, 'You know, if there was a way for these guys to mess this up, they would.' And that has been how we remember Murphy's Law, right? If there's a way for

human beings to mess things up, they will. But another guy there – an engineer by the name of Nichols – had a different take on it. And by his accounting, the sentiment – as it was expressed as they were distilling this wisdom of the things going wrong in their testing – was that 'If something can happen, it will happen.' It doesn't have to be a bad thing; it doesn't have to be a good thing. Humans are capable of both. We're lucky enough to live in a universe in which both things can happen. And it's interesting to see how many films and books tend to concentrate on all the terrible things that we can do. The parasitic relationship between innovation and violence and all those sorts of things. And there's something under it, certainly. But they do tend to ignore the self-evident part too.

CN Yeah, exactly.

JN We exist. We survived. Hopefully, we will continue to survive, and that is probably a good thing.

Interstellar

THE SCREENPLAY

BLACK. THE GENTLE SOUND OF WIND IN CORN 1

A row of books. From spaces between them, dust falls.

INTERSTELLAR

> ELDERLY FEMALE VOICE
> (*V.O.*)

Sure. Dad was a farmer.

BRIGHT CORN STALKS FILL THE FRAME, SWAYING IN THE BREEZE 2

> ELDERLY FEMALE VOICE
> (*V.O.*)

Like everybody else back then.

The wind is RISING, *shaking the plants more* FORCEFULLY . . .

Insert cut: a WOMAN *in her eighties against a dark background.*

> ELDERLY WOMAN

Course, he didn't start that way . . .

The WIND IS HOWLING, SHRIEKING *and we* RIP INTO –

EXT. THE STRATOSPHERE – DAY 3

BURNING *through the fringes of space* –

INT. COCKPIT – CONTINUOUS 4

A young PILOT *fights his* BUFFETING *craft* –

> RADIO
> (*O.S.*)

Computer says you're too tight –

> PILOT

I got this –

The Pilot grabs a panicked glance at his instruments –

> RADIO
> (O.S.)

Crossing the Straights . . . shutting it down, Cooper. Shutting it *all* down . . .

> PILOT

NO! I need the power up –

EXT. THE STRATOSPHERE – CONTINUOUS 5

The BLACK *and* RED SKY *starts* SPINNING HORRIFYINGLY –

INT. COCKPIT – DAY 6

As the controls RIP *themselves free, the pilot* SHOUTS *and we –*

CUT TO:

INT. BEDROOM, FARMHOUSE – NIGHT 7

A man WAKES, *nightmare* SWEATY. *This is* COOPER.

> YOUNG GIRL'S VOICE
> (O.S.)

Dad? Dad?

Cooper turns: in the doorway – his sleepy ten-year-old daughter. This is MURPH.

> COOPER

Sorry. Go back to sleep.

> MURPH

I thought you were the ghost.

> COOPER

There's no ghost, Murph.

> MURPH

Grandpa says you can get ghosts.

4

COOPER

Maybe Grandpa's a little too close to being one himself. Back to sleep.

MURPH

Were you dreaming about the crash?

COOPER

Back to sleep, Murph.

Murph shuffles back out the door. Cooper moves to the window. DAWN *breaks over an* ENDLESS SEA OF CORN . . .

ELDERLY FEMALE VOICE
(*V.O.*)

Corn, sure. But dust. In your ears, your mouth . . .

INSERT CUT: AN OLD-TIMER IN CLOSE UP, WATERY-EYED, DESCRIBES DUST BOWL CONDITIONS.

OLD-TIMER
(*V.O.*)

Dust just everywhere. Everywhere.

EXT. COOPER'S FARM – MORNING 8

*An old man, handkerchief across his face, sweeps dust out of the door onto the porch. This is Grandpa (*DONALD*).*

INT. KITCHEN, FARMHOUSE – MORNING 9

Cooper pours himself coffee as Donald puts grits on the table. TOM, *Cooper's fifteen-year-old son, stuffs his face.*

Murph, wet hair, towel around neck, plays with pieces of a MODEL (*a lunar lander*).

DONALD

Not at the table, Murph.

MURPH

Dad, can you fix this?

COOPER
(*takes pieces, frowning*)

What'd you do to my lander?

5

MURPH

Wasn't me.

TOM

Lemme guess – your ghost?

MURPH

It knocked it off my shelf. It keeps knocking books off.

TOM

There's no such things as ghosts, dumb-ass –

COOPER
(*to Tom*)

Hey –

MURPH

I looked it up, it's called a poltergeist.

TOM

Dad, tell her.

COOPER

Murph, you know that's not *scientific*.

MURPH

You say science is about admitting what we *don't* know.

DONALD

She's got you there.

COOPER
(*hands her pieces*)

Start looking after our stuff.

Donald looks at Cooper, admonishing. Cooper shrugs.

COOPER

Fine. Murph, you wanna talk science, don't just tell me you're scared of some ghost – record the facts, analyze, present your conclusions.

MURPH

Sure.

Cooper gets up, grabs his keys.

DONALD

Hold up. (*Off look.*) Parent–teacher conferences. 'Parent' – not 'grandparent'.

The kids pile into an old pickup truck, scraping DUST *off the seats. Cooper, coffee in hand, peers at a black cloud.*

COOPER

Dust storm?

DONALD
(*shakes his head*)
Nelson's torching his whole crop.

COOPER

Blight?

DONALD

They're saying it's the last harvest for okra. Ever.

Cooper stares at the smoke. Uneasy. Gets into the truck.

COOPER
Shoulda planted corn like the rest of us.

DONALD
Be nice to Miss Hanley. She's single.

COOPER
What's that supposed to mean?

DONALD
Repopulating the Earth – start pulling your weight.

COOPER
Start minding your business.

INT./EXT. PICKUP TRUCK ON DIRT ROAD – MOMENTS LATER 11

Cooper sips his coffee, steering while Murph shifts –

COOPER
Okay, gimme second –

Murph wrestles the long gear stick into second. Cooper sips.

> COOPER

Now third –

Murph struggles to find third – GRIND.

> TOM

Find a gear, dumb-ass.

> MURPH

Shut up, Tom!

BANG – A TIRE BLOWS OUT. *Cooper stops the truck.*

> TOM

What'd you do, Murph?

> COOPER

She didn't do anything. We lost a tire is all.

> TOM

Murphy's Law.

> MURPH

Shut up, Tom.

Cooper gets out of the truck, checks the flat, turns to Tom.

> COOPER

Grab the spare.

> TOM

That is the spare.

> COOPER

Okay, patch kit.

> TOM

How'm I supposed to patch it out here?

> COOPER

Figure it out. I'm not always going to be here to help you.

Tom moves to the back of the truck. Murph is there.

> MURPH

Why'd you and Mom name me after something bad?

> COOPER

We didn't.

MURPH

Murphy's Law?

COOPER

Murphy's Law doesn't mean bad stuff will happen. It means 'whatever can happen, will happen'. And that sounded just fine to us.

Murph frowns, hearing something . . .

COOPER

What?

Then Cooper hears it, too. A LOW RUMBLE. *Cooper* GRABS *Murph as a* DRONE SOARS *low overhead –*

COOPER

Come on!

Cooper jumps into the truck – he pulls out a laptop and antenna hands them to Murph – shouts at Tom –

COOPER

Get in!

TOM
(jack in hand)

What about the tire?

INT./EXT. PICKUP TRUCK THROUGH FIELDS – MOMENTS LATER 12

Close on the SHREDDING TIRE *as the truck* BARRELS *through cornfields. Murph fires up the laptop. Cooper strains to see through the cornstalks, scanning the horizon –*

TOM

There!

To the right, the dark shape of the drone, cruising low over the fields. Cooper JERKS *the wheel – the drone has long, thin wings like a U-2, but no cockpit.*

COOPER

Indian air force surveillance drone. Solar cells could power an entire farm. (*To Tom.*) Take the wheel –

Tom takes the wheel – Cooper hands Murph the antenna.

Keep it pointed right at it –

Cooper works the laptop – the screen fills with Hindi.

Faster, Tom. I'm losing it.

Tom WEAVES *through the corn – they round a corner, almost* HIT *a* HARVESTER – BANG – *the truck loses a wing mirror –*

Ahead the drone SOARS, *banking, pulling away –*

The truck BURSTS *out of the corn, Cooper's nose is in the laptop.*

TOM

Dad?

COOPER

Almost got it. Don't stop.

In front of them, the drone plummets from view into the next valley – the path ahead leads to a three-hundred-foot drop.

TOM

DAD . . .

Cooper looks up.

COOPER

Tom!

Tom locks up the brakes. Cooper looks at him – he shrugs.

TOM

You told me to keep going.

Cooper grabs the laptop and opens the door.

COOPER

Guess that answers the 'if I told you to drive off a cliff' scenario.

Murph is still pointing the antenna.

MURPH

We lost it.

COOPER
(*smiles*)

No, we didn't.

The DRONE SOARS BACK OVER THEM – *Cooper is moving his fingers across the track pad,* PILOTING THE DRONE.

As the kids watch, Cooper sends the drone soaring over them, banking above the valley. Cooper crouches next to Murph.

> COOPER
> Want to give it a whirl?

Murph, guided by Cooper, moves her fingers across the track pad – the massive drone BANKS *in response. Murph is in heaven.*

> COOPER
> Let's set her down next to the river.

EXT. RIVERBANK – MOMENTS LATER 13

The truck limps up to the drone. Cooper and the kids climb down. Cooper runs a hand along the smooth carbon flank of the aircraft.

> TOM
> How long you think it's been up there?

> COOPER
> Delhi mission control went down same as ours, ten years ago.

> TOM
> It's been up there ten years? Why'd it come down so low?

> COOPER
> Sun finally cooked its brain. Or it came down looking for something.

> MURPH
> What?

> COOPER
> Some kind of signal. Who knows?

Cooper finds an access hatch. Pries it open. Examines the black-box brain of the machine.

> MURPH
> What are you going to do with it?

> COOPER
> Give it something socially responsible to do, like drive a combine.

MURPH

Couldn't we just let it go? It's not hurting anyone.

Cooper looks down at his daughter. Good kid.

COOPER

This thing has to adapt, just like the rest of us.

EXT. COUNTY SCHOOL – DAY 14

The truck pulls up to school, drone fuselage hanging out.

COOPER

How's this work? You guys come with?

TOM

I've got class. But *she* . . .

Pats Murph on shoulder.

Needs to wait.

Murph glares at Tom as he hops out.

COOPER

Why? What?

MURPH

Dad, I had a thing . . . well, they'll tell you about it. Just try
and . . .

COOPER

Am I gonna be mad?

MURPH

Not with me. Just try not to –

COOPER

Relax, I got this.

Murph pulls out a notebook. Starts drawing a BARCODE.

INT. PRINCIPAL'S OFFICE – LATER (MORNING) 15

Cooper enters, awkward. The PRINCIPAL *(male, fifties) turns from
the window.*

PRINCIPAL

Little late, Coop. (*Indicates chair.*) Guess you had to stop off at the Asian fighter plane store.

COOPER
(*sits, smiles*)

Actually, sir, it's a surveillance drone. With outstanding solar cells.

Cooper nods at Murph's teacher, Ms Hanley, thirties, attractive.

PRINCIPAL

We got Tom's scores back. He's going to make an excellent farmer. Congratulations.

The Principal slides a paper across the desk.

COOPER
(*taken aback*)

What about college?

PRINCIPAL

The university only takes a handful. They don't have resources –

COOPER

I'm still paying taxes – where's that go? There's no more armies.

PRINCIPAL

Not to the university. Coop, you have to be realistic.

COOPER

You're ruling him out for college *now*? He's fifteen.

PRINCIPAL

Tom's score simply isn't high enough.

COOPER

What're you? About a thirty-six-inch waist? (*Beat.*) Thirty-inch inseam?

PRINCIPAL

I'm not sure I see what –

COOPER

You're telling me you need two numbers to measure your own ass, but just one to measure my son's future?

Ms Hanley stifles a laugh. The Principal shoots her a look.

PRINCIPAL

You're a well educated man, Coop. A trained pilot –

COOPER

And an engineer.

PRINCIPAL

Okay. Well, right now the world doesn't need more engineers. We didn't run out of planes, or television sets. We ran out of *food*.

Cooper leans back. He's not going to win this one.

PRINCIPAL

The world needs farmers. Good farmers, like you. And Tom. (*Smiles benignly.*) We're a caretaker generation. And things are getting better. Maybe your grandchildren –

COOPER

Are we done, sir?

PRINCIPAL

No. Ms Hanley is here to talk about Murph.

Cooper shifts his gaze to Ms Hanley.

MS HANLEY

Murph's a bright kid. A wonderful kid, Mr Cooper. But she's been having a little trouble . . .

Ms Hanley places a textbook on the desk.

She brought this to school, to show the other kids the section on the lunar landings . . .

COOPER

Yeah, it's one of my old textbooks, she likes the pictures.

MS HANLEY

This is an old federal textbook. We've replaced them with corrected versions.

COOPER

Corrected?

MS HANLEY

Explaining how the Apollo missions were faked to bankrupt the Soviet Union.

COOPER

You don't believe we went to the moon?

MS HANLEY

(*tolerant smile*)

I believe it was a brilliant piece of propaganda. The Soviets
bankrupted themselves pouring resources into rockets and other
useless machines.

COOPER

'Useless machines'?

MS HANLEY

Yes, Mr Cooper. And if we don't want a repeat of the
wastefulness and excess of the twentieth century, our children
need to learn about *this* planet, not tales of leaving it.

Cooper considers this in silence. Looks at Ms Hanley.

COOPER

One of those useless machines they used to make was called
an MRI. And if we had any of them left, the doctors might have
been able to find the cyst in my wife's brain *before* she died,
rather than afterwards. Then *she* could be sitting here listening
to this, which'd be good, cos she was always the *calmer* one . . .

Ms Hanley looks at Cooper, embarrassed. Then –

MS HANLEY

I'm sorry about your wife, Mr Cooper. But Murph got into a
fist fight with several of her classmates over this Apollo nonsense
and we thought it best to bring you in and see what ideas you
might have for dealing with her behavior on the home front.

COOPER

Sure. Well, there's a ball game tomorrow night, and Murph's
going through a bit of a baseball phase. There'll be candy and
soda . . .

Ms Hanley looks at him, expectant.

COOPER

I think I'll take her to that.

Ms Hanley turns to the Principal, not happy.

Murph looks up from her notebook at her dad, expectantly.

> MURPH

How'd it go?

> COOPER

I, uh . . . got you suspended.

> MURPH

What?!

> COOPER

Sorry.

> MURPH

Dad! I told you not to –

The CB radio CRACKLES *to life.*

> CB OPERATOR

Cooper? Boots for Cooper.

> COOPER

Cooper.

> BOOTS
> (*over radio*)

Coop, those combines you rebuilt went haywire.

> COOPER

Power the controllers down for a couple minutes.

> BOOTS
> (*over radio*)

Did that. You should come take a look, it's kinda weird.

EXT. FARMHOUSE – DAY 17

Cooper and Murph pass a slow-moving harvester pulling up to the house, which is surrounded by AUTOMATED FARM MACHINES. *They've nosed up to the house like animals at a Nativity. Boots, the farm hand, approaches –*

> BOOTS

One by one they been peeling off from the fields and heading over.

Cooper pops open the cabin to a harvester. Checks the autopilot hooked up to the controls.

> BOOTS
>
> Something's interfering with their compass . . .

Cooper jumps down and heads to the front door. Enters.

> BOOTS
> (O.S.)
>
> Magnetism or some such . . .

INT. FARMHOUSE – CONTINUOUS 18

Cooper looks at the kitchen. Nothing. Murph comes in.

> MURPH
>
> What is it, Dad?

A small BANG *from upstairs. Cooper heads up.*

INT. MURPH'S BEDROOM – CONTINUOUS 19

Murph's bedroom clearly used to be her mother's. Cooper, in the doorway, looks at the wall of BOOKS *opposite – several* GAPS*. He looks down at some books on the floor.*

> MURPH
>
> Nothing special about *which* books. (*Off look.*) Been working on it, like you said.

Murph holds up her notebook with its barcode.

> MURPH
>
> I counted the spaces.

> COOPER
>
> Why?

> MURPH
>
> In case the ghost's trying to say something. I'm trying Morse.

> COOPER
>
> Morse?

> MURPH
>
> Yeah. Dots and dashes, used for –

COOPER

Murph, I know what Morse code is. I just don't think your bookshelf's trying to talk to you.

He leaves. Murph, embarrassed, turns back to the shelf.

INT. FRONT PORCH, FARMHOUSE – NIGHT 20

Donald hands Cooper a beer.

COOPER

Had to reset every compass clock and GPS to offset for the anomaly.

DONALD

Which is?

COOPER

No idea. If the house was built on magnetic ore, we'd've seen this the first time we switched on a tractor.

Donald nods. Sips.

DONALD

Sounds like your meeting at school didn't go so well.

COOPER
(*sighs*)

We've forgotten who we are, Donald. Explorers, pioneers. Not *caretakers*.

Donald nods, thoughtful. Weighs up his words.

DONALD

When I was a kid it felt like they made something new every day. Some gadget or idea. Like every day was Christmas. But *six billion people* . . . just try to imagine that. And every last one of them trying to have it all.

He turns to Cooper.

This world isn't so bad. And Tom'll do just fine – you're the one who doesn't belong. Born forty years too late, or forty years too early. My daughter knew it, God bless her. And your kids know it. 'Specially Murph.

COOPER

We used to look up and wonder at our place in the stars. Now we just look down and worry about our place in the dirt.

DONALD

Cooper, you were good at something and you never got a chance to do anything with it. I'm sorry. But that's not your kids' fault.

Cooper looks up at the stars above.

OLD-TIMER
(V.O.)

May 14th. Never forget. Clear as a bell. You'd never think . . .

INSERT CUT: THE OLD-TIMER REMEMBERS. CUT TO A SECOND OLD-TIMER . . .

SECOND OLD-TIMER

When the first of the real big ones rolled in . . . I thought it was the end of the world.

EXT. BASEBALL FIELD – LATE AFTERNOON 21

The CRACK of ball off bat – a pop-fly caught to a trickle of applause. Half-filled stands at what looks like a minor league game.

DONALD

In my day we had real ball players. Who're these bums?

As the team runs in from the field we see: NEW YORK YANKEES.

COOPER

Well, in *my* day people were too busy fighting over food for baseball, so consider this progress.

Murph offers Donald some popcorn.

DONALD

Fine. But popcorn at a ball game is unnatural. I want a hot dog.

MURPH
(*confused*)

What's a hot dog?

Cooper sits with Tom a row in front.

COOPER

The school says you're gonna follow in my footsteps. I think that's great.

TOM

You think that's great?

MURPH

You hate farming, Dad. Grandpa said.

Cooper looks at Donald, who shrugs 'sorry'.

COOPER

What's important is how *you* feel about it, Tom.

TOM

I like what you do. I like our farm.

On the field: the batter hits one along the ground – it rolls to an infielder's foot – but the infielder IGNORES *it,* STARING *up at the sky. The crowd starts to look up . . .*

OLD-TIMER
(V.O.)

You've never seen the like. Black. Just black . . .

INSERT CUT: THE OLD-TIMER CHOKES BACK FEAR AS HE REMEMBERS.

Cooper stares at the horizon, where an ENORMOUS BLACK DUST STORM IS MASSING. *People start leaving, tying handkerchiefs across their faces.*

COOPER

Come on, guys.

INT./EXT. PICKUP TRUCK – MOMENTS LATER 22

Cooper speeds along as Donald and the kids stuff RAGS *into cracks and vents . . . behind them the* WALL OF BLACK DUST ADVANCES, SWALLOWING UP ROADS, BUILDINGS. *A nasty* SOUND *is developing – the truck* ROCKING *with* GUSTS *of wind . . .*

Suddenly, BLACK DUST ENVELOPS *the car,* LIGHTNING CRACKLING.

DONALD

It's a bad one . . .

CObOPER

 COOPER
 Mask up, guys.

Murph and Tom take SURGICAL MASKS *out of the glove box.*

EXT. FARMHOUSE – CONTINUOUS 23

VISIBILITY MERE FEET *as the dust storm* BRUTALIZES *the farm.
The truck* CRAWLS *up to the house. Cooper leans in to try and see
better* . . . CRACK – *a panel of sheet metal* SMASHES *into the
windshield – Cooper turns – wrestles Murph out of the truck as
Donald blindly stumbles towards the front door with Tom* . . .

INT. FARMHOUSE – CONTINUOUS 24

The SHUTTERS BANG *as the wind* WHIPS *around the house,* FORCING
JETS OF DUST *up through cracks in the window frames, floorboards* . . .
Donald SLAMS *the door. Murph is* COUGHING . . . *Cooper looks
around. Sees dust coming from upstairs.*

 COOPER
 Did you both shut your windows?

Tom nods. Murph looks at Cooper. Runs for the stairs.

 COOPER
 Wait –

INT. MURPH'S BEDROOM – CONTINUOUS 25

*Cooper gets to the doorway. Murph stands in the middle of the
room,* STARING. *Cooper* SHUTS *the window. The dust hangs in the
relative quiet. Murph is staring,* TRANSFIXED, *at* LINES *where dust is*
FALLING UNNATURALLY FAST, STREAMING DOWN *through the air,
collecting on the floor in a* PATTERN –

 MURPH
 The Ghost.

Cooper STARES *at dust collecting like snow on power lines* . . .

 COOPER
 Grab your pillow, sleep in with Tom.

EXT. FARMHOUSE – DAWN – MORNING 26

Calm. Dust settled.

INT. TOM'S ROOM – CONTINUOUS 27

Murph slips out of bed, wrapped in her blanket. Pads down the hall, peeks in her bedroom door at –

INT. MURPH'S BEDROOM – CONTINUOUS 28

Cooper sits, staring at the PATTERN *of dust: thick radial lines, like a* CIRCULAR BARCODE.

Murph sits down next to her dad. They STARE *at it together. He holds up a coin . . .*

> COOPER
>> It's not a ghost . . .

Cooper tosses the coin across a line. It SHOOTS *at the floor –*

>> It's *gravity.*

INT. SAME – LATER 29

Donald pokes his head in.

> DONALD
>> I'm dropping Tom, then heading to town . . . (*Looks at dust pattern.*) You wanna clean that up when you've finished praying to it?

Cooper reaches for Murph's notebook. Starts writing . . .

INT. KITCHEN, FARMHOUSE – LATER 30

Murph fills a glass of water. Picks up a plate of sandwiches.

INT. MURPH'S BEDROOM – CONTINUOUS 31

Follow Murph into the room, to find Cooper standing there.

> COOPER
>> I got something.

Cooper is pointing to the thick and thin radial lines –

Binary. Thick is one, thin is zero – it's numbers . . . number
pairs . . .

He holds up the notebook to show Murph the number pairs.

Coordinates.

INT. KITCHEN, FARMHOUSE – MOMENTS LATER 32

Cooper and Murph pore over MAPS. *Cooper* TOSSES *one aside, lays
it out on the table. Finds a spot. Looks up at Murph . . .*

EXT. FARMHOUSE – MOMENTS LATER 33

Cooper packing his truck – sleeping bag, flashlight . . .

> MURPH
> You can't leave me behind!

> COOPER
> Grandpa's back in two hours.

> MURPH
> You don't know what you're going to find –

> COOPER
> That's why I can't take you.

INT. KITCHEN, FARMHOUSE – MOMENTS LATER 34

Cooper grabs the maps and a bottle of water. He calls up –

> COOPER

Murph?

Nothing.

Murph, just wait here for Grandpa. Tell him I'll call him on the
radio.

INT./EXT. PICKUP TRUCK ON ROAD – MOMENTS LATER 35

*Cooper drives, map spread on the wheel, looks for a pen – reaches
over to the passenger wheel well – lifts a* BLANKET *– Murph is there –*

COOPER

JESUS!

The truck WOBBLES *as Cooper regains control.*

Murph, what are you doing?!

Murph is LAUGHING *as she climbs into the passenger seat –*

COOPER

It's not funny –

But Murph's laugh is infectious.

MURPH

You wouldn't be here if it wasn't for me.

Cooper hands Murph the map.

COOPER

Fair enough. Make yourself useful . . .

The pickup cruises down the road, heading for the MOUNTAINS.

EXT. PLAINS APPROACHING MOUNTAINS – DUSK 36

The tiny pickup is dwarfed by the darkening foothills.

EXT. DIRT ROAD OFF MOUNTAIN PASS – NIGHT 37

Cooper pulls up to a gate in chain-link fence. Murph is asleep next to him.

COOPER

Murph. Murph.

Murph wakes.

I think this is as far as we get.

Murph glances out at the fence. Closes her eyes again.

MURPH

Why? You didn't bring the bolt-cutters?

COOPER

I like your spirit, young lady.

Cooper gets out of the truck, retrieves his bolt-cutters and comes up to the fence. He looks up and down the road. Nothing. He reaches out and puts the jaws of the cutters –

WHAM! SPOTLIGHTS IN COOPER'S EYES – A HARSH ELECTRIC VOICE –

> VOICE
> STEP AWAY FROM THE FENCE.

Cooper drops the cutters, puts his hands in the air –

> COOPER
> Don't shoot! My child is in the car! I'm unarmed! My daughter is –

Murph watches, terrified as, with a ZAP, *Cooper* DROPS. *Murph* SCRAMBLES *back along the seat as* MASSIVE FOOTSTEPS APPROACH. *The door is* WRENCHED *open –* a BLINDING LIGHT

> VOICE
> DON'T BE AFRAID.

Murph SCREAMS.

INT. BRIGHT, INDUSTRIAL ROOM – LATER 38

Cooper comes to, sitting in a chair. Opposite him is an ARTICULATED MACHINE. *A* VOICE *emanates from its side.*

> MACHINE
> How did you find this place?

> COOPER
> Where's my daughter?

> MACHINE
> You had the coordinates for this facility marked on your map. Where did you get them?

Cooper leans in to the machine.

> COOPER
> WHERE'S MY DAUGHTER?!

Cooper's scream REVERBERATES. *Cooper sizes up the machine.*

You might think you're still in the Marines, but the Marines don't exist anymore, pal. I've got grunts like you mowing my grass . . .

The Machine RISES *to its full height.*

MACHINE

How did you find us?

COOPER

But you don't look like a lawnmower to me . . . you, I'm gonna turn into an overqualified vacuum cleaner –

FEMALE VOICE
(O.S.)

No, you're not.

Cooper turns to see a businesslike woman in her thirties.

WOMAN

Tars, back down, please.

The machine, TARS, *sinks back down.*

COOPER

You're taking a risk using ex-military for security. They're old, their control units are unpredictable . . .

WOMAN

Well, that's what the government could spare.

COOPER

Who are you?

WOMAN

Dr Brand.

COOPER

I knew a Dr Brand once. But he was a professor –

WOMAN (BRAND)
What makes you think I'm not?

COOPER

And nowhere near as cute.

BRAND

You think you can *flirt* your way out of this mess?

26

COOPER
(*honest, scared*)
Dr Brand, I have no idea what this mess is. I'm scared for my little girl and I want her by my side. Then I'll tell you anything you want to know. Okay?

Brand considers this. Turns to Tars.

BRAND
Get the principals and the girl into the conference room. (*To Cooper.*) Your daughter's fine. Bright kid. (*Rises.*) Must have a *very* smart mother.

INT. UNDERGROUND FACILITY – MOMENTS LATER 39

Cooper follows Brand into a corridor. Tars LURCHES *behind.*

COOPER
It's pretty clear you don't want visitors – why not let us back up from your fence and be on our way?

BRAND
It's not that simple.

COOPER
Sure it is. I don't know anything about you or this place.

BRAND
Yes, you do.

Brand ushers Cooper through a door into a conference room –

INT. CONFERENCE ROOM – CONTINUOUS 40

Where an OLD MAN *is crouched down, talking to Murph.*

MURPH
Dad!

Murph runs into Cooper's arms. The Old Man SMILES *at Cooper.*

OLD MAN
Hello, Cooper.

COOPER
(*stunned*)
Professor Brand?

MAN AT TABLE (DOYLE)
Just take a seat, Mr Cooper.

Cooper and Murph sit at a table where five people are waiting – a bespectacled man, WILLIAMS, leans forward to address Cooper.

WILLIAMS
Explain how you found this facility.

COOPER
Stumbled across it. Looking for salvage and I saw the fence –

WILLIAMS
You're sitting in the world's best kept secret – you don't stumble in. And you certainly don't stumble *out*.

PROFESSOR BRAND
Cooper, please. Cooperate with these people.

Cooper looks nervously around the room.

COOPER
It's hard to explain, but we learned these coordinates from an anomaly . . .

DOYLE
What sort of anomaly?

COOPER
I don't want to term it 'supernatural' . . . but . . .

Cooper is losing them. Williams leans forward. Serious.

WILLIAMS
You're going to have to, Mr Cooper. Real quick.

COOPER
After that last storm, it was a pattern . . . in dust . . .

MURPH
It was *gravity*.

All eyes turn to Murph. She's said the magic word. Doyle looks at Professor Brand, excited. Turns to Cooper –

DOYLE
Where was this gravitational anomaly?

COOPER

Look, I'm happy you're excited about gravity, but if you want
more answers from us I'm gonna need assurances –

WILLIAMS

Assurances?

Cooper looks at Murph. Then covers Murph's ears.

COOPER

That we're getting out of here . . . and not in the trunk of some
car.

Brand laughs. Williams smiles. Cooper looks confused.

PROFESSOR BRAND

Don't you know who we are, Coop?

COOPER

No. No, I don't.

BRAND
(*points around table*)
Williams, Doyle, Jenkins, Smith, you already know my father,
Professor Brand. We're *NASA.*

COOPER

NASA?

PROFESSOR BRAND

NASA. Same NASA you flew for.

Now Cooper is laughing, too. Murph looks around, confused.

INT. UNDERGROUND FACILITY – MOMENTS LATER 41

Professor Brand shows Cooper the facility.

COOPER

I heard you got shut down for refusing to drop bombs from the
stratosphere onto starving people.

PROFESSOR BRAND

When they realized killing other people wasn't a long term
solution they needed us back. Set us up in the old NORAD
facility. In secret.

 COOPER
Why secret?

 PROFESSOR BRAND
Public opinion won't allow spending on space exploration. Not
when we're struggling to put food on the table.

Professor Brand ushers Cooper through a large door –

INT. GREENHOUSE – CONTINUOUS 42

Professor Brand gestures to large PLANTATIONS *under glass.*

 PROFESSOR BRAND
Blight. Wheat seven years ago, okra this year. Now there's just
corn.

 COOPER
But we're growing more than ever –

 PROFESSOR BRAND
Like the potatoes in Ireland, like the wheat in the dust bowl, the
corn will die. Soon.

Brand enters with Murph. She shows her the greenhouses.

 COOPER
We'll find a way, we always have.

 PROFESSOR BRAND
Driven by the unshakable faith that the Earth is ours.

 COOPER
Not *just* ours, but it is our home.

 PROFESSOR BRAND
Earth's atmosphere is 80 percent nitrogen. We don't even
breathe nitrogen.

Professor Brand shows him a blighted stalk.

Blight does. And as it thrives our air contains less and less
oxygen . . .

Professor Brand gestures over at Murph . . .

The last people to starve will be the first to suffocate. Your
daughter's generation will be the last to survive on Earth.

Cooper looks over at Murph. Then back to Professor Brand.

> COOPER
>
> Tell me this is where you explain how you're going to save the
> world.

INT. VAST CIRCULAR CHAMBER (LAUNCH FACILITY) – MOMENTS
LATER 43

*Cooper and Professor Brand enter like ants in a grain silo. A ROCKET
is on a pad, DWARFED by the circular chamber. Far above, a ring of
mirrors reflects the dawn down into the facility.*

> PROFESSOR BRAND
>
> We're not meant to save the world . . . we're meant to *leave it.*

*Cooper stares up at the rocket. He recognizes the arrangement of two
CRAFT at the top.*

> COOPER
>
> Rangers.

> PROFESSOR BRAND
>
> The last components of our one versatile ship in orbit, the
> Endurance. Our final expedition.

> COOPER
>
> What happened to the other vehicles?

> PROFESSOR BRAND
>
> The Lazarus missions.

> COOPER
>
> Sounds cheerful.

> PROFESSOR BRAND
>
> Lazarus came back from the dead –

> COOPER
>
> He had to die in the first place. You sent people out there
> looking for a new *home* . . .

Professor Brand nods.

> There's no planet in our solar system that can support life . . .
> and it'd take them a thousand years to reach the nearest star –

that doesn't even qualify as *futile* . . . Where did you send them, Professor?

PROFESSOR BRAND
Cooper, I can't tell you any more unless you agree to pilot this craft. You're the best we ever had.

COOPER
I barely left the stratosphere.

PROFESSOR BRAND
This crew's never left the *simulator*. We can't program this mission from Earth, we don't know what's out there. We need a pilot. And this is the mission you were trained for.

COOPER
Without ever knowing. An hour ago, you didn't even know I was still alive. And you were going anyway.

PROFESSOR BRAND
We had no choice. But something brought you here. They *chose* you.

COOPER
Who's 'they'?

Professor Brand is silent. Cooper wrestles.

How long would I be gone?

PROFESSOR BRAND
Hard to know. Years.

COOPER
I've got my kids, Professor.

PROFESSOR BRAND
Get out there and save them.

Cooper considers this. Decides.

COOPER
Who's 'they'?

INT. CONFERENCE ROOM – LATER 44

A man in his forties has the solar system up on the screen. This is ROMILLY.

ROMILLY

We started detecting gravitational anomalies almost fifty years ago. Mostly small distortions to our instruments in the upper atmosphere – I believe you encountered one yourself . . .

COOPER
(*realizing*)

Over the Straights – my crash – something tripped my fly-by wire –

ROMILLY

Exactly. But the most significant anomaly was *this* . . .

Cooper stares at an image of Saturn and its moons. Romilly zooms in on some stars DISTORTED *like ripples in a pond.*

ROMILLY

A disturbance of spacetime out near Saturn.

COOPER

A *wormhole*?

ROMILLY

It appeared forty-eight years ago.

COOPER

Where does it lead?

PROFESSOR BRAND

Another galaxy.

COOPER

A wormhole isn't a naturally occurring phenomenon.

BRAND

Someone placed it there.

COOPER

'They'.

BRAND

And whoever 'They' are, they appear to be looking out for us – that wormhole lets us travel to other stars. It came along right as we needed it.

DOYLE

They've put potentially habitable worlds within our reach.

Twelve, in fact from our initial probes.

 COOPER
You sent probes into it?

 PROFESSOR BRAND
We sent *people* into it. Ten years ago.

 COOPER
The Lazarus missions.

Professor Brand rises and moves to a MEMORIAL, *pointing –*

 PROFESSOR BRAND
Twelve possible worlds. Twelve Ranger launches carrying the
bravest humans ever to live, led by the remarkable Dr Mann.

 DOYLE
Each person's landing pod had life support for two years – but
they could use hibernation to stretch that, making observations
on organics over a decade or more. Their mission was to assess
their world, and if it showed promise, send a signal, bed down
for the long nap, and wait to be rescued.

 COOPER
And if their world didn't show promise?

 DOYLE
Hence the bravery.

 COOPER
Because you don't have resources to visit all twelve.

 DOYLE
No. Data transmission back through the wormhole is
rudimentary, simple binary 'pings' on an annual basis to give
some clue as to which worlds have potential. One system shows
promise.

 COOPER
One? Kind of a long shot.

 BRAND
One system with *three* potential worlds . . . no long shot.

 COOPER
So if we find a new home, what then?

34

PROFESSOR BRAND

That's the long shot. There's Plan A and there's Plan B. Did you notice anything strange about the launch chamber . . .

INT. LAUNCH FACILITY – MOMENTS LATER 45

Cooper cocks his head, puzzling at the VAST *chamber . . . there are structures built* SIDEWAYS *around the* CURVED *walls . . .*

COOPER

This whole facility . . . it's a *vehicle*? A space station?

PROFESSOR BRAND

Both. We've been working on it, and others like it for twenty-five years. Plan A.

COOPER

How does it get off the Earth?

PROFESSOR BRAND

Those first gravitational anomalies changed everything – suddenly we knew that harnessing gravity was real. So I started working on the theory – and we start building this station.

COOPER

But you haven't solved it, yet.

PROFESSOR BRAND

That's why there's a Plan B.

INT. LABORATORY – MOMENTS LATER 46

TECHNICIANS *work the complex, high-tech lab. Professor Brand and Cooper follow Brand to a large glass and steel apparatus.*

BRAND

The problem is gravity. How to get a viable amount of human life off this planet. This is one way – Plan B. A population bomb. Almost five thousand fertilized eggs, weighing in at under 900 kilos.

COOPER

How could you raise them?

35

BRAND

With equipment on board we incubate the first ten. After that, with surrogacy, the growth becomes exponential – within thirty years we might have a colony of hundreds. The real difficulty of colonization is genetic diversity, (*Indicates vials.*) This takes care of that.

Cooper looks at the equipment. Unenthusiastic.

COOPER

We just give up on the people here?

PROFESSOR BRAND

That's why Plan A's a lot more fun.

INT. PROFESSOR BRAND'S OFFICE 47

Professor Brand watches Cooper as he gazes over the vast tracts of ALGEBRA *covering every available surface.*

COOPER

Where have you got to?

PROFESSOR BRAND

Almost there.

COOPER

Almost? You're asking me to hang everything on an 'almost'?

Professor Brand moves close to Cooper.

PROFESSOR BRAND

I'm asking you to trust me.

Cooper looks at the passion in Professor Brand's eyes.

COOPER

All those years of training – you never told me.

PROFESSOR BRAND

We can't always be open about everything, Coop, even if we want to be. What can you tell your children about this mission?

Cooper considers this. Uneasy.

PROFESSOR BRAND

Find us a new home. When you return, I'll have solved the problem of gravity. You have my word.

Donald, on the porch, gets to his feet as he sees Cooper's pickup approaching. The truck pulls up. Murph TEARS *past Grandpa into the house – Donald looks at Cooper, questioning.*

INT. HALL OUTSIDE MURPH'S ROOM – CONTINUOUS 49

Cooper tries to open the door, but Murph has stacked a desk and chair against it –

> COOPER

Murph?

> MURPH

Go! If you're leaving, just go!

EXT. PORCH – NIGHT 50

Donald looks out at the night, taking it all in.

> DONALD

This world never was enough for you, was it, Coop?

> COOPER

I'm not gonna lie to you, Donald – heading out there is what I feel born to do and it excites me. That doesn't make it wrong.

Donald considers this. Turns to Cooper.

> DONALD

It might. Don't trust the right thing done for the wrong reason. The 'why' of a thing? That's the foundation.

> COOPER
> (*sadly*)

Well, the foundation's solid. (*Gestures at landscape.*) We farmers sit here every year when the rains fail and say 'next year'. Next year ain't gonna save us. Nor the one after. This world's a treasure, Donald. But she's been telling us to leave for a while now. (*Stares at the horizon.*) Mankind was born on Earth. It was never meant to die here.

Donald considers this. Scoops the dust off the rail.

 DONALD
Tom'll be okay. But you have to make it right with Murph.

 COOPER
I will.

 DONALD
Without making any promises you don't know you can keep.

Cooper meets Donald's gaze. Looks away, nodding.

INT. MURPH'S BEDROOM – MORNING 51

*Cooper's hand, reaching in, removes the chair from the desk,
barricading the door. Murph is lying on the bed, turned away.
Cooper pushes the desk back gently. Enters, quietly.*

 COOPER
You have to talk to me.

Nothing.

 I have to fix this before I go.

Murph turns, tear-stained, angry cheeks blazing –

 MURPH
Then I'll keep it broken so you have to stay.

Cooper sits down on the bed next to Murph.

 COOPER
After you kids came along, your mother said something I didn't
really understand – she said, 'I look at the babies and I see
myself as they'll remember me.' She said, 'It's as if we don't
exist anymore, like we're ghosts, like now we're just there to
be memories for our kids.' Now I realize – once we're parents,
we're just the ghosts of our childrens' futures.

 MURPH
You said ghosts don't exist.

 COOPER
That's right. I can't be your ghost right now – I need to exist.
Because they chose me. They chose me, Murph. You saw it.

Murph sits up. Points at the shelves. The gaps.

 38

MURPH

I figured out the message . . . (*Opens her notebook.*) It was Morse code . . .

COOPER

Murph –

MURPH

One word. You know what it is?

Cooper shakes his head sadly. Murph holds out her notebook –

'STAY'. It says 'STAY', Dad.

COOPER

Oh, Murph.

MURPH

You don't believe me?! Look the books! Look at –

Cooper takes his daughter in his arms . . .

COOPER

It's okay, it's okay . . .

Murph buries her head on Cooper's shoulder, sobbing.

Murph, a father looks in his child's eyes and thinks – maybe it's them . . . maybe my child will save the world. And everyone, once a child, wants to look into their own dad's eyes and know he saw how they saved some little corner of their world. But, usually, by then, the father is gone.

MURPH

Like you will be.

Cooper looks at his daughter. Lies with head, not heart:

COOPER

No. I'm coming back.

MURPH

When?

Cooper reaches into his pocket. Pulls out two WATCHES.

COOPER

One for you. One for me.

Murph takes the watch, curious. Cooper holds up his watch.

When I'm in hyper-sleep, or travel near the speed of light, or near a black hole, time will change for me. It'll run more slowly. When I get back we'll compare.

> MURPH
> Time will run differently for us?

> COOPER
> Yup. By the time I get back we might even be the same age. You and me. Imagine that . . .

Murph takes this in. Cooper sees he's made a mistake.

Wait, Murph –

> MURPH
> You have no idea when you're coming back.

Cooper looks at his daughter.

> MURPH
> No idea at all!

Murph THROWS *the watch* – TURNS HER BACK.

> COOPER
> Don't make me leave like this.

Nothing.

Please. I have to go now.

Murph will not turn around. Cooper tries to rest his hand on the back of her head, but she shakes it off.

> COOPER
> I love you, Murph. Forever. And I'm coming back.

Cooper walks slowly out. A BOOK DROPS FROM THE SHELF. *Cooper turns to look at it. Then leaves.*

EXT. FARMHOUSE – MOMENTS LATER 52

Cooper, mechanical, puts his small bag in the truck.

> DONALD
> How'd it go?

 COOPER

Fine. It was fine.

Cooper turns to Tom. Hugs him. Tight enough for both kids.

I love you, Tom.

 TOM

Travel safe, Dad.

 COOPER
 (*indicates farm*)
Look after our place, you hear?

 TOM

Can I use your truck while you're gone?

 COOPER
 (*smiles*)
I'll make sure they bring it back for you.

Cooper gets in. Starts the engine.

Mind my kids for me, Donald.

Donald nods. Cooper pulls out.

INT. MURPH'S BEDROOM – CONTINUOUS 53

Murph jumps off the bed, GRABS *the watch,* RUNS *downstairs.*

INT. PICKUP TRUCK – CONTINUOUS 54

As Cooper drives he lifts the blanket in the wheel-well where Murph hid last time. Nothing. And we hear a COUNTDOWN . . .

 VOICE
 (O.S.)

TEN . . . NINE . . .

EXT. FARMHOUSE – CONTINUOUS 55

Murph RACES *out of the house, watch in hand –*

 MURPH

Dad?! DAD?!

> VOICE
> (V.O.)

EIGHT . . . SEVEN . . .

But Cooper is a dust trail far down the road.

> VOICE
> (O.S.)

SIX . . . FIVE . . .

Murph SOBS *as her grandpa puts his arms around her . . .*

INT./EXT. PICKUP TRUCK ON DUSTY PLAIN – CONTINUOUS 56

As Cooper drives away tears roll down his cheeks

> VOICE
> (O.S.)

FOUR . . . THREE . . . TWO . . . ONE . . .

INT. LAUNCH FACILITY – DAY 57

> VOICE
> (O.S.)

IGNITION.

FIRE SHOOTS FROM THE BASE OF THE ROCKET . . . *The rocket* RISES *slowly from the pad, up into the sky . . .*

INT. RANGER COCKPIT – CONTINUOUS 58

Cooper, in his space helmet, lets the FORCE *of the rocket vibrate through him . . .*

> VOICE
> (O.S.)

Stage one . . . SEPARATION.

Cooper starts to see the Earth's curve through the window . . .

> VOICE
> (O.S.)

Stage two . . . SEPARATION.

And Cooper shakes loose the bonds of Earth.

The rocket RIPS *upwards into the sky.*

Cooper glances around the vibrating, cramped cockpit – Brand, Doyle, Romilly, Tars. Tars spots Cooper's glance –

> TARS
>
> All here, Mr Cooper. Plenty of slaves for my robot colony.

Cooper looks at him, confused.

> DOYLE
>
> They gave him a humor setting so he'd fit in with his unit better. He thinks it relaxes us.

> COOPER
>
> A massive, sarcastic robot. What a great idea.

> TARS
>
> I have a cue light I can turn on when I'm joking, if you like.

> COOPER
>
> Probably help.

> TARS
>
> You can use it to find your way back to the ship after I blow you out the airlock.

Tars looks at Cooper. A beat. An LED turns on. Cooper shakes his head.

> COOPER
>
> What's your humor setting, Tars?

> TARS
>
> One hundred percent.

Cooper turns to the instruments –

> COOPER
>
> Take it to seventy-five, please.

The Rangers streak across the Earth, settle into a low orbit.

Quiet. Cooper stares down at the continents sliding by. He looks over at Brand who is doing the same, abstracted.

> COOPER
>
> We'll get back.

She stares at the land. The oceans.

> It's hard. Leaving everything. My kids . . . your father . . .

> BRAND
>
> We're going to spend a lot of time together . . .

> COOPER
> (*nods*)
>
> We should learn to talk.

> BRAND
>
> And when not to. (*Off look.*) Just trying to be honest.

> COOPER
>
> Maybe you don't need to be *that* honest. (*Turns to Tars.*) Tars, what's your honesty parameter?

Tars DISENGAGES *from the floor and* MOVES *to the rear airlock –*

> TARS
>
> Ninety percent.

> COOPER
>
> *Ninety?* What kind of robot are you?

> TARS
>
> Absolute honesty isn't always the most diplomatic, or safe form of communication with emotional beings.

Cooper turns to Brand. Shrugs.

> COOPER
>
> Ninety percent honesty it is, then.

Brand looks at Cooper. Can't help smiling.

 VOICE
 (*over radio*)
 Sixty seconds out. . .

EXT. EARTH ORBIT – CONTINUOUS 63

The Rangers approach a RING MODULE, *fire retro-thrusters and slide
gracefully into the center of the ring – the last piece of a large
modular craft: the* U.S.S. ENDURANCE. *Four* LANDERS (*including the
Rangers*) *are nestled inside the ring module.*

INT. RING MODULE, ENDURANCE – MOMENTS LATER 64

Brand, Doyle and Romilly, following Tars, FLOAT *through the
cramped cabins, powering up. Tars powers up a second articulated
machine,* CASE.

 DOYLE
 Cooper, you should have control.

INT. COCKPIT, ENDURANCE (RANGER) – CONTINUOUS 65

Cooper checks instruments –

 COOPER
 Talking fine. Ready to spin?

INT. RING MODULE, ENDURANCE – CONTINUOUS 66

Doyle and Romilly are strapped in – Brand grabs a handhold –

INT. COCKPIT, ENDURANCE – CONTINUOUS 67

 BRAND
 (*over radio*)
 All set.

Cooper hits a switch . . .

EXT. EARTH ORBIT – CONTINUOUS 68

Thrusters silently fire on the Endurance. It starts ROTATING.

The crew members settle in as gravity is established. Romilly is clearly struggling to find his sea legs in the rotating ship.

> BRAND

You okay there?

> ROMILLY

Yup. Just need a little time –

> BRAND

There should be Dramamine in the hab pod.

The crew listen to Professor Brand over the video link –

> PROFESSOR BRAND
> (*on screen*)

I miss you already. Amelia, be safe. Give my regards to Dr Mann.

> BRAND

I will, Dad.

> PROFESSOR BRAND
> (*on screen*)

Things look good for your trajectory. We're calculating two years to Saturn.

> ROMILLY

That's a lot of Dramamine . . .

Cooper thinks about two years. What it means to his kids.

> COOPER
> (*on screen*)

Keep an eye on my family, sir. Specially Murph. She's a smart one.

> PROFESSOR BRAND
> (*on screen*)

We'll be waiting when you get back . . .

Cooper and Doyle flick switches and check instruments –

PROFESSOR BRAND
(V.O.)
... A little older. A little wiser. But happy to see you ...

INT. RING MODULE, ENDURANCE – CONTINUOUS 72

Brand, Romilly, Tars and Case strap in.

PROFESSOR BRAND
(V.O.)
'Do not go gentle into that good night ...'

INT. COCKPIT, ENDURANCE – CONTINUOUS 73

Cooper turns to Doyle. HITS *the thrusters.*

EXT. EARTH ORBIT – CONTINUOUS 74

Endurance's main engines FIRE. *The craft* PUSHES *out of orbit –*

PROFESSOR BRAND
(V.O.)
'Rage, rage against the dying of the light.' God speed,
Endurance.

The craft accelerates away from Earth.

INT. RING MODULE, ENDURANCE – DAY 75

The crew sets up their CRYO-BEDS. *Cooper looks out at the
diminishing Earth floating in the void. Brand joins him.*

COOPER
So alone.

BRAND
We've got each other – Dr Mann had it worse.

COOPER
(*points at Earth*)
I meant *them*. Look at that perfect planet. We're not gonna find
another one like her.

47

BRAND

No. This isn't like looking for a new condo – the human race is going to be *adrift* . . . desperate for a rock to cling to while they catch their breaths. We have to find that rock. Our three prospects are at the edge of what might sustain human life.

Brand shows him a blurry image of a dark blue planet.

Laura Miller's first. She started our biology program.

She shows him a red world, just a tiny dot.

And Wolf Edmunds is *here*.

Cooper hears something in her voice.

COOPER

Who's Edmunds?

BRAND
(*fondly*)

Wolf's a particle physicist.

COOPER

None of them had family?

BRAND

No attachments. My father insisted. They knew the odds against ever seeing another human being. I'm hoping we surprise at least three of them.

COOPER

Tell me about Dr Mann.

Brand replaces the screen image for a grainy, white orb.

BRAND

Remarkable. The best of us. My father's protégé. He inspired eleven people to follow him on the loneliest journey in human history. Scientists, explorers . . . That's what I love – out there we face great odds. Death. But not evil.

COOPER

Nature can't be evil?

BRAND

Formidable, frightening – not evil. Is a tiger evil because it rips a gazelle to pieces?

COOPER

Just what we bring with us, then.

BRAND

This crew represents the best aspects of humanity.

COOPER

Even me?

Brand looks at him. Smiles.

BRAND

Hey, we agreed, ninety percent.

Brand moves to her cryo-bed. Cooper looks out at space.

BRAND

Don't stay up too late. We can't spare the resources.

COOPER

Hey, I've been waiting a long time to be up here –

BRAND

You are *literally* wasting your breath.

Cooper nods at her. Joins Tars.

COOPER

Show me the trajectory again.

TARS

Eight months to Mars, then counter-orbital slingshot around –

Brand's cryo-bed darkens.

COOPER
(*whisper*)

Tars? Was Dr Brand –

TARS

Why are you whispering? You can't wake them.

COOPER

Were Dr Brand and Edmunds . . . close?

TARS

I wouldn't know.

COOPER

Is that ninety percent, or ten percent 'wouldn't know'?

TARS

I also have a discretion setting.

COOPER

So I gather . . . (*Rises.*) But not a poker face.

Tars watches Cooper head for the comm. station. He sits down to record a message. Awkward. Stuck. He dives in –

Hey, guys. I'm about settle down for the long nap, so I figured I'd send you an update . . .

EXT. OUTER SPACE – CONTINUOUS 76

The Endurance slips away from the small blue planet . . .

COOPER
(*V.O.*)

The Earth looks amazing from here . . . you can't see any of the dust –

EXT. CORNFIELDS – DAY 77

A line of dust slides across the shimmering horizon.

COOPER
(*V.O.*)

Hope you guys are doing great. This should get to you okay . . .

EXT. FRONT PORCH, FARMHOUSE – DAY 78

Donald watches two approaching vehicles kick up dust.

COOPER
(*V.O.*)

Professor Brand said he'd make sure of it. Guess I'll say good night.

Donald recognizes Cooper's truck . . . Murph BURSTS *out of the house –*

> MURPH
> (*quiet*)

Is it him?

> DONALD

I don't think so, Murph.

Donald rises to meet the truck. Professor Brand gets out.

> PROFESSOR BRAND

You must be Donald. Hello, Murph.

> MURPH

Why're you in my dad's truck?

> PROFESSOR BRAND

He wanted me to bring it for your brother.

Silence. Professor Brand reaches into his briefcase.

He sent you a message –

Murph TURNS and goes back into the house. Donald takes a disc from Professor Brand.

> DONALD

Pretty upset with him for leaving.

> PROFESSOR BRAND

If you record messages, I'll transmit them to Cooper.

Donald nods. Professor Brand looks up at the house.

Murph's a bright spark. Maybe I could fan the flame.

> DONALD

She's already making fools of her teachers. She should come make a fool out of you.

Professor Brand smiles. Donald looks up into the blue.

Where are they?

> PROFESSOR BRAND

Heading towards Mars . . .

EXT. MARS – DAY 79

The Endurance streaks away from Mars . . .

PROFESSOR BRAND
(*V.O.*)
Next time we hear from Cooper, they'll be coming up on
Saturn.

EXT. SATURN – DAY 80

The Endurance settles into an orbit around the ringed giant.

TOM
(*O.S.*)
But they said I can start advanced agriculture a year early . . .

INT. COMMUNICATIONS BOOTH, ENDURANCE – CONTINUOUS 81

*Cooper, blanket around his shoulders, watches a highly compressed
video of Tom –*

TOM
Got to go, Dad. Hope you're safe up there.

Tom makes way for Donald:

DONALD
I'm sorry, Coop, I asked Murph to say hi, but she's stubborn as
her old man. I'll try again next time, stay safe.

The video cuts out. Cooper gets up, puts a pair of EAR BUDS *in his
ears and heads into –*

OMITTED 82

INT. HAB POD, RING MODULE – LATER 82A

Cooper enters. Romilly is staring out the window.

COOPER
You good, Rom?

Romilly looks at Cooper.

ROMILLY
It gets to me, Coop. This tin can. Radiation, vacuum outside –
everything wants us dead. We're just not supposed to be here.

Cooper looks at him, sympathetic.

COOPER

We're explorers, Rom, on the greatest ocean of all.

Romilly bangs on the side of the ship.

ROMILLY

Millimeters of aluminium. That's it. And nothing within millions of miles that won't kill us in seconds.

COOPER

A lot of the finest solo yachtsmen couldn't swim. They knew if they went overboard that was it, anyway. This is no different.

Romilly considers this. Cooper passes him his ear buds –

COOPER

Here –

And the sounds of a THUNDERSTORM *wash over Romilly, sounds that take us to . . .*

EXT. SPACE – CONTINUOUS 82B

The Endurance is a tiny speck before the ringed gassy giant.

INT. NAVIGATION, RING MODULE, ENDURANCE – CONTINUOUS 82C

Cooper looks over Doyle's shoulder – he's flicking through images of star fields, distorted as if through a fish-eye lens.

COOPER

From the relay probe?

DOYLE

It was in orbit around the wormhole – each time it swung around we got images of the other side of the foreign galaxy.

COOPER

Like swinging a periscope around?

DOYLE

Exactly.

COOPER

So we've got a pretty good idea what we're gonna find on the other side?

53

Navigationally.

Brand approaches.

BRAND
We'll be coming up on the wormhole in less than forty-five.
Suit up.

INT. COCKPIT, RANGER – LATER 83

Cooper straps in, peering out at the inky blackness past Saturn.
Romilly joins him there, excited.

COOPER
(*over radio*)
Strap in – I'm killing the spin . . .

EXT. SATURN – CONTINUOUS 84

As the Endurance streaks past Saturn, it stops rotating, headed for a
DISTORTED BLUR *of stars.*

INT. COCKPIT, RANGER – CONTINUOUS 85

ROMILLY
There!

He points at the SPHERICAL *blur of stars.*

ROMILLY
That's it! That's the wormhole!

COOPER
Say it, don't spray it, Rom.

ROMILLY
Cooper, this is a *portal*, cutting through spacetime – (*Points.*)
We're seeing into the heart of a galaxy so far away we don't
even know where it is in the universe.

Cooper stares at the wormhole as they approach: a massive spherical
lens into another galaxy.

COOPER
It's a *sphere.*

ROMILLY

Of course it is. You thought it would be just a hole?

COOPER

No . . . well, in all the illustrations –

Romilly grabs a piece of paper, draws two points, far apart –

ROMILLY

In the illustrations they're trying to show you how it works –

He pokes a hole in one point with his pen . . .

So they say 'You wanna go from here to there but it's too far?
A wormhole bends space like this . . .'

*He folds the paper over and jams the pen through the second point,
connecting them.*

ROMILLY

'So you can take a shortcut across a higher dimension.' But to
show that, they've turned three-dimensional space . . . (*Gestures
around.*) Into two dimensions. (*Hold up paper.*) Which turns the
wormhole into two dimensions . . . a circle. (*Indicates hole in
paper.*) But what's a circle in three dimensions?

COOPER

A sphere.

ROMILLY

Exactly. (*Points out window.*) It's a *spherical hole* . . .

Cooper marvels at the concept. And at the looming sphere . . .

And who put it here? Who do we thank?

COOPER

I'm not thanking anyone till we get through it in one piece.

OMITTED 86

EXT. WORMHOLE – CONTINUOUS 87

As the Endurance SWINGS *around the wormhole, the view of the
foreign galaxy* SWINGS *in opposition, like an* ENORMOUS SHAVING
MIRROR . . . *it's extremely disorienting.*

The Endurance fires retro-thrusters to slow, descending towards the wormhole . . .

INT. COCKPIT, RANGER – CONTINUOUS 88

Cooper is at the controls. Doyle is next to him.

> COOPER
>
> Any trick to this?

> DOYLE
>
> No one knows.

> COOPER
> (glances at Doyle)
>
> But the others made it, right?

> DOYLE
>
> At least some of them.

> COOPER
>
> Thanks for the confidence boost.

Cooper stares down into the vast lens of the wormhole.

> Everybody ready to say goodbye to our solar system?

> ROMILLY
> (over radio)
>
> To our galaxy . . .

Cooper pushes the sticks forward, nosing down and letting gravity PULL them towards the center of the wormhole . . .

EXT. WORMHOLE – CONTINUOUS 89

The Endurance reaches the surface of the wormhole. As it crosses the threshold it becomes apparent that THERE IS NO SURFACE . . . the craft simply passes into the space of the distortion, its own warped reflection flickering towards it as if the ship were leaning into a giant shaving mirror . . .

INT. COCKPIT – CONTINUOUS 90

Cooper and Doyle stare at the distortion of space ahead . . .

INT. RING MODULE, ENDURANCE – CONTINUOUS 91

Brand and Romilly look out at reflections bordering the bulk – a space beyond our three dimensions . . .

EXT. WORMHOLE – CONTINUOUS 92

The Endurance moves through a TUNNEL OF DISTORTED REFLECTIONS, *seeming to gather more and more dizzying speed, but getting no closer to the far mouth, as if on an accelerating treadmill –*

INT. COCKPIT, RANGER – CONTINUOUS 93

Cooper, awestruck, checks his instruments –

> DOYLE
> They won't help you in here. We're cutting through the bulk – space beyond our three dimensions . . . (*Checks his equipment.*) All we can do is record and observe.

INT. RING MODULE, ENDURANCE – CONTINUOUS 94

Brand JUMPS *– a shape in the air in front of her is* BENDING, *warping to form ripples in spacetime inside the cabin – Romilly* STARES *at the distortion –*

> ROMILLY
> What is that?!

Brand watches the distortion move towards her –

> BRAND
> I think – I think it's *them.*

> ROMILLY
> Distorting spacetime? Don't –!

Brand is reaching out towards the warped space – it MOVES *towards her,* DISTORTING *her hand – but Brand is not in pain . . .*

INT. COCKPIT, RANGER – CONTINUOUS 95

Cooper and Doyle watch the tunnel mouth STREAK *towards them, a mass of stars and nebulae* GROWING *. . .*

EXT. FAR SIDE OF THE WORMHOLE – CONTINUOUS 96

The Endurance slides out of the wormhole.

INT. COCKPIT, LANDER – CONTINUOUS 97

Suddenly, the instruments are chirping –

> DOYLE

We're . . . here.

Cooper and Doyle look out at the new galaxy . . .

INT. RING MODULE, ENDURANCE – CONTINUOUS 98

Brand's hand is back to normal. She stares at her fingers.

> ROMILLY

What was that?

Brand flexes her fingers, delighted.

> BRAND

The first handshake.

EXT. FAR SIDE OF THE WORMHOLE – CONTINUOUS 99

The cosmos is more CROWDED *here –* STAR *upon* STAR, NEBULAE . . .

INT. RING MODULE, ENDURANCE – LATER 100

Doyle calls up data on a workstation –

> DOYLE

The lost communications came through –

> BRAND

How?

> DOYLE

The relay on this side cached them.

Doyle flicks through data –

Years of basic data – no real surprises. Miller's site has kept
pinging thumbs up, as has Mann . . . but Edmunds went down,
three years ago.

BRAND

Transmitter failure?

DOYLE

Maybe. He was sending the thumbs up right till it went dark.

ROMILLY

Miller still looks good?

Doyle nods. Romilly is drawing on a whiteboard –

She's coming up fast . . . with one complication – the planet is much closer to Gargantua than we thought.

COOPER

Gargantua?

DOYLE

A *very* large black hole. Miller's and Dr Mann's planets orbit it.

BRAND

And Miller's is on the horizon?

ROMILLY

A basketball around the hoop. Landing there takes us dangerously close. A black hole that big has a *huge* gravitational pull.

Cooper glances around the concerned faces –

COOPER

Look, I can swing around that neutron star to decelerate –

BRAND

It's not that, it's *time.* That gravity will slow our clock compared to Earth's. *Drastically.*

COOPER

How bad?

ROMILLY

Every hour we spend on that planet will be maybe . . . *seven years* back on Earth.

COOPER

Jesus –

ROMILLY

That's relativity, folks.

COOPER

We can't drop down there without considering the consequences.

DOYLE

Cooper, we have a mission –

COOPER

That's easy for you to say – you don't have anyone back on Earth waiting for you, do you?

DOYLE

You have no idea what's easy for me.

BRAND

Cooper's right. We have to think of time as a resource, just like oxygen and food. Going down there is going to cost us.

Doyle steps up to the screen, points out three planets.

DOYLE

Look, Dr Mann's data is promising, but we won't get there for months. Edmunds is even further. Miller hasn't sent much, but what she *has* sent is promising – water, organics . . .

BRAND

You don't find that every day.

DOYLE

No, you do not. So think about the resources it would take to come *back* here . . .

They look at each other, considering. Cooper turns to Romilly –

COOPER

How far off the planet do we have to stay to be out of the time shift?

Romilly indicates a spot on his white board.

ROMILLY

Just back from the cusp.

COOPER

So we track a wider orbit of Gargantua, parallel with Miller's planet but a little further out . . . take a Ranger down, grab Miller and her samples, debrief and analyze back here.

 BRAND
That'll work.

 COOPER
No time for monkey business down there – Tars, you'd better
wait up here. Who else?

 ROMILLY
If we're talking about a couple *years* – I'd use that time to work
on gravity – observations from the wormhole. That's gold to
Professor Brand.

 COOPER
Okay. Tars, factor an orbit of Gargantua – minimal thrusting –
conserve fuel – but stay in range.

 TARS
Don't worry, I wouldn't leave you behind . . . (*Swivels around.*)
Dr Brand.

She smiles at him.

EXT. BLACK HOLE, GARGANTUA – DAY 101

*A black sphere sucking light from the cosmos, visible by its distorting
effect on the light of stars behind it – squeezed into a* GLOWING,
CURVED HORIZON. *The Endurance approaches.*

INT. RANGER COCKPIT – DAY 102

Cooper looks out at Gargantua. Doyle peers over his shoulder

 DOYLE
A literal heart of darkness . . .

Brand points to a small glowing planet nearer the blackness.

 BRAND
There's Miller's planet.

Cooper turns to Case, the machine riding shotgun.

 COOPER
Ready?

<div align="center">CASE</div>

Yup.

<div align="center">COOPER</div>

Don't say much, do you?

<div align="center">CASE</div>

Tars talks plenty for both of us.

Cooper chuckles as he throws a final switch –

<div align="center">COOPER</div>

Detach –

EXT. ENDURANCE – CONTINUOUS 103

The Ranger DETACHES *from the ring module, like an X-1 from a B-29,* FIRES *retro-thrusters to slow and . . .* DROPS –

EXT. THE BLACK HOLE, GARGANTUA – DAY 104

The Ranger SHOOTS *down towards Gargantua –*

INT. COCKPIT, RANGER – CONTINUOUS 105

Cooper is in awe at their acceleration –

<div align="center">COOPER</div>
<div align="center">(into radio)</div>

Romilly, you reading these forces?

INT. RING MODULE, ENDURANCE – CONTINUOUS 106

Romilly studies data, marveling.

<div align="center">ROMILLY</div>

Unbelievable. (*Looks out at Gargantua.*) If we could see the collapsed star inside, the singularity, we'd solve gravity.

INT. COCKPIT, RANGER – CONTINUOUS 107

Cooper looks down at the eerie blackness sliding beneath –

<div align="center">COOPER</div>

No way to get anything from it?

ROMILLY
(*over radio*)
Nothing escapes that horizon. Not even light. The answer's
there, just no way to see it.

EXT. GARGANTUA – CONTINUOUS 108

The Ranger looks tiny as it STREAKS *over the blackness, high above
the* GLOWING HORIZON. *It is approaching Miller's planet, a gleaming
dark-blue world . . .*

INT. COCKPIT, RANGER – CONTINUOUS 109

Cooper studies his trajectory.

CASE
This is fast for atmospheric entry. Should we use the thrusters to
slow?

COOPER
We're gonna use the Ranger's aerodynamics to save the fuel.

CASE
Air brake?

COOPER
Wanna get in fast, don't we?

CASE
Brand, Doyle, get ready.

EXT. MILLER'S PLANET – CONTINUOUS 110

The Ranger STREAKS *down towards the planet. It starts to encounter
the* STRATOSPHERE –

INT. COCKPIT, RANGER – CONTINUOUS 111

The craft starts to HOWL *and* SHAKE. *Cooper studies the curving
horizon, concentrating –*

CASE
We should ease –

 COOPER

Hands where I can see them, Case! Only time I ever went down
was a machine easing at the wrong moment –

 CASE

A little caution –

 COOPER

Can get you killed, same as reckless.

 DOYLE

Cooper! Too damn fast!

 COOPER

I got this.

Cooper squeezes the shaking controls with white knuckles –

 CASE

Should I disable the feedback?

 COOPER

No! No, I need to feel the air . . .

EXT. STRATOSPHERE, MILLER'S PLANET – CONTINUOUS 112

The Ranger glows WHITE HOT, *slicing through* FLAT CLOUDS –

INT. COCKPIT, RANGER – CONTINUOUS 113

Cooper peers out at the razor-like layers of cloud –

 COOPER

Do we have a fix on the beacon?

 CASE

Got it. Can you maneuver?

 COOPER

Gotta shave more speed. I'll try and spiral down on it –

Doyle looks at Brand, nervous. She takes a breath.

EXT. MILLER'S PLANET – CONTINUOUS 114

The Ranger CUTS *through cloud formations,* BURSTING *out into*
CLEARER AIR, HIGH ABOVE AN ENDLESS OCEAN –

The crew peer at SPARKLING WATER, *streaking below them –*

> DOYLE
> Just water.

> BRAND
> The stuff of life . . .

> CASE
> Twelve hundred meters out.

Cooper BANKS *sharply, eases down.*

> BRAND
> It's shallow. Feet deep . . .

EXT. MILLER'S PLANET – CONTINUOUS 116

The Ranger is low now, kicking up backwash –

INT. COCKPIT, RANGER – CONTINUOUS 117

> CASE
> Seven hundred meters . . .

Cooper peers ahead –

> COOPER
> Wait for it . . .

> CASE
> Five hundred meters . . .

Cooper YANKS *the stick –*

> COOPER
> Fire!

EXT. MILLER'S PLANET – CONTINUOUS 118

The Ranger's retro-rockets FIRE *– killing the craft's speed just feet
from the surface. Water* SPRAYS UP *as the Ranger* SLEWS *diagonally,
gear is lowered, the Ranger drops, its landing gear holding it just
above the shallow water.*

Everyone BOUNCES *with the impact. Then* BREATHES.

> BRAND
>
> *Very* graceful.

> COOPER
>
> No. But it was very *efficient.* (*Looks at them.*) What're you waiting for? Go!

Brand and Doyle hurry out of their harnesses, helmets on. Case moves to the hatch. With a CRACK, *the hatch opens and* LIGHT *and* SPRAY *whip inside . . .*

EXT. MILLER'S PLANET – MOMENTS LATER (DAY) 120

Case climbs quickly from the craft, knee deep in the water. Brand and Doyle follow. Case TRACKS *the beacon.*

> CASE
>
> This way, about two hundred meters.

Brand and Doyle peer into the distance. Smooth, ankle-deep water to the horizon, where a distant MOUNTAIN RANGE LOOMS. *They start splashing towards it in their heavy spacesuits . . .*

> DOYLE
> (*panting*)
>
> The gravity's punishing . . .

> BRAND
>
> Floating through space too long?

> CASE
>
> One hundred and thirty percent Earth gravity.

INT. COCKPIT, RANGER – CONTINUOUS 121

Cooper listens to their chatter, IMPATIENT.

> COOPER
> (*under his breath*)
>
> Come on . . .

EXT. MILLER'S PLANET – CONTINUOUS 122

Doyle falls behind. Brand pushes on. Ahead, Case stops.

> CASE
> Should be here.

Brand joins him, searching the shallows for some sign of Miller's mission. She looks up, confused.

> BRAND
> If the signal's coming from here –

Case DROPS to his knees THRASHING under the water, like a bear fishing. Doyle arrives –

> DOYLE
> What's he doing?

INT. COCKPIT, LANDER – CONTINUOUS 123

Cooper notices something. In the distance. The mountains –

EXT. MILLER'S PLANET – CONTINUOUS 124

Case WRENCHES a piece of DAMAGED EQUIPMENT from the sea bed.

> BRAND
> Her beacon . . .

Case starts lugging the beacon to the Ranger.

> DOYLE
> Wreckage. Where's the rest . . . ?

> BRAND
> Towards the mountains!

She starts moving fast towards some FLOATING OBJECTS.

INT. COCKPIT, RANGER – CONTINUOUS 125

Cooper is staring out at the horizon –

> COOPER
> Those aren't mountains . . .

EXT. MILLER'S PLANET – CONTINUOUS 126

Brand pauses –

> COOPER
> (*over radio*)
> They're *waves* –

Brand looks closer – the 'mountains' are moving, tiny lines of white sea spray are blowing from the tops . . .

INT. COCKPIT, RANGER – CONTINUOUS 127

Cooper looks the other direction . . . there is a MOUNTAIN WAVE BEARING DOWN ON THE SHIP *. . .*

EXT. MILLER'S PLANET – CONTINUOUS 128

Brand is searching the wreckage –.

> COOPER
> (*over radio*)
> Brand, get back here!

> BRAND
> We need the recorder –

Doyle looks from Brand to Case, who is loading the beacon. Beyond him Doyle sees the mountain wave approaching –

> DOYLE
> Case, go get her!

INT. COCKPIT, RANGER – CONTINUOUS 129

Cooper hits the dash, frustrated.

> COOPER
> Dammit! Brand, get back here!

EXT. MILLER'S PLANET – CONTINUOUS 130

Brand sloshes along, checking DEBRIS *–*

BRAND

We can't leave without her data –

COOPER
(*over radio*)

You don't have time!

Case is back at Doyle.

DOYLE

Go, go!

Case takes off towards Brand, who is trying to lift a piece of equipment from the water. She drops it and moves on –

EXT. RANGER – CONTINUOUS 131

Cooper swings open the hatch, stands in the doorway, peering out at the approaching mountain waves – turns back to Brand –

COOPER

Get back here! Now!

Brand has pulled something heavy from the wreckage – she SLIPS, *the wreckage* PINNING *her down . . .*

She looks back at the Ranger – sees the mountain wave THOUSANDS OF FEET HIGH ALMOST UPON THEM –

BRAND

Cooper, go! Go! I can't make it!

Cooper looks at Case RACING *towards her –*

COOPER

Get up, Brand!

BRAND

GO! GET OUT OF HERE!

Case THROWS *her onto his back and starts running. Doyle stands, mesmerized by the sheer liquid mountain face . . .*

COOPER

Doyle! Come on! Case has her!

Doyle turns, starts sloshing back, the water RUNNING *against his ankles now . . . Two hundred yards behind, Case* POUNDS *through*

the shallows, Brand on his back –

Cooper looks up at the EVER CLOSER MOUNTAIN WAVE *– jumps inside.*

INT. COCKPIT, RANGER – CONTINUOUS 132

Cooper powers up, as the wall of liquid fills his view.

> COOPER
> Come on, come on . . .

He sees the water right upon them – RUNS *back to the hatch. Doyle is at the foot of the ladder,* Case RUNNING FAST.

> DOYLE
> Go!

Case JUMPS *up the ladder,* THROWS *Brand inside –* TURNS *for Doyle. The Ranger* TILTS, RISES – DOYLE IS RIPPED FROM CASE'S HAND – WATER RAGES ACROSS THE OPEN HATCH –

> COOPER
> Shut the hatch!

Case shuts the hatch. Cooper is throwing switches –

> COOPER
> Power down! Power down! We have to ride it out! (*To Brand, furious.*) We are not prepared for this!

EXT. MILLER'S PLANET – CONTINUOUS 133

Doyle is DRAGGED *under and away . The Ranger is* SUCKED SIDEWAYS *up the face of the mountain –*

INT. COCKPIT, RANGER – CONTINUOUS 134

Brand and Cooper are thrown across the cockpit. Case GRABS *Brand, pulls her into her seat – Cooper holds on as the craft* ROLLS *and* ROLLS *–*

EXT. MILLER'S PLANET – CONTINUOUS 135

The Ranger reaches the top of the wave, rocks upright –

INT. COCKPIT, RANGER – CONTINUOUS 136

Cooper drops into his seat as the water pours off the canopy –

EXT. MILLER'S PLANET – CONTINUOUS 137

The Ranger tilts over the backside of the wave, SURFING *for a second then* PITCHING FORWARD – TUMBLING DOWN 8,000 FEET . . .

INT. COCKPIT, RANGER – CONTINUOUS 138

They hang on for dear life, THRASHED MERCILESSLY –

EXT. MILLER'S PLANET – CONTINUOUS 139

The Ranger comes AGROUND *as the wave leaves it behind . . .*

INT. COCKPIT, RANGER – CONTINUOUS 140

The craft comes to rest. Cooper jumps to the controls, powers up the electrics. The engines won't respond –

EXT. RANGER – CONTINUOUS 141

The gear LIFTS *the Ranger. Water* FLOODS *out –*

INT. COCKPIT, RANGER – CONTINUOUS 142

Cooper tries the engines again. Nothing.

> CASE
> Too waterlogged. Let it drain.

> COOPER
> (*hits console*)

GODDAMN!

> BRAND
> I told you to leave me.

> COOPER
> And I told you to get your ass back here! Difference is, only one of us was thinking about the mission –

BRAND

Cooper, you were thinking about getting home – I was trying to do the right thing!

COOPER

Tell that to Doyle.

Quiet. Cooper looks down at the clock. Bitter.

How long to drain, Case?

CASE

Forty-five to an hour.

Cooper shakes his head. Pulls his helmet off.

COOPER

The stuff of life, huh? What's this gonna cost us, Brand?

BRAND

A lot. Decades.

Cooper rubs his face. Mind reeling. Trying to breathe.

COOPER

What happened to Miller?

BRAND

Judging by the wreckage, she was broken up by a wave soon after impact.

COOPER

How could the wreckage still be together after all these years?

BRAND

Because of the time slippage. On this planet's time, she landed here just hours ago. She might've only died minutes ago.

Case indicates the beacon.

CASE

The data Doyle received was just the initial status, echoing endlessly.

Cooper takes this in. Breathes hard. Takes off his gloves.

COOPER

We're not prepared for this, Brand. You're a bunch of eggheads without the survival skills of a boy-scout troop.

BRAND

We got this far on our brains – farther than any humans in history –

COOPER

Not far enough. And we're stuck here till there won't be anyone left on Earth to save –

BRAND

I'm counting every second, same as you, Cooper.

Cooper takes this in. They're in the same boat.

COOPER

Don't you have some clever way we jump into a black hole and get back the years?

She shakes her head, dismissive.

COOPER

Don't just shake your head at me –!

BRAND

Time is relative – it can stretch and squeeze – but it can't run backwards. The only thing that can move across dimensions like time is *gravity*.

COOPER
(*thinks*)

The *beings* who led us here . . . they communicate through gravity . . .

Brand nods.

Could they be talking to us from the future?

BRAND
(*considers*)

Maybe . . .

COOPER

Well, if *they* can –

BRAND

Look, Cooper, they're creatures of at least five dimensions – to *them* time may be just another physical dimension. To *them* the

past might be a canyon they can climb into and the future a mountain they can can climb up . . . but to *us* it's not, okay?

Brand pulls her helmet off. Looks Cooper in the eyes.

> BRAND
> I'm sorry, Cooper. I screwed up. But you knew about relativity.

> COOPER
> My daughter was ten. I couldn't explain Einstein's theories before I left.

> BRAND
> Could you tell her you were going to save the world?

> COOPER
> No. I wasn't much of a parent, but I understood the most important thing – let your kids feel *safe*. Which rules out telling a ten-year-old that the world's ending.

> CASE
> Cooper?

Case is pointing out at another MOUNTAIN RANGE.

> COOPER
> How long for the engines?

> CASE
> A minute or two –

> COOPER
> We don't have it!

The mountain wave is approaching. Cooper tries the engines –

EXT. RANGER – CONTINUOUS 143

The rockets COUGH *and steam . . .*

INT. COCKPIT, RANGER – CONTINUOUS 144

Cooper tries the engines again. Close. But no ignition.

> COOPER
> Helmets on!

The wave is upon them . . .

> COOPER
>
> Blow our cabin oxygen through the main thrusters. We'll spark
> it –

Case hits a button – a HISS *and* SHRIEK *of gas escaping . . . Brand
seals her helmet just as the cockpit* DEPRESSURIZES –

> COOPER
>
> Come on, now . . .

Cooper hits the engines – they BLAST TO LIFE –

EXT. RANGER – CONTINUOUS 145

A fiery BLAST *sends the Ranger clear of the mountain wave.*

*Down below, Doyle's body lies in the shallows, about to be swept up
into the next rush of water . . .*

INT. RING MODULE, ENDURANCE – DAY 146

Romilly watches as Cooper and Brand enter the Endurance.

> BRAND
>
> Hello, Rom.

> ROMILLY
>
> I've waited years.

> COOPER
>
> How many years?

> ROMILLY
>
> By now . . . it must be –

> TARS
>
> Twenty-three years . . .

Cooper's head lowers.

> TARS
>
> . . . four months, eight days.

Cooper turns away.

ROMILLY

Doyle?

Brand's eyes flicker down. She shakes her head. She grasps Romilly's hands, looks up into his eyes, vulnerable –

BRAND

I thought I was prepared. I knew all the theory. Reality's different.

ROMILLY

And Miller?

BRAND

There's nothing here for us.

Brand looks at Romilly's wrinkles. His greying beard.

BRAND

Why didn't you sleep?

ROMILLY

I did a couple of stretches. But I stopped believing you were coming back, and something seems wrong about dreaming your life away. I learned what I could from studying the black hole, but I couldn't send anything to your father. We've been receiving, but nothing gets out.

She looks up at Romilly, not wanting to ask . . .

BRAND

Is he still alive?

Romilly nods. Brand closes her eyes with relief.

ROMILLY

We've got years of messages stored . . .

Brand opens her eyes, looks for Cooper. He is in the comm. booth. He SHUTS *the privacy curtain. She looks down.*

INT. COMMUNICATIONS BOOTH, ENDURANCE – CONTINUOUS 147

Cooper studies the machine like it might bite him.

COOPER

Cooper.

76

COMPUTER VOICE

Messages span twenty-three years –

COOPER

I know. (*Whispers.*) Just start at the beginning.

Cooper leans forward as the screen flickers to life: Tom, still seventeen, turns on the camera.

TOM

Hi, Dad –

Cooper pauses it. Prepares himself. Lets it run –

TOM

I met another girl, Dad. I really think this is the one –

Tom holds up a picture of himself and a teenage GIRL.

Murph stole Grandpa's car. She crashed it – she's okay, though. Your truck's still running – Grandpa said she should steal that next time. I said if she did it'd be the last thing she did . . .

Cooper leans back . . .

INT. COMMUNICATIONS BOOTH, ENDURANCE – DAY 148

Cooper is holed up, still watching, unshaved. He's been watching for days. On the screen, Tom is in his twenties –

TOM

I've got a surprise for you, Dad. You're a grandpa . . .

Tom holds up an infant wrapped tight in swaddling.

Congratulations. Meet Jesse.

Cooper smiles a tearful smile.

Grandpa said he already earned the 'great' part so we just leave it at that.

The screen cuts out. Then comes back on. Tom in his thirties –

Hi, Dad. I'm sorry it's been awhile. What with Jesse and all . . .

He stops, emotional.

Grandpa died last week. We buried him out in the back forty, next to Mom and Jesse. (*Looks down.*) Where we'd have buried

you, if you'd ever come back. (*Looks up.*) Murph was there for the funeral. I don't see her so much anymore. (*Sighs.*) You're not listening to this. I know that. All these messages are just out there, drifting in the darkness . . . I figured as long as they were willing to send them there was some hope, but . . . (*Pauses.*) You're gone. You're never coming back. And I've known that for a long time. Lois says – that's my wife, Dad – she says I have to let you go. So I am. (*Reaches up to turn off camera.*) Wherever you are, I hope you're at peace. Goodbye, Dad.

The screen goes black. Tears are streaming down Cooper's face. He stares at the black screen, wiping his face. He starts to get up – the screen flickers to life once more –

A beautiful WOMAN *of about forty has turned on the camera – she looks at us, unsure about this. Makes a start –*

> WOMAN

Hello, Dad. You sonofabitch.

Cooper peers into the face, recognizing –

> COOPER
> (*whispers*)

Murph?

> WOMAN (MURPH)

I never made one of these when you were still responding cos I was so mad at you for leaving. When you went quiet, it seemed like I should just live with my decision. And I have . . . (*Looks around.*) But today's my birthday. And it's a special one because you once told me –

She stops, unable to speak for a second.

> MURPH

You once told me that when you came back we might be the same age . . . and today I'm the age you were when you left . . . (*Starts crying.*) So it'd be a real good time for you to come back.

Murph reaches up, switches off the camera and we stay with her in –

INT. COMMUNICATION ROOM, NASA – DAY 149

Murph brings her hand down from the camera. Wipes her tears.

PROFESSOR BRAND
(*O.S., softly*)
I didn't mean to intrude.

Murph turns to see Professor Brand, now ELDERLY, *in a* WHEELCHAIR *in the doorway.*

PROFESSOR BRAND
I've never seen you in here before.

Murph rises –

MURPH
I've never *been* in here before.

Murph wheels Professor Brand out into the corridor.

INT. CURVING CORRIDOR, NASA – MOMENTS LATER 150

Murph pushes Professor Brand.

PROFESSOR BRAND
I talk to Amelia all the time. It helps. I'm glad you've started –

MURPH
I haven't. I just had something I wanted to get out.

INT. PROFESSOR BRAND'S OFFICE – MOMENTS LATER 151

Professor Brand wheels behind his desk.

PROFESSOR BRAND
I know they're still out there.

MURPH
I know.

PROFESSOR BRAND
There are so many reasons their communications might not be getting through.

MURPH
(*smiles gently*)
I know, Professor.

PROFESSOR BRAND
I'm not sure which I'm more afraid of . . . they never come back, or they come back to find we've failed.

She watches his introspection. Brings him back with –

> MURPH
> Then let's succeed.

> PROFESSOR BRAND
> *(gestures at formula)*
> So, back from the fourth iteration, let's run it with a finite set.

Murph has picked up a notebook. Pauses.

> MURPH
> With respect, Professor. We've tried that hundreds of times.

> PROFESSOR BRAND
> And it only has to work once, Murph.

She shrugs. Starts to work.

INT. LAUNCH FACILITY – LATER 152

Murph and Professor Brand sit, eating sandwiches on a walkway. WORKERS *move about the* CIRCULAR CHAMBER, *building more* SIDEWAYS INFRASTRUCTURE. *Professor Brand looks down, proud.*

> PROFESSOR BRAND
> Every rivet they drive in could have been a bullet. We've done well for the world, here. Whether or not we crack the equation before I kick –

> MURPH
> Don't be morbid, Professor.

> PROFESSOR BRAND
> I'm not afraid of death, Murph. I'm an old physicist – I'm afraid of *time*.

INT. PROFESSOR BRAND'S OFFICE – MOMENTS LATER 153

Murph stands before the algebra. She REALIZES *something.*

> MURPH
> Time . . . you're afraid of time . . .

CONVINCED, *she* TURNS –

> Professor, the equation . . .?

He looks up.

For years we've tried to solve it without changing the
underlying assumptions about time –

> PROFESSOR BRAND

And?

> MURPH

And that means each iteration becomes an attempt to prove its
own proof – it's recursive. *Nonsensical* –

> PROFESSOR BRAND
> (*sharp*)

Are you calling my life's work 'nonsense', Murph?

> MURPH

No, I'm saying you've been trying to finish it with one arm – no,
with *both* arms tied behind your back . . .

Murph focuses on Professor Brand, suddenly WARY . . .

. . . and I don't understand why.

Professor Brand looks down. Starts wheeling his chair.

> PROFESSOR BRAND

I'm an old man, Murph. Could we pick this up some other
time? I'd like to go talk to my daughter.

Murph nods. Looking at the Professor. Confused.

> PROFESSOR BRAND
> (V.O.)

Stepping out into the universe, we must first confront the reality
that nothing in our solar system can help us . . .

INT. COMMUNICATIONS BOOTH, ENDURANCE – NIGHT 154

Brand watches her father on screen.

> PROFESSOR BRAND
> (V.O.)

. . . then we must confront the realities of interstellar travel.
We must venture far beyond the reach of our own life spans. We
must think not as individuals, but as a *species* . . .

Romilly, Brand, Cooper, Tars and Case sit in discussion.

COOPER

Tars kept the Endurance right where we needed her, but it took *years* longer than we anticipated . . .

Cooper puts both planets on screen – Dr Mann's ice world, and Edmunds' desert planet.

COOPER

We don't have the fuel to visit both prospects. We have to choose.

ROMILLY

How? They're both promising. Edmunds' data was better, but Dr Mann is the one still transmitting.

BRAND

We've got no reason to suppose Edmunds' results would have soured. His world has key elements to sustain human life –

COOPER

As does Dr Mann's.

BRAND

Cooper, this is my field. And I really believe Edmunds' is the better prospect.

COOPER
(*challenging*)

Why?

BRAND

Gargantua, that's why. (*Steps to board.*) Look at Miller's world – hydrocarbons, organics, yes. But no life. Sterile. We'll find the same thing on Dr Mann's.

ROMILLY

Because of the black hole?

BRAND
(*nods*)

Murphy's Law – whatever *can* happen will happen. Accident is the first building block of evolution – but when you're orbiting

82

a black hole not enough *can* happen – it sucks in asteroids and comets, random events that would otherwise reach you. We need to go to further afield.

<div align="center">COOPER</div>

You once referred to Dr Mann as the 'best of us'.

<div align="center">BRAND</div>

He's remarkable. We're only here because of him.

<div align="center">COOPER</div>

And he's there on the ground sending an unambiguous message that we should go to that planet.

Brand is silent. Romilly looks from Brand to Cooper.

<div align="center">ROMILLY</div>

Should we vote?

<div align="center">COOPER</div>

If we're going to vote, there's something you need to know. Brand?

She says nothing.

He has a right to know.

<div align="center">BRAND</div>

That has nothing to do with it.

<div align="center">ROMILLY</div>

What does?

<div align="center">COOPER</div>

She's in love with Wolf Edmunds.

<div align="center">ROMILLY
(to Brand)</div>

Is that true?

<div align="center">BRAND</div>

Yes. And that makes me want to follow my heart. But maybe we've spent too long trying to figure all this with theory –

<div align="center">COOPER</div>

You're a *scientist*, Brand –

<div align="center">83</div>

BRAND

I am. So listen to me when I tell you that love isn't something
we invented – it's observable, powerful. Why shouldn't it mean
something?

COOPER

It means social utility – child rearing, social bonding –

BRAND

We love people who've died . . . where's the social utility in
that? Maybe it means *more* – something we can't understand,
yet. Maybe it's some evidence, some artifact of higher dimensions
that we can't consciously perceive. I'm drawn across the universe
to someone I haven't seen for a decade, who I know is probably
dead. Love is the one thing we're capable of perceiving that
transcends dimensions of time and space. Maybe we should
trust that, even if we can't yet understand it.

Brand looks at Romilly, who can't meet her eye.

BRAND

Cooper, yes – the tiniest possibility of seeing Wolf again excites
me. But that doesn't mean I'm wrong.

Cooper thinks back to his conversation with Donald.

COOPER

Honestly, Amelia . . . it might.

Romilly looks at Brand. It's clear she's lost.

COOPER

Tars, set the course for Dr Mann.

Brand is starting to tear up. She turns away.

EXT. OUTER SPACE – MOMENTS LATER 156

The thrusters FIRE, *pushing the Endurance out of its orbit of
Gargantua.*

INT. RING MODULE, ENDURANCE – LATER 157

Brand is checking her POPULATION BOMB. *Cooper enters.*

COOPER

Brand, I'm sorry.

BRAND

Why? You're just being objective. (*Beat.*) Unless you're punishing me for screwing up on Miller's planet.

COOPER

This wasn't a personal decision for me.

Brand turns from her equipment. Looks him in the eye.

BRAND

Well, if you're wrong, you'll have a very personal decision to make. (*Off look.*) Your fuel calculations are based on a return journey. Strike out on Dr Mann's planet, and we'll have to decide whether to return home, or push on to Edmunds' planet with Plan B. Starting a colony could save us from extinction.

She closes the population bomb.

You might have to decide between seeing your children again . . . and the future of the human race. (*Smiles bitterly.*) I trust you'll be as objective, then.

EXT. OUTER SPACE – CONTINUOUS 158

The Endurance sinks past a GLORIOUS NEBULA *whose* GOLDEN MISTS DISSOLVE TO ROILING BLACK CLOUDS *and we are –*

EXT. FARMHOUSE – DAY 159

Murph stands with Tom, now late forties. Watching a field BURN.

TOM

We'll lose about a third this season. But *next year* . . . I'm gonna start working Nelson's fields. Should make it up.

MURPH

What happened to Nelson?

Tom glances at her. Don't ask. Heads for the house.

Murph at family dinner with Tom, LOIS, *and their six-year-old son*
COOP.

> LOIS
> Will you stay the night? We left your room like it was . . .

Murph looks down, awkward . . .

> MURPH
> No, I need to . . .

Murph looks upstairs. At Lois.

> Too many memories, Lois.

*She nods. Coop helps Tom clear. As Coop takes Murph's plate he
starts* COUGHING. *Looks up at her, sees her concern,* GRINS.

> COOP
> The dust.

He and Tom head into the kitchen.

> MURPH
> I have a friend who should look at his lungs, Lois.

She nods, is about to speak. Tom sits back down.

*Pull back to reveal the glowing windows against the darkening plain,
dust clouds rolling across the horizon . . .*

INT. CORRIDOR, NASA – NIGHT 161

Murph hurries down a corridor with a doctor, GETTY.

> GETTY
> He started asking for you after he came to, but we couldn't raise
> you –

INT. HOSPITAL ROOM, NASA – MOMENTS LATER 162

*Murph is at Professor Brand's bedside. He is hooked up to machines.
Barely breathing.*

> PROFESSOR BRAND
> Murph . . . Murph . . .

Murph takes his hand with gentle concern.

> MURPH

I'm here, Professor.

> PROFESSOR BRAND

I don't have much life . . . (*Breathes.*) I have to tell you . . .

> MURPH

Try to take it easy.

> PROFESSOR BRAND

All these . . . years. All these people . . . counted on me . . .

> MURPH

It's okay, Professor.

> PROFESSOR BRAND

I let you . . . all you . . . down.

> MURPH

No. I'll finish what you started.

Professor Brand looks up into Murph's eyes, tears welling.

> PROFESSOR BRAND

Murph. Good, good Murph. Such faith . . . all these years, I told you to have faith . . . to *believe* . . .

> MURPH

I do believe –

> PROFESSOR BRAND

I needed you to believe your father was coming back . . .

> MURPH

I do, Professor –

> PROFESSOR BRAND

Forgive me, Murph . . .

> MURPH

There's nothing to forgive.

> PROFESSOR BRAND

I *lied*, Murph. I lied to you . . .

Murph looks at Professor Brand, confused.

87

PROFESSOR BRAND
There's no reason to come back . . . no way to help us . . .

MURPH
But Plan A – all this – all these people . . . the *equation*!

But Professor Brand slowly shakes his head, tears rolling down. As Murph tries to comprehend, he settles, DRIFTING.

MURPH
(*whispers*)

Did he know?

Nothing.

Did my dad know?!

Nothing.

Did he *abandon* me?!

PROFESSOR BRAND
Do . . . not . . . go . . .

She leans in to hear.

PROFESSOR BRAND
Gentle . . . into . . . into . . .

MURPH
NO! NO! Professor, stay! You can't! You can't leave . . .

Getty is at her shoulder.

MURPH
You can't, you can't, you . . .

Getty puts his hand on her shoulder. She sits there. Stuck. As Professor Brand goes still . . .

MURPH
(V.O.)

Dr Brand, I'm sorry to tell you that your father died today . . .

INT. COMMUNICATION ROOM, NASA – DAY 163

Murph, controlled anger, sits in front of the camera.

MURPH

He had no pain and was . . . at peace. I'm sorry for your loss.

She reaches to switch off the camera. STOPS. *Acid.*

Did you know, Brand? Did he tell you . . . ?

INT. RING MODULE, ENDURANCE – DAY 164

Murph's voice rings through the empty ship. Only Case there to register it.

MURPH
(V.O.)

Did you know that Plan A was a sham . . . ?! You left us here.
To die. Never coming back . . .

Through the window we see the Ranger moving away, towards –

EXT. DR MANN'S PLANET – DAY 165

The Endurance orbits the silvery white globe as the Ranger heads towards the planet.

EXT. STRATOSPHERE – MOMENTS LATER 166

The Ranger drops through layers of large, MOUNTAINOUS CLOUD.

INT. COCKPIT, RANGER – CONTINUOUS 167

Cooper and Tars, Brand and Romilly. Cooper peers out, concerned, studying a heads-up display of CLOUD DENSITY . . .

EXT. DR MANN'S PLANET – CONTINUOUS 168

The Ranger cuts through one cloud, banks left and SCRAPES AGAINST THE NEXT 'CLOUD', PANELS TEARING FROM THE WING – THE CLOUDS ARE ACTUALLY SOLID ICE FORMATIONS . . .

INT. COCKPIT, RANGER – CONTINUOUS 169

Cooper banks away from the ICE, *glancing out at the damage –*

EXT. DR MANN'S PLANET – CONTINUOUS 170

The Ranger moves cautiously through the 'cloudscape' like a ship through an ice field . . .

INT. COCKPIT, RANGER – CONTINUOUS 171

Romilly and Brand put their helmets on. Tars indicates the beacon's position. Cooper looks, BANKS *the Ranger.*

EXT. DR MANN'S PLANET – CONTINUOUS 172

The Ranger's gear lowers as it comes to rest, tentatively, at the base of what looks like a large CUMULUS CLOUD.

EXT. DR MANN'S PLANET – LATER 173

Cooper leads them up the ICE CLOUD. *From a distance, they are walking on a cloud. Tars brings up the rear.*

Cooper crests a ridge. SPOTS *something. He starts down towards a dirty orange dot in the cloudscape.*

EXT. DR MANN'S POD – MOMENTS LATER 174

Cooper is there. The others arrive at the large metal pod – WEATHERED *and* DAMAGED *over the years, half buried in ice. Nearby, various* WIRE MARKERS *stick out of the ice. Tars starts digging out the hatch.*

INT. DR MANN'S POD – LATER 175

A CRACK *of* COLD LIGHT, *as the outer hatch is wrenched open. Cooper steps through the airlock, into a* CRYPT-LIKE SPACE –

Cooper's hand sweeps ice from the nameplate of a cryo-chamber, 'DR MANN'.

Tars fires up the cryo-chamber. The ice starts to melt.

Cooper, helmet off, CRACKS *the lid, pushes it back, revealing a figure in a plastic shroud. Cooper rips the seal . . .*

Dr Mann's eyes flicker open. He watches Cooper, breathing, focusing – reaches up with TREMBLING *hands –* GRABS *Cooper –* PULLS *himself up,* CHEEK AGAINST CHEEK – SOBBING – *hands desperately*

CARESSING *Cooper's face. Cooper holds him tight.*

> COOPER
> (*whispering*)
> It's okay. It's okay.

INT. SAME – LATER 176

Dr Mann sits, blanket over his shoulders, sipping from a steaming cup. He looks at their faces, marveling.

> DR MANN
> (*cracked, parched*)
> Pray you never learn just how good it can be to see another face. (*Shaky sip.*) I hadn't much hope to begin with. After so much time, I had none. My supplies were exhausted. The last time I went to sleep, I set no waking date. (*Looks at them all.*) You have literally raised me from the dead.

> COOPER
> (*smiles*)
> Lazarus.

> DR MANN
> (*nods*)
> And the others?

> ROMILLY
> I'm afraid you're it, sir.

> DR MANN
> So far, surely?

> COOPER
> With our situation, there's not much hope of any other rescue.

This hits Dr Mann hard. He looks down at his tea.

> BRAND
> Dr Mann, tell us about your world.

> DR MANN
> (*smiles gently*)
> My world. Yes. *Our* world, we hope. Our world is cold, stark . . .

Dr Mann leads the others up to the summit of a cloud.

> DR MANN
> (V.O.)
> But undeniably beautiful . . .

From the top, they watch the planet's pale sun setting.

> DR MANN
> The days are sixty-seven cold hours, the nights are sixty-seven
> far colder hours . . .

They make their way back into the shelter.

> DR MANN
> (V.O.)
> The gravity is a very pleasant 80 percent of Earth's. Up here,
> where I landed, the 'water' is alkali and the 'air' has too much
> ammonia in it to breathe for more than a few minutes . . .

Brand checks readings on Dr Mann's instruments.

INT. DR MANN'S POD – NIGHT 178

The crew are captivated by Dr Mann . . .

> DR MANN
> But down at the surface, and there *is* a surface . . . the chlorine
> dissipates and the ammonia gives way to crystalline hydrocarbons
> and breathable air. To organics. Possibly even to *life*. (*Off looks.*)
> Yes. We may be sharing this world.

> BRAND
> (*giddy*)
> These readings are from the surface?

Brand is reviewing Dr Mann's piles of data.

> DR MANN
> Over the years I've dropped various probes.

> COOPER
> How far have you explored?

DR MANN

I've mounted several major expeditions, but with oxygen in limited supply, Kipp there had to do most of the legwork.

Dr Mann indicates a DEFUNCT ARTICULATED MACHINE.

TARS

What's wrong with him?

DR MANN

Degeneration. He misidentified the first organics we found as ammonia crystals. We struggled on for a time, but ultimately, I decommissioned him and used his power source to keep the mission going. (*Remembers, sadly.*) I thought I was alone *before* I shut him down.

TARS

Would you like me to look at him?

DR MANN

No, I think he needs a *human* touch.

Tars turns to Brand.

TARS

Dr Brand, Case is relaying a message for you from the comm. station.

She nods.

MURPH
(V.O.)

. . . He had no pain and was . . . at peace.

INT. DR MANN'S POD – LATER 179

Brand watches Murph's message on Tars' data screen.

MURPH

I'm sorry for your loss.

Brand STARES. *Cooper is there. Murph reaches up –*

BRAND
(*abstract*)

Is that Murph?

93

Cooper nods.

She's become a –

MURPH
(*acid*)

Did you know, Brand? Did he tell you? That Plan A was a sham . . .?!

Cooper looks at Brand, who is shocked.

You left us here to set up your colony. Never coming back . . .

Murph does not want to ask, tears are running down her cheeks –

(*Small.*) Did my father know? Dad . . .?

Cooper stares. Murph's eyes bore into his . . .

Did you leave me here to die?

The screen goes dark. Cooper stands there, SHOCKED.

BRAND
Cooper, my father devoted his whole life to Plan A – I have no idea what she means –

DR MANN
(*O.S.*)
I do.

They turn. Dr Mann looks at them with gentle calm.

COOPER
He never even hoped to get people off the Earth.

DR MANN
No.

BRAND
But he's been trying to solve the gravity equation for forty years!

Dr Mann comes over, looks into Brand's eyes.

DR MANN
Amelia, your father solved his equation before I even left.

BRAND
Then why wouldn't he use it?!

DR MANN

The equation couldn't reconcile relativity with quantum
mechanics. You need more –

COOPER

More *what*?!

DR MANN

More data. You need to see inside a black hole. And the laws of
nature prohibit a naked singularity.

COOPER
(*to Romilly*)

Is that true?

ROMILLY

If a black hole is an oyster, the singularity is the pearl inside. Its
gravity is so strong, it's always hidden in darkness, behind the
horizon. That's why we call it a black hole.

COOPER

If we could look *beyond* the horizon –

DR MANN

Some things aren't meant to be known. (*To Brand.*) Your father
had to find another way to save the human race from extinction.
Plan B. A colony.

BRAND

Why not tell people? Why keep building that damn station?

DR MANN

He knew how much harder it would be for people to come
together and save the *species*, instead of themselves . . . (*To
Cooper, sympathetic.*) Or their children.

COOPER

Bullshit.

DR MANN

Would you have left if you hadn't believed you were trying to
save *them*? Evolution has yet to transcend that simple barrier –
we can care deeply, selflessly for people we know, but our
empathy rarely extends beyond our line of sight.

BRAND

But the *lie*. A *monstrous* lie . . .

DR MANN

Unforgivable. And he knew it. Your father was prepared to destroy his own humanity to save our species. He made the ultimate sacrifice.

COOPER

No. That's being made by the people of Earth who'll die because, in his arrogance, he declared their case hopeless.

DR MANN

I'm sorry, Cooper. Their case is hopeless. *We* are the future.

Cooper REELS. *Brand puts her hand on his shoulder –*

BRAND

Cooper, what can I do?

He turns to her. Looks her in the eyes.

COOPER

Let me go home.

And the sound of WIND *in* DRY CORNSTALKS *takes us –*

INT./EXT. PICKUP TRUCK ON DUSTY PLAIN – DAWN 180

Murph drives. Getty next to her. In the distance, several fields BURN.

GETTY

Are you sure?

MURPH

His solution was correct. He'd had it for years.

GETTY

It's worthless?

MURPH

It's half the answer.

GETTY

How do you find the other half?

Murph points at the sky.

MURPH

Out there? A black hole. Stuck here on Earth? I'm not sure you can.

They pass vehicles PILED HIGH *with belongings and people.*

GETTY

They just pack up and leave. What are they hoping to find?

MURPH

Survival. (*Looks ahead.*) Dammit!

A DUST STORM SWAMPS *the truck, killing visibility. Murph pulls over. Kills the engine. The wind rocks the car.*

GETTY

Don't people have a right to know?

MURPH

Panic won't help. We have to keep working, same as ever.

GETTY

Isn't that just what Professor Brand . . . ?

MURPH
(*sharp*)

Brand gave up on us – I'm still trying to solve this.

GETTY

So you have an idea?

MURPH

No. I have a . . . *feeling.*

Getty looks at her as she STARES *out at the dust.*

INSERT CUT: MURPH (TEN), *wet hair, towel around neck, turns and* STARES *at a book on the floor –*

MURPH
(V.O.)

I told you about my ghost . . .

She stoops to pick up the toy next to it – a broken LUNAR LANDER.

MURPH (FORTY) *puts her hands on the glass, watching the sand scrape the car's window . . .*

<div style="text-align:center">MURPH</div>

My dad thought I called it a ghost because I was scared of it . . .

INSERT CUT: MURPH (TEN) *counts the books and gaps.* MARVELING.

<div style="text-align:center">MURPH
(V.O.)</div>

But I was never scared of it . . .

MURPH (TEN) *takes out her notebook and starts drawing lines to represent the books.*

<div style="text-align:center">MURPH
(V.O.)</div>

I called it a ghost because it felt like . . .

MURPH (FORTY) *turns to Getty.*

<div style="text-align:center">MURPH</div>

Like a person. Trying to tell me something . . .

The storm is clearing. Murph starts the engine.

If there's an answer here on Earth, it's back there, somehow. No one's coming to save us. (*Pulls out.*) I have to find it . . .

Murph pulls past a pickup piled with worldly goods and people. She makes eye contact with two filthy kids in the back . . .

And we're running out of time.

EXT. RANGER, DR MANN'S PLANET – DAWN 181

Tars is up on the wing of the Ranger. Case pilots the LANDER *in to land near the Ranger.*

INT. COCKPIT, RANGER – CONTINUOUS 182

Cooper is sitting with his feet on the console.

<div style="text-align:center">CASE
(over radio)</div>

What about auxiliary oxygen scrubbers?

<div style="text-align:center">COOPER</div>

They can stay. I'll sleep most of the journey. (*Wry.*) I saw it all on the way out here.

Romilly comes through the airlock. Removes his helmet.

ROMILLY

I have a suggestion for your return journey.

COOPER

What?

ROMILLY

Have one last crack at the black hole . . .

Tars enters.

ROMILLY

Gargantua's an older, spinning black hole – what we call a *gentle* singularity.

COOPER

Gentle?

ROMILLY

They're hardly gentle, but their tidal gravity is quick enough that something crossing the horizon fast might survive . . . a probe, say.

COOPER

What happens to it after it crosses?

ROMILLY

Beyond the horizon is a complete mystery – who's to say there isn't some way the probe can glimpse the singularity and relay the quantum data? If he's equipped to transmit every form of energy that can pulse – X-ray, visible light, radio –

TARS

Just when did this probe become a 'he'?

Romilly looks from Tars to Cooper, sheepish.

ROMILLY

Tars is the obvious candidate. I've already told him what to look for.

TARS

I'd need to take the old optical transmitter from Kipp.

COOPER
(*to Tars*)

You'd do this for us?

TARS

Before you get teary, try to remember that as a robot I have to
do anything you say, anyway.

COOPER

Your cue light's broken.

TARS

I'm not joking.

Bing. The light flashes on.

EXT. RANGER, DR MANN'S PLANET – DAY 183

*Brand and Dr Mann approach Cooper and Romilly at the foot of the
ladder. Cooper addresses Brand –*

COOPER

Ranger's almost ready. Case is on his way back down with
another load.

BRAND

I'll start a final inventory.

ROMILLY

Dr Mann, I need Tars to remove and adapt some components
from Kipp.

Dr Mann considers this. Looks at Tars. At Romilly.

DR MANN

He musn't disturb Kipp's archival functions.

ROMILLY

I'll supervise.

Dr Mann considers this. Nods.

COOPER

We need to pick out a site. You don't wanna move the module
once we land it.

DR MANN

I'll show you the probe sites.

Cooper glances around at the winds picking up –

COOPER

Will conditions hold?

DR MANN

These squalls usually blow over. You've got a long-range transmitter?

Cooper reaches up to check a box plugged in at his neck.

COOPER

Good to go.

Dr Mann points at a nozzle on his elbow –

DR MANN

Charged?

Cooper checks, thumbs up. Dr Mann sets off, Cooper follows.

EXT. DR MANN'S PLANET – LATER 184

As Cooper follows Dr Mann down a ridge, they see the lander fly over. Cooper waves, reaches up to his long-range transmitter –

COOPER

A little caution, Case?

CASE
(*over radio*)

Safety first, Cooper.

Cooper follows Dr Mann down to the edge of the ice. They peer down a fifty-foot drop.

DR MANN

Just take it gently –

He steps off, DROPPING – his ELBOW JETS FIRE, slowing his descent in time for him to land with a THUD. Cooper follows.

They set out through a massive CANYON of ice . . .

DR MANN

Brand told me why you feel you have to go back –

Cooper STOPS.

COOPER

If this excursion is about trying to change my mind, let's turn around right now.

DR MANN

No. I understand your position.

He turns and starts walking. Cooper follows.

DR MANN

You have attachments. I'm not supposed to, but even without family, I can promise you that the yearning to be with other people is massively powerful. Our instincts, our emotions, are at the foundations of what makes us human. They're not to be taken lightly.

The wind WHIPS *ice crystals between them . . .*

INT. KITCHEN, FARMHOUSE – DAY 185

Murph introduces Getty to Lois and Coop. Getty pulls out a STETHOSCOPE *and starts examining Coop, Murph slips upstairs . . .*

INT. MURPH'S BEDROOM – DAY 186

Murph opens the door. Stands in her old bedroom. Feeling . . .

COOP
(O.S.)

Mama lets me play in here . . .

Murph turns to see Coop. He points at a box on the shelf –

I don't touch your stuff.

EXT. LANDER – CONTINUOUS 187

Brand turns away as the lander touches down in a spray of ice.

Romilly watches Tars crouch down beside Kipp and connect Kipp to his own power. Kipp shows signs of life . . .

EXT. ICE CANYON, DR MANN'S PLANET – CONTINUOUS 189

Dr Mann waits for Cooper catch up. The WIND *is picking up –*

> DR MANN
> You know why we couldn't just send machines on these missions, Cooper?

> COOPER
> (*breathless*)
> Frankly, no.

> DR MANN
> (*pressing on*)
> A trip into the unknown requires improvisation. Machines can't improvise well because you can't program a fear of death. The survival instinct is our single greatest source of inspiration.

Dr Mann pauses to take a breath. Turns to Cooper.

> Take you – a father. With a survival instinct that extends to your kids . . .

> COOPER
> That's why I'm going home, hopeless or not.

> DR MANN
> And what does research tell us is the last thing you'll see before you die? (*Off look.*) Your *children*. At the very moment of death, your mind pushes you a little harder to survive. For them.

Dr Mann turns and starts walking out onto a massive ice field.

INT. KITCHEN, FARMHOUSE – DAY 190

Murph brings Coop downstairs. Getty is listening to Lois' back. He looks up at Murph. GRAVE. *Shakes his head . . .*

> GETTY
> They can't stay here.

 TOM
 (O.S.)
 Murph?

Murph turns to see Tom in the doorway.

 What is this . . .?

EXT. LANDER, DR MANN'S PLANET – CONTINUOUS 191

Brand is counting flight cases when a WIND *whips ice at her . . .*

INT. DR MANN'S POD – CONTINUOUS 192

Romilly takes his helmet off, PEERING *over Tars' shoulder at Kipp's
data screen. Confused.*

 ROMILLY
 I don't understand.

EXT. ICE FIELD, DR MANN'S PLANET – CONTINUOUS 193

Cooper and Dr Mann are like two ants on a sheet.

 DR MANN
 The first window's up ahead –

Cooper peers ahead to an OPENING *in the ice. Dr Mann stops at the
edge. Looks around the wind-blasted ice plane.*

 When I left Earth I felt fully prepared to die. But I just never
 faced the possibility that *my* planet wouldn't be the one. None
 of this turned out the way it was supposed to.

 COOPER
 Professor Brand would disagree.

Cooper peers over the edge at an enormous CREVASSE . . .

Dr Mann RIPS COOPER'S LONG-RANGE TRANSMITTER FROM HIS
NECK –

Cooper TURNS *to Dr Mann – who* BLASTS *him with his* ELBOW JET.
He SLIPS *backwards, but avoids going over the edge –*

 COOPER
 What are you doing?!

 104

Until Dr Mann KICKS *him. Cooper hits his jets, pushing himself onto a lower ledge of ice –*

INT. KITCHEN, FARMHOUSE – DAY 194

Tom confronts Murph while Getty looks on –

> MURPH
>
> They can't stay here, Tom!

> GETTY
>
> Not one more day –

Tom TURNS, PUNCHES *Getty – who collapses.*

> LOIS
>
> Tom?!

> TOM
>
> Coop, get your aunt's things – she's done here.

> MURPH
>
> Tom, Dad didn't raise you this dumb –

> TOM
>
> Dad didn't raise us, Grandpa did, and he's buried outside with Mom in our ground. I'm not leaving them –

> MURPH
>
> You have to, Tom –

> TOM
>
> I'm a *farmer*, Murph! You don't give up on the Earth.

> MURPH
>
> No! But she gave up on you! And she's poisoning your family.

EXT. DR MANN'S PLANET – DAY 195

Cooper SCRAMBLES *to his knees. Dr Mann approaches –*

> DR MANN
>
> I'm sorry – I can't let you leave.

> COOPER
>
> Why?!

DR MANN

We're going to need your ship to continue the mission . . . once the others realize what this place *isn't*.

Cooper's mind races. He looks around.

COOPER

You faked all the data?

DR MANN

I had a lot of time.

COOPER

Is there even a surface?

DR MANN

I'm afraid *not* –

Dr Mann KICKS *Cooper over the edge, Cooper* CLINGS *on* –

DR MANN

I tried to do my duty, Cooper, but the day I arrived I could see this place had *nothing*. I resisted the temptation for years . . . but I knew there was a way to get rescued.

COOPER

You fucking coward.

Cooper BLASTS *Dr Mann off his feet with his jet* – SCRAMBLES *up onto the ice. Dr Mann* TACKLES *him, they go down,* WRESTLING. WIDER *shows us two* TINY FIGURES *in a* VAST LANDSCAPE, *deciding the future of humanity with a* BRAWL . . .

INT. KITCHEN, FARMHOUSE – DAY 196

Murph begs Tom –

MURPH

Please, come with us.

TOM

To live underground, praying Dad comes back to save us all?

MURPH

He's not coming back. He was never coming back. It's up to us. To me.

> TOM

You're gonna save the human race, Murph? Really? How? Our
dad couldn't –

> MURPH

HE DIDN'T EVEN TRY! (*Off look.*) He just abandoned us,
Tom.

Murph looks around, frustrated. Coop hands Murph the box.

> MURPH

Tom, if you won't come, let *them* –

> TOM

Murph. (*Points at box.*) Take your stuff, and go.

Murph hands the box back to Coop.

> MURPH

Keep it.

She leaves. Getty follows.

EXT. ICE FIELD, DR MANN'S PLANET – DAY 197

Dr Mann LUNGES *at Cooper, who* SIDESTEPS *him and* PINS *him* . . .

> COOPER

Stop this!

Dr Mann HEADBUTTS COOPER, FACEPLATE IMPACTS FACEPLATE.

> COOPER

Mann! Don't – you'll kill us both –

CRACK. *Dr Mann* SMASHES *his helmet into Cooper's* AGAIN AND
AGAIN *as he* –

> DR MANN

SOMEONE'S – GLASS – WILL – GIVE – WAY – FIRST –!

> COOPER

FIFTY-FIFTY YOU KILL *YOUR SELF*! STOP!

Dr Mann STOPS. *Looks up at Cooper,* BREATHING. *Both faceplates
have* TINY FRACTURES . . .

DR MANN

Best odds I've had in years –

WHACK – *He* BUTTS *Cooper's faceplate, which* CRACKS SICKENINGLY. AMMONIA HISSES INSIDE – COOPER ROLLS OFF, HANDS UP, DESPERATELY TRYING TO PLUG THE LARGE CRACK –

Dr Mann RISES. *Checks the fractures in his own helmet. Bends down to look at Cooper,* STRUGGLING, CHOKING –

DR MANN

Please don't judge me, Cooper – you were never tested like I was. Few men have been . . .

INT./EXT. PICKUP TRUCK ON DUSTY PLAIN – DAY 198

Murph drives. Getty looks over, sympathetic.

GETTY

You did your best, Murph.

She just stares ahead at the road . . .

EXT. ICE FIELD, DR MANN'S PLANET – DAY 199

With curiosity and FEAR, *Dr Mann watches Cooper* CRAWL . . .

DR MANN

You're feeling it, aren't you? That survival instinct – that's what drove me. It's always driven the human race, and it's going to save it now. I'm going to save it. For all mankind. For you, Cooper.

Unable to watch any more, he RISES, *walking away, continuing to talk to Cooper via the radio . . .*

DR MANN

I'm sorry, I can't watch you go through this – I thought I could. But I'm still here. I'm here for you . . .

Dr Mann, hurrying away, listens to Cooper RASPING –

DR MANN

Cooper. When you left, did Professor Brand read you that poem? How does it end . . . ?

Dr Mann hauls himself up a ledge. The wind WHIPS *up ice.*

> DR MANN
> (*over radio*)

'Do not go gentle . . .'

Cooper FREEZES. REMEMBERS. TRANSMITTER . . .

> DR MANN
> (*over radio*)

'. . . into that good night . . .'

Cooper LOOKS *around – on the ice ten feet away – the* TRANSMITTER –

INT./EXT. PICKUP TRUCK ON DUSTY PLAIN – DAY 200

Murph and Getty drive past a long line of DESPERATE REFUGEES – *glimpsing* FACES *hardened against insurmountable odds . . .*

> DR MANN
> (*over radio*)

'. . . Rage, rage against the dying of the light.'

EXT. DR MANN'S PLANET – DAY 201

Cooper CRAWLS – CRAWLS – CHOKING – CRAWLING . . .

Dr Mann leap/jets up onto the higher ice – glances back at the floundering figure on the ice with pity and awe.

> DR MANN
> (*whispers*)

Cooper . . .? Do you see your children, yet?

Dr Mann hears only CHOKING, GASPING, HACKING. *He kills his radio. Scared. Watches Cooper's silent thrashing.* TURNS.

Cooper GRABS *the transmitter – tries to calm his* FRANTIC HANDS – *can't reconnect it with clumsy gloves – pulls glove off –* FREEZING – BITING – WAKING – *he gets the connector* IN –

> COOPER

BRAND! BRAND!

EXT. LANDER – CONTINUOUS 202

Brand is STARTLED *by Cooper's* RASPING *over her radio –*

> COOPER
> (*over radio*)
> HELP . . . ME . . . HELP . . .

INT. /EXT. PICKUP TRUCK ON DUSTY PLAIN – CONTINUOUS 203

Murph DECIDES *– she* SPINS *the truck around – floors it back in the direction they came . . .*

INT. COCKPIT, LANDER – CONTINUOUS 204

Brand JUMPS *into the lander –*

> BRAND
> Case?!

Case is already FIRING *engines –*

> CASE
> I have a fix.

> BRAND
> Cooper?! Cooper, we're coming!

EXT. ICE PLAIN, DR MANN'S PLANET – CONTINUOUS 205

Cooper GASPS *–*

> COOPER
> NO AIR – AMMONIA.

> BRAND
> (*over radio*)
> Don't talk – breathe as little as possible. We're coming –!

EXT. CORNFIELDS – DAY 206

Murph PULLS *off the road,* CUTTING *through the corn –*

EXT. DR MANN'S PLANET – CONTINUOUS 207

The lander HURTLES *through the cloudscape,* RECKLESSLY, DANGEROUSLY FAST, PUNCHING *through some clouds,* DODGING *others –.*

INT. COCKPIT, LANDER – CONTINUOUS 208

Brand watches Case fly, praying he's not just guessing –

INT. DR MANN'S POD – CONTINUOUS 209

Romilly is crouched next to Tars, perturbed.

> ROMILLY
> This data makes no sense. Access the archive –

EXT. CORNFIELDS – DAY 210

Murph PULLS UP *in a* SCREECH *of dust – jumps out –* GRABS *her spare gas can,* THROWING FUEL *over the nearby stalks . . .*

EXT. ICE PLAIN, DR MANN'S PLANET – CONTINUOUS 211

Cooper FLOPS *back onto the ice,* STARING SKYWARD . . .

INSERT CUT: MURPH (TEN) *examines the* WATCH *Cooper has given her . . . She* THROWS *it – turns her tear-stained face to Cooper – Cooper's eyes water, from poison or memory –*

EXT. CORNFIELDS – DAY 212

Murph SETS FIRE *to the corn . . .* JUMPS *in the truck –*

EXT. DR MANN'S PLANET – CONTINUOUS 213

The lander SWEEPS *around a towering cumulus,* SPIRALING *in on the* ICE PLAIN –

INT. COCKPIT, LANDER – CONTINUOUS 214

Brand POINTS –

BRAND

I see him –

EXT. FARMHOUSE – DAY 215

Tom RACES *out of the house,* JUMPS *in Cooper's old truck, heading out to the fire . . . calling on the radio –*

EXT. ICE PLAIN, DR MANN'S PLANET – CONTINUOUS 216

Through WATERING EYES *and* WIND-WHIPPED ICE, *Cooper glimpses Brand* LEAPING *from the lander, elbow jets firing. Brand* RIPS *Cooper's helmet off –* THRUSTS *an* OXYGEN MASK *over his nose and mouth. Cooper* GASPS, SUCKING AIR HARD –

COOPER

MANN – WAS – MANN –

BRAND

Dr Mann did this?!

Cooper nods. Brand takes this in – REALIZES –

Romilly!

She keys her long-range transmitter –

Romilly?! Romilly?!

INT. DR MANN'S POD – CONTINUOUS 217

Tars turns back from Kipp.

TARS

It needs a person to unlock its archival function.

Tars makes way for Romilly, who leans in to the screen. He glances at his helmet – the radio is SQUAWKING. *As he reaches for his helmet, he places his hand on the screen – Kipp* FLICKERS TO LIFE . . . *Romilly lifts his helmet –*

ROMILLY

Brand –?

Kipp LOOKS UP –

 KIPP
 Please, don't make –

And EXPLODES –

EXT. DR MANN'S PLANET – CONTINUOUS 218

Dr Mann hears the explosion – sees a BLACK CLOUD *rising from up
the hill.* PANIC-STRICKEN –

 DR MANN
 Dammit, Romilly . . .

He switches his radio back on –

 BRAND
 (*over radio*)
 Come on, Cooper! Couple more steps –

Dr Mann THINKS – *makes for the Ranger.*

INT. COCKPIT, LANDER – CONTINUOUS 219

Brand pulls the mask off Cooper, who looks at Case –

 COOPER
 What happened to caution?

 CASE
 Safety first.

 COOPER
 Brand, I'm sorry. We should've followed your instincts. Mann
 lied about this place –

 BRAND
 (*scared*)
 Oh, no –

EXT. FARMHOUSE – DAY 220

Murph SCREECHES *up – turns to Getty –*

 MURPH
 Keep watch –

She runs towards the farmhouse.

Lois!

INT. COCKPIT, LANDER – DAY 221

Case spots something on the console.

 CASE
There's been an explosion –

 BRAND
Where?

 CASE
Dr Mann's compound.

Case puts the lander into the air.

INT. COCKPIT, RANGER – CONTINUOUS 222

Dr Mann straps in. Powers up.

EXT. DR MANN'S PLANET – CONTINUOUS 223

The Ranger RISES –

INT. COCKPIT, RANGER – CONTINUOUS 224

Dr Mann pushes the craft into the air –

EXT. DR MANN'S PLANET – CONTINUOUS 225

The lander comes through the black smoke from Dr Mann's pod.

Below – a figure BURSTS *out of the smoke: Tars, blackened, burned, but* RUNNING . . . *towards the lander –*

INT. COCKPIT, LANDER – CONTINUOUS 226

Case SWINGS *the lander around and* HITS *the airlock open –*

EXT. DR MANN'S POD – CONTINUOUS 227

Tars LEAPS UP *into the airlock – the lander* THRUSTS *away –*

INT. COCKPIT, THE LANDER – CONTINUOUS 228

Cooper looks over at Case –

> COOPER
> Do you have a fix on the Ranger?

> CASE
> He's pushing into orbit –

> COOPER
> If he takes control of the ship we're dead –

> BRAND
> He'd maroon us?

> COOPER
> He *is* marooning us –

INT. KITCHEN, FARMHOUSE – DAY 229

Lois and Coop head outside with a few essentials. Murph heads upstairs . . .

EXT. FARMHOUSE – CONTINUOUS 230

Getty helps them into the truck, glances nervously at the distant fire –

> GETTY
> Come on, Murph!

EXT. STRATOSPHERE, DR MANN'S PLANET – CONTINUOUS 231

The Ranger ROCKETS *upwards . . .*

INT. COCKPIT, LANDER – CONTINUOUS 232

Cooper moves up next to Case. Hits the transmitter –

> COOPER
> Dr Mann? Dr Mann, please respond –

> CASE
> He doesn't know the Endurance docking procedure.

COOPER

The autopilot does.

CASE

Not since Tars disabled it.

Cooper looks into the airlock –

COOPER

Nice. What's your trust setting?

TARS

Lower than yours, apparently.

Cooper hits the transmitter –

COOPER

Dr Mann?

INT. COCKPIT, RANGER – CONTINUOUS 233

*Dr Mann hears Cooper. Ignores him – looking instead at the
navigation computer.*

COOPER
(*over radio*)

Dr Mann, if you attempt docking –

Dr Mann switches off the transmitter –

INT. MURPH'S BEDROOM – DAY 234

Murph looks at the bookshelves. Spots the box. Moves over to it and
LOOKS INSIDE . . .

EXT. FARMHOUSE – CONTINUOUS 235

Outside, Getty paces, Lois and Coop sit tight . . .

EXT. ORBIT, DR MANN'S PLANET – CONTINUOUS 236

The Ranger approaches the Endurance . . .

INT. COCKPIT, RANGER – CONTINUOUS 237

Dr Mann pilots the lander alongside the ship. Hits the autopilot –

COMPUTER VOICE
Auto-docking sequence withheld.

Dr Mann looks at the screen, surprised.

DR MANN
Override.

COMPUTER VOICE
Unauthorized.

Dr Mann thinks. Looks over at the MANUAL DOCKING CONTROLS . . .

INT. COCKPIT, LANDER – CONTINUOUS 238

Cooper peers ahead as they SHOOT *up into orbit. Brand looks – the Ranger is in close to the Endurance –*

COOPER
Dr Mann, do not attempt docking. Dr Mann?

Static.

INT. COCKPIT, RANGER – CONTINUOUS 239

Dr Mann SCRAMBLES *from the controls to the airlock,* FOCUSED . . .

EXT. ENDURANCE – CONTINUOUS 240

The Ranger inches closer to an OUTER HATCH *of Endurance –* A ROW OF MECHANICAL GRAPPLES *tries to connect with Endurance –*

INT. COCKPIT, RANGER – CONTINUOUS 241

Dr Mann works the docking system, concentrating –

EXT. ENDURANCE – CONTINUOUS 242

The grapples PULL *the Ranger into the Endurance hatch.*

INT. COCKPIT, RANGER – CONTINUOUS 243

A CLANG *as the ships come together –*

 COMPUTER VOICE
 Imperfect contact – hatch lockout.

 DR MANN
 Override.

 COMPUTER VOICE
 Hatch lockout disengaged.

Dr Mann moves to the airlock control . . .

INT. COCKPIT, LANDER – CONTINUOUS 244

Cooper stares out at the Ranger –

 COOPER
 Is he locked on?

 CASE
 Imperfectly.

Cooper grabs the transmitter –

 COOPER
 Dr Mann! Dr Mann! Do not, repeat do not attempt to open the
 hatch! If you –

INT. COCKPIT, RANGER – CONTINUOUS 245

In SILENCE *Dr Mann looks through the hatch window. Hits the
button opening the outer door –*

EXT. ENDURANCE – CONTINUOUS 246

The outer door of the Ranger SLIDES OPEN. *Several grapples are*
OPENING AND CLOSING BLINDLY, *trying to seal the join –*

INT. COCKPIT, LANDER – CONTINUOUS 247

Cooper looks at Case –

 COOPER
 What happens if he blows the hatch?

 CASE
 Nothing good.

 118

> COOPER

Pull us back!

Case hits the retro-thrusters.

> BRAND

Case, relay my transmission to his onboard computer, and have it rebroadcast as emergency p.a. –

> BRAND
> (*hits transmitter*)

DR MANN, DO NOT OPEN THE IN—

INT. COCKPIT, RANGER – CONTINUOUS 248

Silence. Dr Mann takes a breath, reaches for the inner lever –

> BRAND
> (*over radio*)

—PEAT – DO NOT OPEN INNER HATCH!

Dr Mann is STARTLED *by the voice. He hits the transmitter –*

> DR MANN

Brand, I don't know what Cooper's told you, but I'm taking control of the Endurance, then we'll talk about continuing the mission. This is not *my* survival, or Cooper's – this is *mankind's –*

Turns back to the lever . . . PULLS IT –

A DEVASTATING RUSH OF AIR YANKS HIM INTO THE AIRLOCK –

EXT. ENDURANCE – CONTINUOUS 249

The ESCAPING AIR AND DEBRIS *push Endurance into a slow* SPIN . . .

INT. COCKPIT, RANGER – CONTINUOUS 250

Dr Mann is HAMMERED *by debris as the airlock starts to* RIP APART –

EXT. ENDURANCE – CONTINUOUS 251

The ship SPINS FASTER AND FASTER – *the Ranger is* RIPPED AWAY, FRAGMENTING, SHREDDING THE CLOSEST MODULE OF THE RING.

INT. COCKPIT, LANDER – CONTINUOUS 252

They STARE *in* HORROR *as their ship is sent* SPINNING OFF ITS ORBIT TOWARDS THE PLANET –

> BRAND
> Oh, my God.

Cooper GRABS *the sticks* – HITS *the thrusters* –

EXT. ORBIT, DR MANN'S PLANET – CONTINUOUS 253

The CRIPPLED *Endurance is in a* FAST FLAT SPIN, *heading down towards the stratosphere* –

The lander FLIES *after it,* DODGING *the Ranger debris* –

INT. COCKPIT, LANDER – CONTINUOUS 254

Cooper's eyes are glued to the Endurance as he flies –

> CASE
> Cooper, there's no point using our fuel to –

> COOPER
> Just analyze the Endurance's spin –

> BRAND
> What're you doing?!

> COOPER
> Docking.

EXT. ORBIT, DR MANN'S PLANET – CONTINUOUS 255

The DIZZYING SPIN *of the Endurance as it* PLUMMETS *towards the* ATMOSPHERE –

The lander ROCKETS *after it,* CLOSING SLOWLY –

INT. COCKPIT, LANDER – CONTINUOUS 256

Cooper pours on the power –

> CASE
> Endurance rotation is 67, 68 RPM –

COOPER

Get ready to match it on the retro-thrusters –

CASE

It's not possible –

COOPER

No. It's *necessary*.

EXT. ORBIT, DR MANN'S PLANET – CONTINUOUS 257

The SPINNING ENDURANCE *starts to encounter the* STRATOSPHERE –
heating up –

INT. COCKPIT, LANDER – CONTINUOUS 258

Brand looks ahead at the spinning ship –

CASE

Endurance is hitting stratosphere –

BRAND

She's got no heat shield –!

*Cooper checks the lander's speed against Endurance – pulls back on
thrust as they come in below it* –

EXT. STRATOSPHERE, DR MANN'S PLANET – CONTINUOUS 259

The lander is PERILOUSLY CLOSE *to the* RED HOT UNDERSIDE *of the*
SPINNING ENDURANCE. *The lander* BANKS *sideways, bringing its
airlock within* FEET *of the spinning Endurance* –

INT. COCKPIT, LANDER – CONTINUOUS 260

Cooper looks sideways at the spinning hull –

COOPER

Case, you ready?

CASE

Ready.

Cooper watches the spinning hull, suddenly UNCERTAIN –

CASE

Cooper? (*Off look.*) This is no time for caution.

COOPER

(*grins*)

If I black out, take the stick – Tars, get ready to engage the docking mechanism – Brand, hold tight –

CASE

Endurance is starting to heat –

COOPER

HIT IT!

Case hits the RETRO-THRUSTERS. *The view* SPINS –

EXT. STRATOSPHERE, DR MANN'S PLANET – CONTINUOUS 261

The lander goes into a FASTER AND FASTER SPIN *as it, with Endurance,* PLUMMETS *towards the planet –*

INT. COCKPIT, LANDER – CONTINUOUS 262

LIGHT FLASHES *across their faces as the G-force of the spin* PULLS THEM AGAINST THEIR RESTRAINTS. *Cooper* STRUGGLES *to stay conscious – they* BUFFET AGAINST THE ATMOSPHERE –

Tars opens the airlock – the Endurance hatch above him is now SLOWLY ROTATING *relative to him . . .*

EXT. STRATOSPHERE, DR MANN'S PLANET – CONTINUOUS 263

The GLOWING HOT *Endurance and the lander* PLUMMET, SPINNING *towards the ice planet, whose curvature is* FAST DISAPPEARING –

INT. AIRLOCK, LANDER – CONTINUOUS 264

Tars peers up as THE SPIN SPEEDS MATCH. *He waits as the* BUFFETING *moves the hatches . . .* THEY LINE UP *– he* FIRES *the* GRAPPLES *– they don't connect – the hatches moved –*

INT. COCKPIT, LANDER – CONTINUOUS 265

Brand loses consciousness – Cooper watches the instruments, not the dizzying view, on the point of RED OUT *–*

COOPER

Come on, Tars . . . come on . . .

INT. AIRLOCK, LANDER – CONTINUOUS 266

Tars sees the hatches roll back into ALIGNMENT. *He* FIRES AGAIN –
this time THE GRAPPLES HOLD –

TARS

GOT IT!

INT. COCKPIT, LANDER – CONTINUOUS 267

Cooper registers this. Case fires the retro-rockets to slow the spin.

COOPER

Gen— gentle, Case . . .

EXT. STRATOSPHERE, DR MANN'S PLANET – CONTINUOUS 268

The two craft, NOW JOINED, *start to spin more* SLOWLY . . .

INT. COCKPIT, LANDER – CONTINUOUS 269

Cooper eases back into his seat as the G-force lessens –

COOPER

Get ready to pull us up –

The spin is slowing to almost nothing –

EXT. STRATOSPHERE, DR MANN'S PLANET – CONTINUOUS 270

Parts are RIPPING *off the Endurance in the* HEAT –

INT. COCKPIT, LANDER – CONTINUOUS 271

Cooper EASES *into* POWER *on the main thrusters –*

COOPER

Come on. You can do it . . .

The THRUSTERS *on the lander start to* DRAG *both ships back up away from the planet, the heat* DIMINISHING –

INT. COCKPIT, LANDER – CONTINUOUS 273

Cooper pulls back on the sticks, RELIEF *washing over him. Brand comes to . . . Cooper turns to Case, grinning –*

> COOPER
> Right? And for our next trick . . .

> CASE
> It'll have to be good. We're heading into Gargantua's pull –

Cooper's smile fades. He UNBUCKLES –

> COOPER
> Take her –

INT. RING MODULE, ENDURANCE – MOMENTS LATER 274

HISSING STEAM – RUSHING AIR – WHIRLING DEBRIS *as Tars and Cooper (in suit and helmet) lock down different* BULKHEADS –

Brand (in suit and helmet) FLOATS *alongside the* POPULATION BOMB, *checking the equipment –*

> CASE
> (*over radio*)
> Cooper, we're slipping towards Gargantua – shall I use main engines?

> COOPER
> No! Let her slide as long as we can –

Cooper FLIES *over to Tars, who is welding a bulkhead –*

> COOPER
> Give it to me.

> TARS
> There's good news and bad news –

> COOPER
> I've heard that one, Tars – just give it to me straight.

Cooper SCRAMBLES *to where Brand is checking her equipment.*

> COOPER
> The navigation mainframe's destroyed and we don't have enough life support to make it back to Earth. But we might scrape to Edmunds' planet.

> BRAND
> What about fuel?

> COOPER
> Not enough. But I've got a plan – let Gargantua suck us right to her horizon – then a powered slingshot around to launch us at Edmunds.

> BRAND
> Manually?

> COOPER
> That's what I'm here for. I'll take us just inside the critical orbit.

> BRAND
> And the time slippage?

> COOPER
> Neither of us can afford to worry about relativity right now.

> BRAND
> I'm sorry, Cooper.

They embrace, delicately touching faceplate to faceplate.

EXT. ENDURANCE – CONTINUOUS 276

The CRIPPLED *Endurance* FALLS *towards the* HEART OF DARKNESS *among the stars . . .*

INT. COCKPIT, LANDER – DAY 277

Cooper looks ahead at Gargantua. Preparing for battle.

EXT. ENDURANCE – MOMENTS LATER 278

The lander DETACHES, *shifting its orientation . . .*

COOPER
(*over radio*)
Once we've gathered enough speed around Gargantua – we use
the lander 1 Ranger 2 as rocket-boosters to push us out of the
black hole's gravity . . .

The lander REATTACHES *to the rear of the ring module.*

INT. COCKPIT, RANGER 2 – CONTINUOUS 279

Cooper slides into Ranger 2 – checking the systems.

COOPER
The linkages between landers are destroyed . . .

INT. COCKPIT, LANDER – CONTINUOUS 280

Tars sits at the controls, running similar checks . . .

COOPER
(*over radio*)
So we'll control manually. When Lander 1's spent, Tars will
detach . . .

TARS
And get sucked into that black hole.

INT. RING MODULE, ENDURANCE – CONTINUOUS 281

Brand and Case listen to Cooper and Tars over the radio.

BRAND
Why does he have to detach?

COOPER
(*over radio*)
We have to shed mass if we're gonna escape that gravity.

TARS
(*over radio*)
*Newton's third law – the only way humans have ever figured
out of getting somewhere is to leave something behind.*

BRAND
Cooper, you can't ask Tars to do this for us –

INT. COCKPIT, RANGER 2 – CONTINUOUS 282

Cooper puts his hands on the controls –

COOPER
He's a robot, Amelia – I don't have to *ask* him to do anything.

INT. RING MODULE, ENDURANCE – CONTINUOUS 283

Brand is furious –

BRAND
Cooper, you *asshole –*

COOPER
(*over radio*)
Sorry, you broke up a little there.

TARS
(*over radio*)
It's what we intended, Dr Brand . . .

INT. COCKPIT, LANDER – CONTINUOUS 284

Tars sits at the controls, ready.

TARS
It's our last chance to save people on Earth – if I can find some
way to transmit the quantum data I'll find in there, they might
still make it.

INT. RING MODULE, ENDURANCE – CONTINUOUS 285

Brand considers this.

BRAND
If there's someone still there to receive it . . .

EXT. ENDURANCE – CONTINUOUS 286

The Endurance ACCELERATES *towards the darkness . . .*

INT. RING MODULE, ENDURANCE – CONTINUOUS 287

The black hole's gravity makes the ship SHUDDER *. . . Brand, helmet
on, tightens her harness . . .*

EXT. ENDURANCE – CONTINUOUS 288

The Endurance STREAKS *above the glowing horizon,* SKIRTING *the* BLACKNESS *beneath . . .*

INT. COCKPIT, LANDER – CONTINUOUS 289

Tars looks out at the DARK OCEAN *. . .*

EXT. ENDURANCE – CONTINUOUS 290

The ship orbits the black hole with BLINDING ACCELERATION *–*

INT. RING MODULE, ENDURANCE – CONTINUOUS 291

The ship is SHAKING *with* GRAVITATIONAL ENERGY *. . .*

CASE

MAXIMUM VELOCITY ACHIEVED . . . PREPARE TO FIRE ESCAPE THRUSTERS –

INT. COCKPIT, LANDER – CONTINUOUS 292

Tars checks his instruments –

TARS

Ready.

INT. COCKPIT, RANGER 2 – CONTINUOUS 293

Cooper checks his instruments –

COOPER

Ready.

INT. RING MODULE, ENDURANCE – CONTINUOUS 294

Brand looks out at the glowing horizon. Glances fearfully at the darkness below . . . Case puts his hand on the button –

CASE

Main engine ignition in three, two, one, mark –

Case hits the button –

EXT. ENDURANCE – CONTINUOUS 295

The MAIN ENGINES FIRE – STRAINING AGAINST GARGANTUA . . .

INT. RING MODULE, ENDURANCE – CONTINUOUS 296

Brand feels the thrusters STRAIN *to lift the craft –*

 CASE
 Lander 1 engines, on my mark, three, two, one, mark –

INT. COCKPIT, LANDER – CONTINUOUS 297

Tars hits the button –

 TARS
 Fire.

EXT. ENDURANCE – CONTINUOUS 298

Lander 1's engines FIRE, *adding to the thrust. The Endurance starts*
RISING *away from the darkness . . .*

 CASE
 (*over radio*)
 Ranger 2's engines, on my mark – three, two, one, mark –

INT. COCKPIT, RANGER 2 – CONTINUOUS 299

Cooper hits the button –

 COOPER
 Fire.

EXT. ENDURANCE – CONTINUOUS 300

Ranger 2's engines add a fresh BLAST *of fire, pushing the Endurance*
higher and higher . . . back into the starlight . . .

INT. COCKPIT, RANGER 2 – CONTINUOUS 301

Cooper, shaking with the thrust, looks at his instruments –

 129

COOPER
That little maneuver cost us fifty-one years . . . !

INT. RING MODULE, ENDURANCE – CONTINUOUS 302
Brand holds on tight –

BRAND
You don't sound so bad for a hundred and twenty!

EXT. ENDURANCE – CONTINUOUS 303
Lander 1's engines DIE OUT . . .

CASE
(*over radio*)
Lander 1, prepare to detach, on my mark . . . three . . .

INT. RING MODULE, ENDURANCE – CONTINUOUS 304
Brand looks over at the lander –

CASE
Two . . .

INT. COCKPIT, LANDER 1 – CONTINUOUS 305

CASE
(*over radio*)
One . . . mark –

Tars hits a switch –

TARS
Detach.

INT. RING MODULE, ENDURANCE – CONTINUOUS 306
Brand sees Lander 1 DROP, *revealing Cooper in Ranger 2 . . .*

BRAND
Goodbye, Tars . . .

 TARS
 (*over radio*)
 See you on the other side, Coop . . .

Something in this makes Brand frown, PUZZLED *. . .*

EXT. ENDURANCE – CONTINUOUS 307

Lander 1 FALLS *behind as the Endurance continues to* RISE *. . .*

INT. COCKPIT, RANGER 2 – CONTINUOUS 308

Cooper checks his dwindling fuel supply . . .

 COOPER
 Hey, Case? Nice reckless flying.

 CASE
 (*over radio*)
 Learned from the master.

EXT. ENDURANCE – CONTINUOUS 309

As Lander 1 FALLS *back towards Gargantua, Ranger 2's engines* DIE
OUT *. . .*

INT. RING MODULE, ENDURANCE – CONTINUOUS 310

Case registers the burnout.

 CASE
 Ranger 2, prepare to detach –

Brand looks up, SHOCKED –

 BRAND
 NO!

She UNBUCKLES –

 CASE
 On my mark –

FLIES *to the window looking onto Cooper –*

BRAND

What are you doing!

CASE

Three . . .

INT. COCKPIT, RANGER 2 – CONTINUOUS 311

Cooper looks across at Brand.

COOPER

Newton's third law – you have to leave something behind.

CASE
(*over radio*)

Two . . .

INT. RING MODULE, ENDURANCE – CONTINUOUS 312

Brand pushes her helmet up against the window,

BRAND

You *told me* we had enough power –

CASE

One . . .

INT. COCKPIT, RANGER 2 – CONTINUOUS 313

Cooper looks at her, fondly –

COOPER

Hey, we agreed – ninety percent.

CASE
(*over radio*)

Mark . . .

Cooper reaches for the button. Takes one last look at Brand – inside her helmet, Brand is crying, zero-G tears catching in her eyelashes like melted snowflakes.

Cooper hits the button. But the word catches in his throat –.

COOPER

Detach –

EXT. ENDURANCE – CONTINUOUS 314

Ranger 2 DROPS AWAY *from the Endurance . . .*

INT. COCKPIT, RANGER 2 – CONTINUOUS 315

Cooper sees the Endurance ACCELERATE AWAY *to a bright point as
he* FALLS AND FALLS *. . . Cooper starts to breathe* FASTER –

EXT. GARGANTUA – CONTINUOUS 316

Ranger 2 PLUMMETS *towards blackness as the horizon* GLOWS
BRIGHTER *and* BRIGHTER *– distorted starlight, plasma jets . . .*

INT. COCKPIT, RANGER 2 – CONTINUOUS 317

Cooper, trying to control his breathing, uses retro-rockets to TURN
the lander down. He GASPS *at the* FLAMING HORIZON –

> COOPER
> (*over radio*)
Tars? Are you there?

STATIC *– Ranger 2* TILTS *down –* INKY BLACKNESS *ahead –*

INT. ENDURANCE – CONTINUOUS 318

Brand, crying, monitors Cooper's lonely transmissions . . .

EXT. GARGANTUA – CONTINUOUS 319

Ranger 2 PLUNGES *towards the black hole. We hear Cooper's panic
breathing get* LOUDER *and* LOUDER *until –*

Ranger 2 SHUDDERS *with* EXPONENTIALLY RISING GRAVITATIONAL
ENERGY *as it* CROSSES THE HORIZON – PLUNGING TOWARDS THE
SINGULARITY – ALL WAVELENGTHS OF LIGHT CASCADING WITH
HIM –

AS WE –

PLUNGE INTO ABSOLUTE . . .

WHITE –

Not a whiteout – a SHIMMERING CAVALCADE OF ALL WAVELENGTHS: LIGHT, SOUND, EVERYTHING . . . *the* SPHERICAL INSIDE OF THE BLACK HOLE, *like a* STAR *turned* INSIDE OUT. COOPER IS SCREAMING *and we* CUT *to –*

BURNING CORN *– men fighting a fire, Tom leading,* GESTURING *–*

INT. MURPH'S BEDROOM – TWILIGHT 320

Murph (forty) sits on the bed, looking into the BOX. *She pulls out the* LUNAR LANDER MODEL, *looks up at the books . . .*

<div align="center">

GETTY
(O.S.)
</div>

Come on, Murph! We don't have much time!

EXT. GARGANTUA – DAY 321

A BLACK DOT *appears,* RUSHING TOWARDS US *to become –* A DARK SPHERE *– we* PLUNGE *through it into* SILENT DARKNESS *– a* WHITE SPHERE *races towards us –*

Just as the wormhole was a spherical hole, THESE SPHERES ARE HOLES WITHIN HOLES . . . *we are dropping through* A FOUR-DIMENSIONAL RABBIT HOLE – LIGHT/DARK/LIGHT/DARK/LIGHT/DARK *with* BLINDING RAPIDITY *– the frequency almost* SPEAKING. *Cooper hangs on for dear life –*

<div align="center">

COMPUTER VOICE
(O.S.)
</div>

FUEL CELL OVERLOAD. DESTRUCTION IMMINENT. INITIATE EJECTION.

Cooper is LAUNCHED *out of Ranger 2, which* EXPLODES, *and,* PULLED *to one side,* MISSES A WHITE HOLE – PLUNGING INSTEAD TOWARDS A SMALLER GLASS-LIKE SPHERE *–*

Cooper slows as he falls towards this sphere, reminiscent of the wormhole, but the light within is not stars but an infinity of WORLD LINES – *(paths of objects through spacetime) –*

Cooper PLUNGES INTO THE WORLD SPHERE . . .

As he falls his SINGLE WORLD LINE *stretches behind him – the* INFINITE FUTURES OF HIS WORLD LINE *splitting ahead to all the different possibilities in spacetime –*

*Cooper himself is now like a ring being pulled down a cone of fabric.
He* STARES *at the* ORDERED CHAOS *of world lines . . .*

As he SLOWS *his past and future world lines* BREAK UP *so they
become like* INFINITE REFLECTIONS IN PARALLEL MIRRORS . . .

Cooper's world line DROPS *into a* SMALL, SQUARE TUNNEL –

INT. THE TESSERACT – CONTINUOUS 322

Tight enough to feel BLINDINGLY FAST *at first, but Cooper (and his*
INFINITE OTHERS) *is actually* SLOWING . . . *Cooper* DESPERATELY
reaches out, KNOCKING *the sides of the tunnel,* TRYING *to slow
himself –* GRAPPLING – KICKING *'BRICKS' out of the 'walls'. He
finally* STOPS. *Looks around in the* SUDDEN CALM, FLOATING,
catching his breath. He reaches out to the tunnel wall – CONFUSED –

Each 'brick' is TIGHTLY PACKED PAPER . . . PAGES . . . BOOKS – AS
SEEN FROM BEHIND A SHELF . . .

Cooper PUSHES *against a book – it* MOVES SLIGHTLY. *Cooper*
PUSHES, HARDER AND HARDER AND HARDER –

The book DROPS *out of sight, revealing –*

Murph, aged ten, wet hair, towel around her neck, TURNS, STARTLED
by THE BOOK FALLING FROM HER SHELF.

<div align="center">COOPER</div>

Murph? Murph?

She can't hear him . . .

INT. MURPH'S BEDROOM – MORNING 323

Murph (ten) stands there, startled, STARING *at the bookshelves. At
the book on the floor, a broken toy beside it . . .*

INT. MURPH'S BEDROOM – TWILIGHT 324

Murph (forty) looks at the bookshelves, REMEMBERING . . .

INT. THE TESSERACT – CONTINUOUS 325

Cooper watches Murph (ten) cautiously approach – she CROUCHES.
Picks something up –

INT. MURPH'S BEDROOM – TWILIGHT 326

Murph (forty) turns the lunar lander in her hands. Thinking.

INT. MURPH'S BEDROOM – DAY 327

Murph (ten) stands up holding the broken LUNAR LANDER . . .

INT. THE TESSERACT – CONTINUOUS 328

Cooper watches Murph (ten) examine the two pieces of the LUNAR
LANDER MODEL –

 COOPER
 MURPH! MURPH!

She turns . . . leaves the room . . . Cooper floats there, staring. He
LOOKS *around – each 'wall' of the tesseract is a different view of
Murph's bedroom, so that by rotating he can effectively orbit her
room . . .*

He claws his way down to the next book wall. PUNCHES *out two
books –*

Murph's bedroom, empty. The door opens, Cooper's EARLIER SELF
*is standing there, staring at the room, perturbed. Murph (ten) joins
Cooper, staring at the empty room . . .*

Cooper LASHES *out at the books – kicks a book out –* SPOTS *–*

Murph (ten) closes her door, crying, sliding the desk in front –

INT. MURPH'S BEDROOM – TWILIGHT 329

*Murph (forty) feels the desk. She puts her hand on the back of the
chair, tilts it slightly, remembering –*

INT. THE TESSERACT – CONTINUOUS 330

Cooper watches Murph (ten) put A CHAIR ON TOP OF THE DESK.
The earlier Cooper nudges the door open –

INT. MURPH'S BEDROOM – EVENING 331

Murph (ten) sees the door NUDGING *against the desk and chair –*

MURPH

Just go. If you're leaving – just leave now.

INT. THE TESSERACT – CONTINUOUS 332

Cooper, the frustrated observer, spins around to see his EARLIER SELF *nudging the door –*

COOPER
(*to his earlier self*)

Don't go, you idiot!

His Earlier Self shuts the door . . .

COOPER

Don't leave your kids. You goddamn fool.

Cooper PUNCHES OUT *books with all his strength –*

COOPER

S . . . T . . .

Murph (ten) is watching, no longer scared, fascinated –

COOPER

A . . . Y . . .

Cooper STOPS. *Catches his breath. Waits . . .*

Earlier Cooper lifts the chair off the table to enter.

Cooper watches his earlier self, FRUSTRATED –

COOPER

Stay, you idiot! Tell him, Murph! Stay . . .

As before, Cooper gives Murph the WATCH *. . . Murph* THROWS THE
WATCH *and* TURNS AWAY. *. . .*

COOPER

Murph, tell him again! Don't let him leave . . . !

INT. MURPH'S BEDROOM – TWILIGHT 333

*Murph (forty) picks up the notebook. Opens it. Finds the word
'*STAY*' . . . looks up at the books,* REALIZING *. . .*

INT. THE TESSERACT – DAY

Cooper is crying with frustration . . .

> COOPER
>
> Murph, don't let me leave . . .

Cooper watches as his earlier self heads to the door –

> COOPER
>
> STAY!!

Cooper SMASHES *a book from the shelf with all his might –*

His earlier self turns back. Looks at the book. Then leaves.

Cooper rests his head against the books, SOBBING.

INT. MURPH'S BEDROOM – TWILIGHT

Murph (forty) lowers her notebook, moves to the bookshelves, IN
AWE . . .

> MURPH
>
> Dad . . . it was you. You were my ghost . . .

She is crying. Joyful.

INT. THE TESSERACT – DAY

Cooper sobs at the back of the books. Lost . . .

> TARS
> (over radio)
>
> Cooper?

Cooper, STARTLED, *turns. Tars is not there.*

> COOPER
>
> You survived.

> TARS
> (over radio)
> Somewhere. In their fifth dimension. They saved us . . .

> COOPER
> (frustrated)
> Who's 'They'? And why would they help us?

TARS
(*over radio*)
I don't know, but they constructed this three-dimensional space inside their five-dimensional reality to allow you to understand it . . .

COOPER
It isn't working –!

TARS
(*over radio*)
Yes, it is. You've seen that time is represented here as a physical dimension – you even worked out that you can exert a force across spacetime –

COOPER
(*realizing*)
Gravity. To send a message . . .

Cooper looks around the infinite tunnel, infinite Coopers.

COOPER
Gravity crosses the dimensions – including time –

Cooper THINKS *. . . He pulls himself up to a different wall, starts counting books . . .*

And you have the quantum data, now –

TARS
(*over radio*)
I'm transmitting it on all wavelengths – but nothing's getting out . . .

COOPER
I can do it –

Cooper HITS *a book's world line, sending a* WAVE *. . .*

TARS
(*over radio*)
Such complicated data . . . to a child . . .

COOPER
Not just any child.

Murph (forty) stands there, looking at her old notebook – the page that says 'STAY' . . .

> GETTY
> (O.S.)

MURPH?! COME ON!

She looks around the room, SEARCHING for an answer . . .

Cooper watches Murph (ten) looking out the window . . .

> TARS
> (over radio)
> *Even if you communicate it here, she wouldn't understand its significance for years . . .*

Cooper is seized by a sudden anger –

> COOPER

Then figure something out! Everybody on Earth is going to die!

> TARS
> *Cooper, they didn't bring us here to change the past.*

Cooper hears something in this –

> COOPER

We brought ourselves here . . .

Cooper PUSHES off, looking through the gaps in the books. Murph's bedroom, full of DUST in the DUST STORM –

> COOPER

Tars, feed me the coordinates of NASA in binary . . .

Cooper is in the room now, drawing a pattern in the dust . . .

Cooper watches Murph (ten) burst into the room. Murph stops and stares at the dust as Cooper's Earlier Self comes in past her, SLAMS the window shut – sees the PATTERN of dust . . .

Murph (forty) runs her finger along the DUST of the windowsill . . . She turns to look around the room. Frustrated.

MURPH

Come on, Dad. Is there something else here . . .?

INT. TESSERACT – CONTINUOUS 340

Cooper looks up from the floor –

COOPER

Don't you see, Tars? I brought myself here. We're here to communicate with the three-dimensional world. We're the bridge . . .

Cooper moves to another iteration of Murph's room. Murph (ten) JUMPS *up –* GRABS *the* WATCH, RUNS *out the door . . .*

INT. MURPH'S BEDROOM – TWILIGHT 341

Murph (forty) looks at the watch, remembering. The second hand TWITCHES. *She drops the watch back into the box . . .*

INT. TESSERACT – CONTINUOUS 342

Cooper pushes himself along the world line of the books . . .

COOPER

I thought they chose me – they never chose me – they chose Murph.

TARS
(*over radio*)

For what?

COOPER

To save the world!

Murph (ten) comes back into her bedroom, SOBBING. *She is holding the watch. She puts it on the shelf.*

INT. MURPH'S BEDROOM – TWILIGHT 343

Murph (forty) puts the box back on the shelf. SIGHS *. . .*

INT. TESSERACT – CONTINUOUS 344

Cooper races FASTER *and* FASTER *down the world lines.*

COOPER
'They' have access to infinite time, infinite space . . .

Cooper gestures at the INFINITIES *in all directions . . .*

COOPER
But no way to find what they need – but I can find Murph and find a way to tell her – like I found this moment –

TARS
(*over radio*)
How?

COOPER
Love, Tars. Love – just like Brand said – that's how we find things here.

TARS
(*over radio*)
So what are we here to do?

Cooper looks around the tesseract. The watch sits there on the shelf for as long as he can see . . .

COOPER
The watch. That's it. She'll come back for it –

TARS
How do you know?

COOPER
Because I gave it to her. We use the second hand. Translate the data into Morse and feed it to me –

Tars starts to transmit. Cooper GRABS *the second-hand world line – starts to* MANIPULATE *it, sending waves down the world line . . .*

TARS
What if she never came back for it?

COOPER
She will. She will . . . I *feel* it . . .

The second hand is FLICKING *back and forth . . .*

INT. MURPH'S BEDROOM – TWILIGHT 345

Murph (forty) turns to leave . . .

GETTY
(O.S.)
MURPH, HE'S COMING!

She pauses. Goes back to the box – reaches in. PULLS OUT THE
WATCH . . . *staring at it . . . wondering . . .*

GETTY
(O.S)
MURPH?! MURPH . . . ?!

EXT. FARMHOUSE – TWILIGHT 346

Getty is holding a tire iron, watching TOM'S TRUCK APPROACH. *Lois
and Coop* STARE, FEARFUL, *from the truck . . .*

Tom APPROACHES, BLACK *from soot . . .*

Murph BURSTS *out of the house . . . right up to Tom . . .*

MURPH
Tom, he came back . . . he came back . . .

TOM
Who?

She holds up the watch . . .

MURPH
Dad. It was him. All this time . . . it was him. He's going to
save us . . .

CLOSE ON *the second hand of the watch,* FLICKING *back and forth –*

INT. PROFESSOR BRAND'S OFFICE – DAY 347

Murph furiously TRANSCRIBES *the movements of the second hand –*

INT. CORRIDOR, NASA – LATER 348

Murph, papers in hand, RUNS *down the corridor,* BUMPS *into Getty –
doesn't stop . . .*

*Murph runs to the railing of the catwalk above the enormous
construction, looks down at the thousands of workers below. Getty
comes out after her, curious. She looks at him, then* SHOUTS OUT *to
the enormous space . . .*

> MURPH

EU–RE–KA!

She turns to Getty – GRINNING.

 Well, it's traditional.

She THROWS *her paper out over the railing –*

EUREKA!!

Workers look up to see her papers flitting down . . .

*Cooper looks out at the world line of the watch, of Murph, as it
leads out into infinite complexity . . .*

> COOPER

Did it work?

> TARS
> (*over radio*)

I think it might have.

> COOPER
> (*hopeful*)

Why?

> TARS
> (*over radio*)

Because the bulk beings are closing the tesseract . . .

Cooper looks out to the distance – it is RAPIDLY APPROACHING,
WORLD LINES BECOMING WORLD SHEETS, BECOMING BULKS . . .

> COOPER

Don't you get it, yet, Tars? 'They' aren't '*beings*' . . . they're
us . . . trying to help . . . just like I tried to help Murph . . .

TARS
(*over radio*)
People didn't build this tesseract –

COOPER
Not yet . . . but one day. Not you and me but *people*, people who've evolved beyond the four dimensions we know . . .

The tesseract EXPANSION BACK INTO FIVE DIMENSIONS IS ALMOST UPON THEM – *Cooper* BRACES HIMSELF –

COOPER
What happens now –?

BAM – *he is swept up in the expansion like a tiny leaf on a* CHURNING WAVE –

Cooper FLIES *through the* EXPANDING COSMOS, *past* PLANETS ORBITING STARS, WHICH BECOME ATOMIC PARTICLES, WHICH BECOME MATTER, BECOMING STARS . . .

Cooper APPROACHES A GLASSY TUBE. *Inside is the* OLD, UNDAMAGED ENDURANCE. *As Cooper looks in from the bulk he sees: Brand, strapped in, Doyle opposite, traversing the wormhole for the first time . . .*

Cooper REACHES *for Brand . . . She sees something, reaches up – their hands would touch if they weren't in different dimensions, her fingers distorting the space of his fingers –*

WHAM! *She, and the Endurance, are* SWEPT PAST – *Cooper is* SMASHED *into the spacetime of the wormhole – he* SCREAMS AND WE –

INT. OUTER SPACE – LATER 351

Cooper FLOATS, *dead or unconscious, near Saturn. In the distance we see two Rangers approaching . . .*

INT. HOSPITAL ROOM – DAY 352

Cooper's eyes flicker open. A bright room with an open window, net curtains obscuring the view. We hear the CRACK *of a baseball off a bat. Children* LAUGHING.

VOICE
(O.S.)
Mr Cooper? Mr Cooper?

145

Cooper looks over to see a Nurse and a Doctor watching him. He tries to sit up.

DOCTOR
Take it slow, sir. Remember you're no spring chicken any more. (*Amused.*) I gather you're one hundred and twenty-four years old. (*Checks Cooper's chart.*) You were extremely lucky. The Rangers found you with only minutes left in your oxygen supply –

COOPER
Where am I?

The Doctor, almost surprised, TURNS, *moves to the window, opens the curtains. Where Cooper should see sky, he sees a* CURVING UPSIDE-DOWN TOWN . . .

DOCTOR
Cooper Station. Currently orbiting Saturn.

The Nurse helps Cooper to the window. He looks out at the VAST CYLINDRICAL STATION – *cornfields and buildings. Outside his window, kids are playing baseball. The batter hits a* POP FLY . . . *the kids watch it up and up, until it carries on, falling up towards the buildings above. The kids* SHOUT *a warning – the ball smashes a skylight. Cooper watches the kids laugh.*

COOPER
Nice of you to name the place after me.

The Nurse giggles. The Doctor shoots her a look –

What?

DOCTOR
The station wasn't named after you, sir . . . It was named after your daughter.

Cooper smiles at this . . .

DOCTOR
Although, she's always maintained just how important you were –

COOPER
Is she . . . (*Braces.*) still alive?

DOCTOR

She'll be here in a couple weeks. She's really far too old for a transfer from another station, but when she heard you'd been found . . . well, this *is* Murphy Cooper we're talking about.

COOPER
(*marveling*)

Yes, it is . . .

The Doctor is wrapping up –

DOCTOR

We'll have you checked out in a couple days.

Cooper turns back to the window, thinking . . .

ADMINISTRATOR
(*V.O.*)

I'm sure you'll be excited to see what's in store . . .

INT. HANGAR, COOPER STATION – DAY 353

The ADMINISTRATOR, *thirties, leads Cooper along a walkway –*

ADMINISTRATOR

We've got a nice situation for you . . .

Cooper looks down at a line of SLEEK NEXT-GENERATION RANGERS. *Sees a* PILOT *climb into one. Mechanics work another . . .*

ADMINISTRATOR

I actually did a paper on you in high school, sir. I know all about your life on Earth . . .

EXT. TOWN SQUARE, COOPER STATION – CONTINUOUS 354

Cooper looks at the strangely ordinary town the Administrator is walking him through . . .

ADMINISTRATOR

So when I made my suggestion to Ms Cooper, I was delighted to hear that she thought it was perfect . . .

The Adminstrator leads Cooper through a cornfield . . . The old farmhouse is there, preserved. As Cooper approaches, a small monitor starts playing the footage of OLD-TIMERS *from the start of the movie.*

 ADMINISTRATOR
 Of course, I didn't speak to her personally . . .

As Cooper passes the monitor it changes to a FAMILIAR OLD LADY, *but Cooper misses it . . .*

INT. KITCHEN, FARMHOUSE – CONTINUOUS 356

OLD-TIMERS *play on video screens: a museum exhibit. The Administrator holds the door open for Cooper.*

 ADMINISTRATOR
 But she confirmed just how much you loved farming.

 COOPER
 She did, huh?

Cooper looks over the kitchen. Cooper sees a familiar-looking articulated machine –

 COOPER
 Is that . . .?

 ADMINISTRATOR
 The machine we found out near Saturn when we found you,
 yes. Its power source was shot, but we could get you another
 if you want to try and get it up and running again.

Cooper turns to the Administrator.

 COOPER
 Please.

INT. HANGAR, COOPER STATION – EVENING 357

Cooper, from the catwalk, watches the last of the Rangers come back from patrol. The PILOT *jumps down as the ground crew wheels it into its place in the line of sleek ships.*

INT. KITCHEN, FARMHOUSE – NIGHT 358

Cooper has Tars' head laid out on the kitchen table.

TARS

Settings: general settings, security setting –

COOPER

Honesty. New level setting. Ninety-five percent.

TARS

Confirmed. Additional customization?

COOPER

Yes. Humor, seventy-five percent. Wait. (*Thinks.*) Sixty percent.

INT. HOSPITAL WAITING ROOM – DAY 359

Cooper enters, nervous. A nurse is there.

COOPER

Is she –?

NURSE

The family's all in there.

COOPER

The family?

NURSE

They all came along to see her – she's been in cryo-sleep for almost two years.

INT. HOSPITAL ROOM – CONTINUOUS 360

Cooper cautiously pushes open the door. The bed is surrounded by people, grown-up children, grandchildren, babies . . . They turn to look at him: some SMILES, *some* CURIOUS *looks, a small child* HIDES *behind a parent's leg . . .*

Cooper approaches, and the family parts to let him see an ELDERLY WOMAN, *lying in the bed,* FRAIL.

She looks up at Cooper. Delighted. Tears of joy. She reaches up to him . . . he takes her hands.

COOPER

Murph.

MURPH

Dad. (*To the others.*) Please.

Her voice is a frail whisper. With authority. The family shuffles out. Cooper watches them go, turns back to Murph.

COOPER

You told them I like *farming*.

Murph smiles, still mischievous. Cooper marvels at her.

COOPER

Murph, it was me. *I* was your ghost.

MURPH

I know . . .

She lifts her wrist – the WATCH *is there . . .*

MURPH

People didn't believe me, they thought I'd done it all myself . . . (*Taps watch.*) But I knew who it was . . .

COOPER

A father looks in his child's eyes and thinks – maybe it's them – maybe my child will save the world.

MURPH

And everyone, once a child, wants to looks into their own dad's eyes and know he saw. But, usually, by then, the father is gone. Nobody believed me, but I knew you'd come back.

COOPER

How?

MURPH

Because my dad promised me.

Cooper is crying now.

COOPER

I'm here now. I'm here for you, Murph.

Murph is shaking her head.

MURPH

No parent should have to watch their child die. My kids are
here for me now. Go.

COOPER

Where?

MURPH
(*it's so obvious*)

Brand.

*And the family comes back in as Cooper releases Murph's hand,
stepping back to let Murph's kids and grandkids swarm over her . . .
He watches them, their love, as if from another dimension. A man
out of time. A ghost.*

MURPH
(*V.O.*)

She's out there . . .

EXT. EDMUNDS' DESERT PLANET – DAY 361

*Brand, in suit and helmet, stands watching Case excavate a pod,
buried under a massive rock fall. She is crying.*

MURPH
(*V.O.*)
Setting up camp . . .

EXT. HANGAR, COOPER STATION – NIGHT 362

MECHANIC *finishes looking over one of the sleek new Rangers. He
packs his tools and heads out.*

*A figure unfolds itself in the shadows – Tars. He picks his way
through the shadows, unlocks the door. Cooper* DARTS *in . . .*

EXT. EDMUNDS' DESERT PLANET – DAY 363

Brand kneels in front of a small CROSS. *Edmunds' nameplate hangs
from it.*

MURPH
. . . Alone in a strange galaxy . . .

She unseals her helmet – PULLS IT OFF . . .

INT. HANGAR, COOPER STATION – NIGHT 364

Cooper and Tars scurry down the line of sleek ships. Cooper points –
Tars starts working the hatch mechanism, while Cooper KEEPS
WATCH . . .

EXT. EDMUNDS' DESERT PLANET – DAY 365

Brand, helmet off, BREATHES. *And breathes again.*

> MURPH
> (V.O.)
> Maybe, right now, she's settling in for the long nap . . .

INT. RANGER IN HANGAR, COOPER STATION – NIGHT 366

Cooper STRAPS *into the pilot's chair, Tars beside him. The outer*
doors slide open. They look out at the inky blackness of space . . .

EXT. EDMUNDS' DESERT PLANET – DUSK 367

Brand looks at the setting sun . . .

> MURPH
> (V.O.)
> By the light of our new sun . . .

INT. HANGAR, COOPER STATION – MORNING 368

The Mechanic opening up, walks along the row of ships until –
One is MISSING.

EXT. EDMUNDS' DESERT PLANET – DUSK 369

Brand turns from the dwindling light . . .

> MURPH
> (V.O.)
> In our new home.

She heads down through the twilight towards camp. And we –
Fade out.
Credits.
End.

Interstellar

THE STORYBOARDS
drawn by Gabriel Hardman

DR MANN VS COOPER

SCENE # 183

183-1

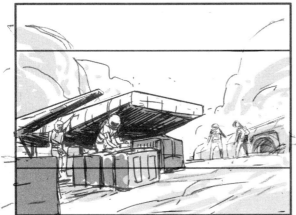

EXT. MANN'S PLANET.

COOPER + MANN IN B.G.
BRAND + ROMOSHOU NEAR
THE RANGER W/ SUPPLIES +
CONTAINERS ALREADY
DROPPED OFF BY LANDER.

COOPER: 'WE NEED
TO PICK OUT A SITE.
YOU DON'T WANT TO
MOVE THE MODULE
ONCE YOU LAND IT.'

83-2

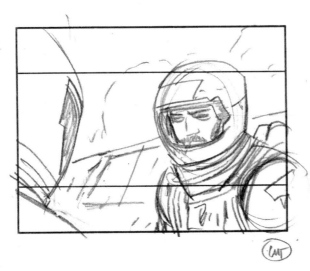

DR. MANN: 'I'LL
SHOW YOU THE
PROBE SITES.'

183-3

COOPER GLANCES
AROUND AS THE
WIND KICKS UP.
COOPER: "WILL CONDITIONS
HOLD?"
DR. MANN: "THESE
SQUALLS USUALLY
BLOW OVER. YOU'VE
GOT A LONG RANGE
TRANSMITTER?"

183-4

COOPER CHECKS
THE TRANSMITTER
ON HIS NECK.

83-5

COOPER MANN

DR. MANN POINTS TO
A NOZZLE ON HIS
ELBOW.
 DR. MANN: "CHARGED."
COOPER CHECKS, THUMBS
UP.

(CMT)

183-6

COOPER + MANN

DR. MANN SETS OFF,
COOPER FOLLOWS

(CMT)

159

SCENE # 184

184-1

EXT. DR. MANN'S
PLANET - LATER.

COOPER FOLLOWS
MANN DOWN A
RIDGE.

CUT

184-2A

COOPER SEES
THE LANDER.
**WHICH IS
CARRYING CONTAINERS
UNDERSLUNG.**

SHOT
CONT'D

184-2B

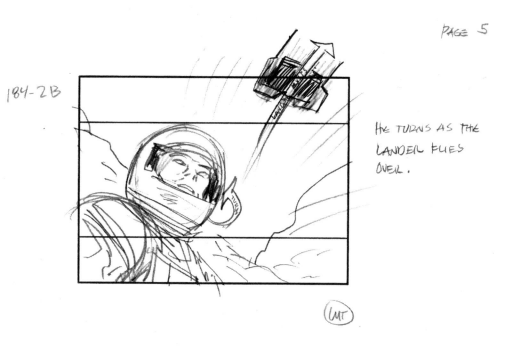

HE TURNS AS THE
LANDER FLIES
OVER.

(MT)

184-3

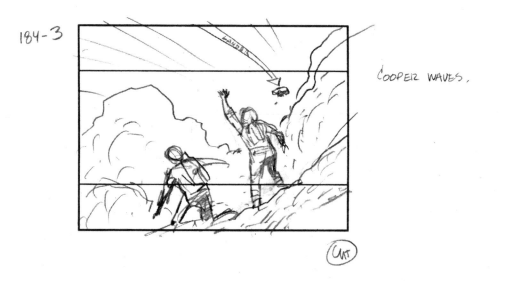

COOPER WAVES.

(MT)

184-4

COOPER REACHES
UP TO HIS LONG RANGE
TRANSMITTER.

COOPER: "A LITTLE
CAUTION I CASE?"
CASE (OVER RADIO):
"SAFETY FIRST,
COOPER."

(CUT)

184-5A

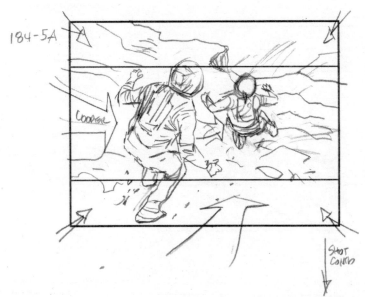

COOPER

COOPER FOLLOWS
DR. MANN DOWN...

SHOT
CONT'D

34-5B

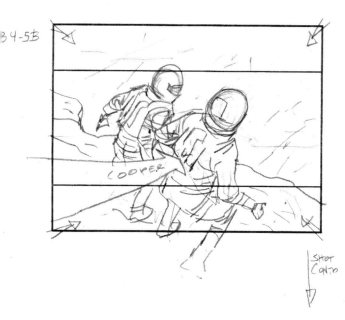

to the edge
of a cliff.

Shot
cont.

34-5C

CAMERA PUSHES
PAST COOPER,
REVEALING A
20 FOOT DROP.

(CUT)

184-6

DR. MANN: "JUST TAKE IT GENTLY."

184-7A

DR. MANN...

SHOT
CONT'D

TILT DOWN

B4-7B

DR. MANN

LEAPS OFF THE
LEDGE.

SHOT
CONT'D

165

184-7C

TILT DOWN
W/ MANN AS
HE MAKES THE
20 FOOT LEAP

184-8

DR. MANN STARTS
HIS ELBOW JETS
JUST BEFORE HE
HITS THE GROUND.

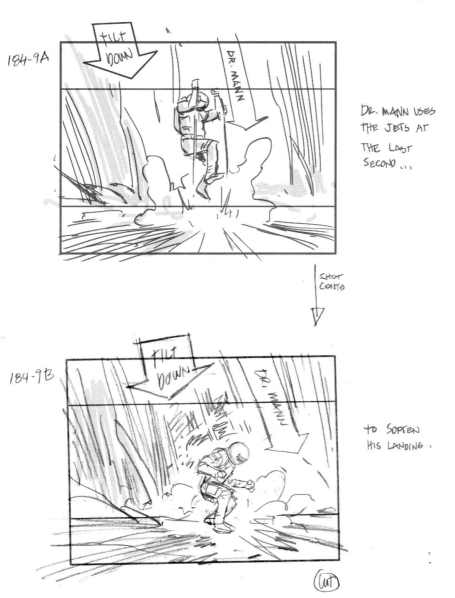

184-9A

DR. MANN USES
THE JETS AT
THE LAST
SECOND ...

SHOT
CONT'D

184-9B

to SOFTEN
HIS LANDING.

167

184-10A

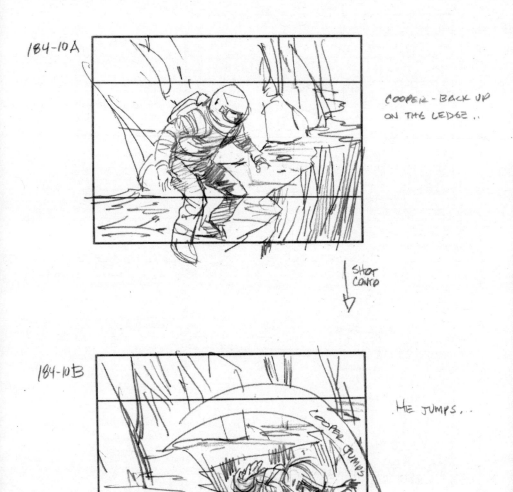

COOPER - BACK UP
ON THE LEDGE ..

SHOT
CONT'D

184-10B

HE JUMPS, ..

COOPER JUMPS

184-11A

COOPER DROPS
... DOWN TOWARD
CAMERA...

SHOT
CONT'D

184-11B

(MT)

184-12

COOPER
+
DR. MANN

THEY SET OUT
THROUGH A MASSIVE
CANYON OF ICE

(MT)

184-13A

HIGH WIDE ANGLE
ON THE MASSIVE
CANYON.

(CMT)

84-14A

DR, MANN: "BRAND
TOLD ME WHY YOU
FEEL YOU HAVE TO
GO BACK - - "

SNOW STARTS
BLOWING...

SHOT
CONTIO

184-15B

COOPER FOLLOWS.

DR. MANN: "YOU HAVE ATTACHMENTS,.."

SHOT
CONT'D

184-15C

THE WIND WHIPS ICE CRYSTALS BETWEEN THEM.

CUT

SCENE # 187

187-1A

PAST BRAND TO
THE LANDER —

SHOT
CONT'D

87-1B

BRAND TURNS AWAY
AS THE LANDER
SETS DOWN A
CONTAINER ...

LANDER

SHOT
CONT'D

187·1C

THE LANDER
TOUCHES DOWN IN
A SPRAY OF ICE.

SCENE # 189

89-1A

DR. MANN WAITS
FOR COOPER TO
CATCH UP.
tHE WIND IS
PICKING UP.

DR. MANN:

" YOU KNOW WHY
WE COULDN'T JUST
SEND MACHINES
ON THESE MISSIONS,
COOPER. "

SHOT
CONT'D

89-1B

COOPER:

"FRANKLY, NO."

DR. MANN:

'A TRIP INTO THE
UNKNOWN REQUIRES
IMPROVISATION..."

CUT

A

DR. MANN PAUSES TO
TAKE A BREATH.
TURNS TO COOPER.

DR. MANN : "TAKE YOU —
A FATHER, WITH
A SURVIVAL INSTINCT
THAT EXTENDS TO
YOUR KIDS..."

SHOT
CONT'D

B

DR. MANN TURNS AND
STARTS WALKING
OUT ONTO A MASSIVE
ICE FIELD.

MANN

(CATT)

SCENE # 193

93 - 1

EXT. ICE FIELD.

COOPER AND DR. MANN
WALK ACROSS IT
LIKE TWO ANTS ON
A SHEET.

DR. MANN. "THE
FIRST WINDOW'S
UP AHEAD."

(CMT)

193-2

(CMT)

193-3

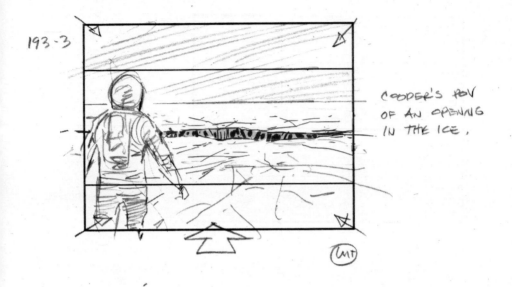

COOPER'S POV
OF AN OPENING
IN THE ICE.

193-4

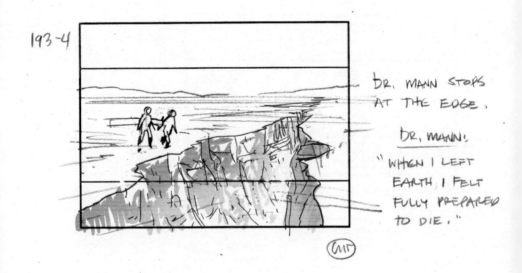

DR. MANN STOPS
AT THE EDGE.

DR. MANN:
"WHEN I LEFT
EARTH, I FELT
FULLY PREPARED
TO DIE."

93-5.

COOPER PEERS
OVER THE EDGE...

193-6

...AT AN ENORMOUS
CREVASSE.

193-7

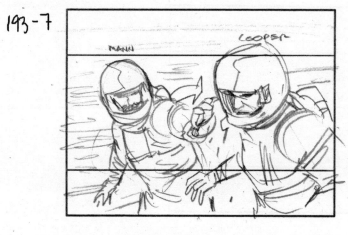

DR MANN. REACHES
TOWARD COSPER.

CUT

193-8

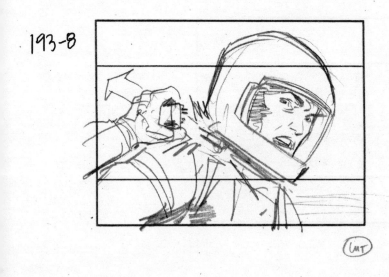

MANN GRABS
COOPER'S
TRANSMITTER.

CUT

193-9

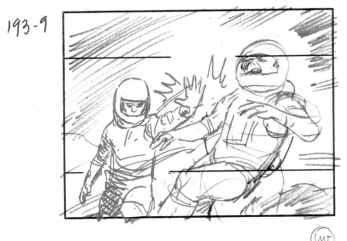

MANN PUSHES COOPER
TOWARD THE CREVASSE.

193-10

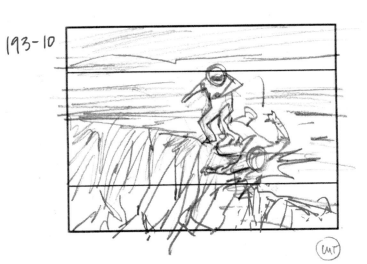

COOPER IS
KNOCKED TO
THE GROUND.

193-11

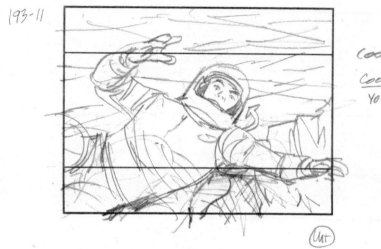

COOPER ON THE EDGE.
COOPER: "WHAT ARE YOU DOING?"

193-12

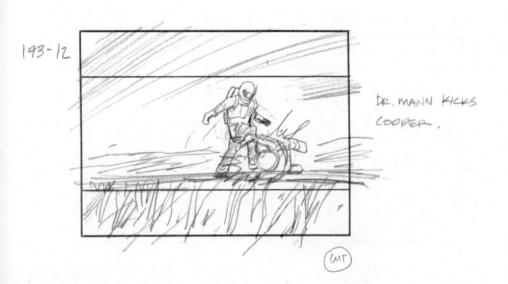

DR. MANN KICKS COOPER.

193-13

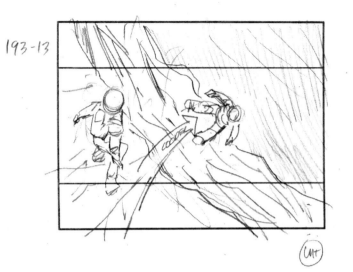

DOWN ANGLE

COOPER SLIPS
BACKWARDS —

193-14A

COOPER HITS HIS
JETS ...

SHOT
CONT'D

193-14B

PUSHING HIMSELF
ONTO A LOWER
LEDGE.

193-15

DOWN ANGLE.
COOPER ON THE
LEDGE.

SCENE # 195

195-1

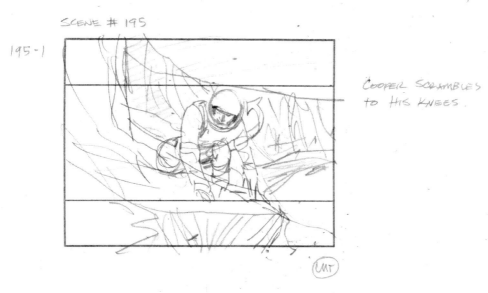

COOPER SCRAMBLES
TO HIS KNEES.

(MT)

195-2

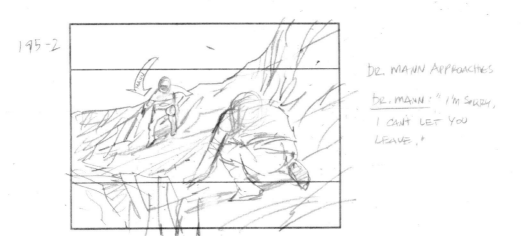

DR. MANN APPROACHES

DR. MANN: " I'M SORRY,
I CAN'T LET YOU
LEAVE. "

MANN

195-3

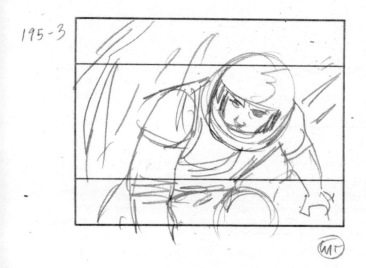

COOPER'S MIND
RACES.

COOPER: "YOU
FAKED ALL THE
DATA?"

195-4

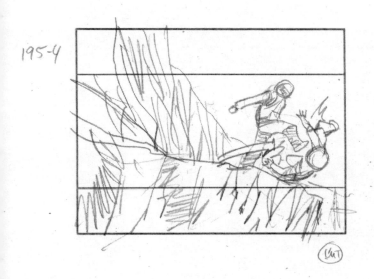

DR. MANN KICKS
COOPER OVER THE
EDGE

195-5

COOPER CLINGS ON.

195-6

DR MANN
KNEEL DOWN.

195-7A

COOPER RAISES
HIS ARM,
THE DIRECTION OF
HIS ELBOW JET
SWIVELS ...

SHOT
CONT'D

195-7B

AND BLASTS
MANN IN THE
CHEST WITH
THE JET.

195 - 8A

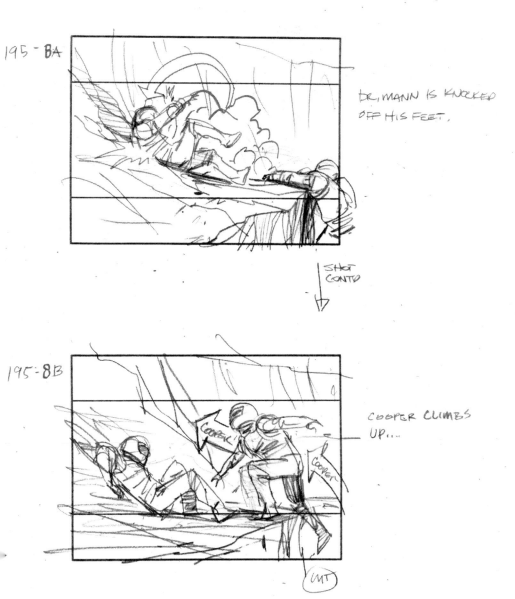

DR. MANN IS KNOCKED
OFF HIS FEET.

SHOT
CONT'D

195 - 8B

COOPER CLIMBS
UP...

195-9

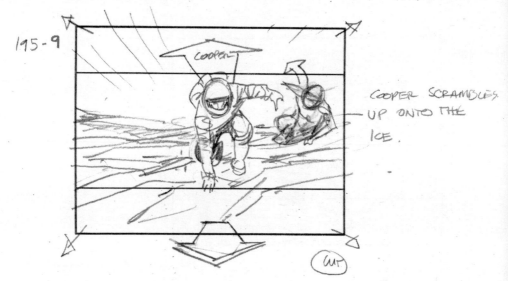

COOPER

COOPER SCRAMBLES
UP ONTO THE
ICE.

CUT

195-10

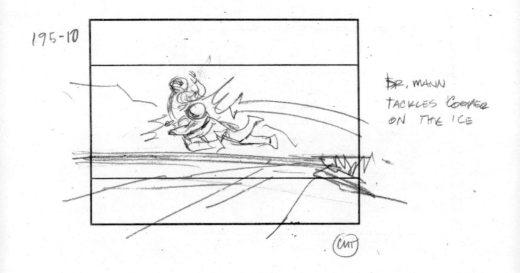

DR. MANN
TACKLES COOPER
ON THE ICE

CUT

195-11

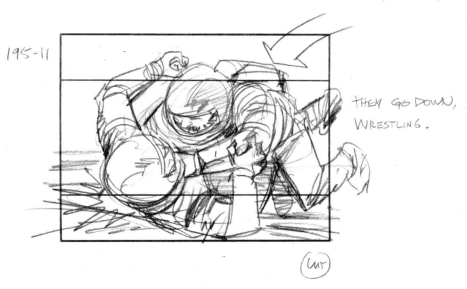

THEY GO DOWN,
WRESTLING.

(CUT)

95-12

WIDER, TWO TINY
FIGURES IN
A VAST LANDSCAPE.

(CUT)

SCENE # 197

197-1

COOPER GETS
TO HIS FEET

CUT

197-2A

DR. MANN LUNGES
TOWARD COOPER..

SHOT
CONT'D

192

97-2B

COOPER SIDESTEPS
AND PINS DR. MANN
TO THE GROUND.

COOPER: "STOP THIS!"

97-3

MANN SMASHES
COOPER'S FACEPLATE.
AGAIN AND AGAIN.

197-4A

CRASH!

MANN

Shot
Cont

197-4B

TINY FRACTURES
FORM ON MANN'S
FACE PLATE.

MANN INT

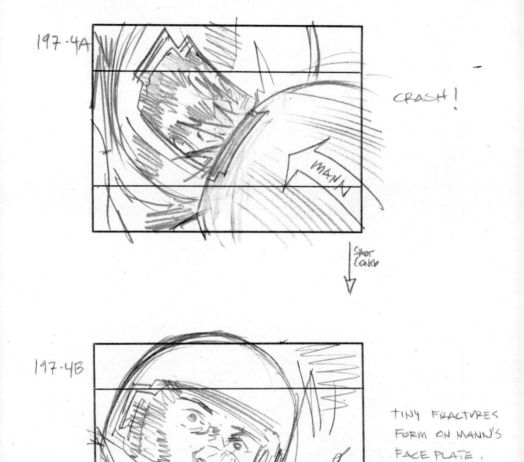

97·5

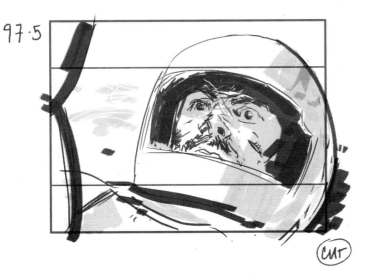

MANN STOPS —
LOOKS UP AT
COOPER — TINY
FRACTURES ON
HIS FACE PLATE.

MANN: "BEST ODDS
I'VE HAD IN YEARS."

CUT

97-6

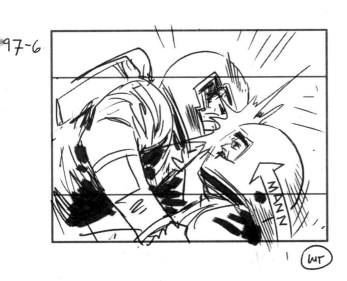

CUT

197-7

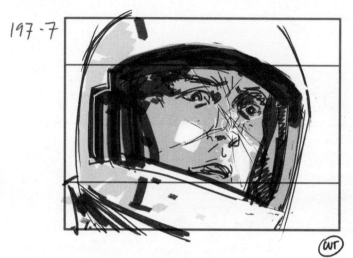

COOPER.
A SICKENING
CRACK.

197-8

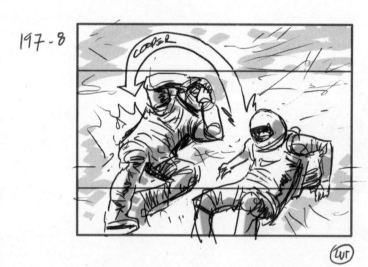

COOPER ROLLS
OFF DESPERATELY
TRYING TO PLUG
THE CRACK.

97-9

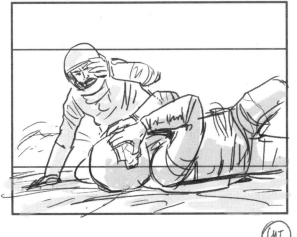

MANN RISES. CHECKS
HIS HELMET — BENDS
DOWN TO LOOK AT
COOPER.

DR.MANN:
"PLEASE DON'T JUDGE
ME. COOPER, YOU
WERE NEVER TESTED
LIKE I WAS — FEW
MEN HAVE BEEN."

(CUT)

SCENE # 199

199-1

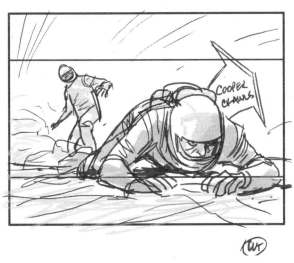

COOPER
CRAWLS

(CUT)

SCENE # 199

199-2

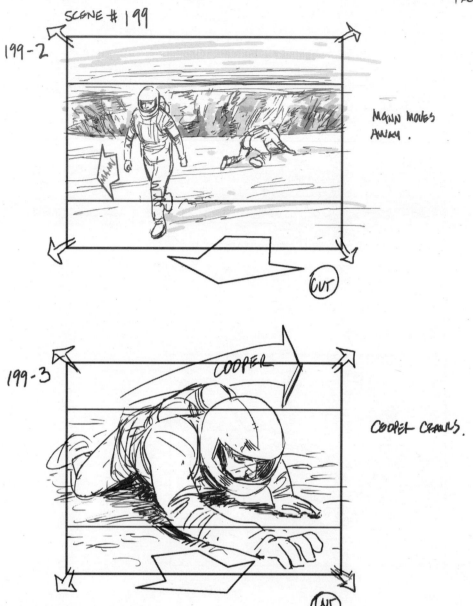

MANN MOVES
AWAY.

CUT

199-3

COOPER

COOPER CRAWLS.

CUT

99-4

MANN CLIMBING
ONTO A LEDGE.

99-5

CLOSE ON COOPER.

MANN (RADIO): INTO THAT
GOOD NIGHT."

199-6

COOPER LOOKS
AROUND.

(CUT)

199-7

PAST COOPER TO
THE TRANSMITTER.

(CUT)

199-8

CLOSE ON THE
TRANSMITTER IN
THE F.G.

SCENE # 201

201-1

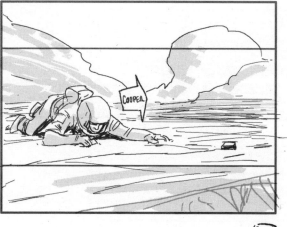

COOPER CRAWLS
TOWARD THE
TRANSMITTER.

(LUT)

201-2A

MANN JUMPS/JETS
UP...

SHOT
CONT'D

201-2D

MANN TURNS AND
EXITS.

201-3

COOPER GRABS
THE TRANSMITTER.

201-4

COOPER PICKS
UP THE TRANSMITTER.
TRIES TO CONNECT IT.

(CUT)

201-5

COOPER TRIES
TO CALM HIS
TREMBLING HAND.

(CUT)

201-5

COOPER PULLS HIS
GLOVE OFF.

CUT

201-6

TRANSMITTER

COOPER CONNECTS
THE TRANSMITTER.

COOPER: "BRAND!"

CUT

SCENE # 202

202-1

EXT. LANDER.
BRAND IS STARTLED
BY COOPER'S RASPING
VOICE.

COOPER (RADIO): "HELP...ME...
HELP..."

SCENE # 204

204-1

INT. LANDER COCKPIT.
BRAND JUMPS IN.
ENGINES ARE
ALREADY FIRING.

204-2

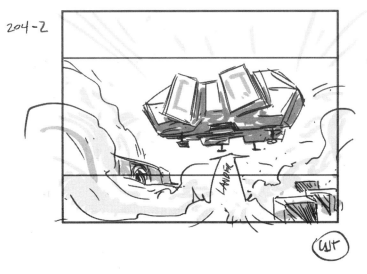

EXT. THE LANDER
IS LIFTING OFF.

SCENE # 205

205-1

CUT

COOPER GASPS.

COOPER: "NO AIR..."

SCENE # 207

207-1A

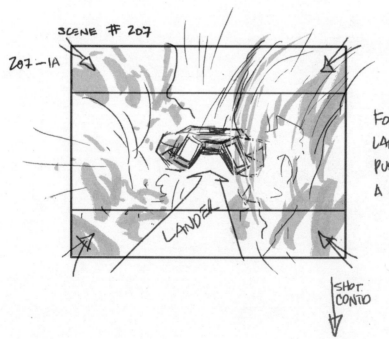

LANDER

FOLLOWING THE
LANDER AS IT
PUSHES THROUGH
A CLOUD...

SHOT
CONT'D

208

207-1B

THEN DODGES
ANOTHER CLOUD.

CUT

SCENE # 208

208-1

BRAND WATCHES
CASE FLY.

CUT

SCENE # 211

211-1

COOPER FLIPS OVER STARING SKYWARD.

SCENE # 213

213-1A

THE LANDER SWOOPS AROUND A TOWERING CLOUD...

213-2A

REVEALING THE
ICE FIELDS.

LANDER

CUT

SCENE # 114

114-1

BRAND POINTS.
BRAND: "I SEE
HIM!"

SCENE # 216

216-1

COOPER.

216-2

BRAND LEAPS FROM
THE HOVERING
LANDER.

216-3

BRAND RUNS
TOWARD COOPER.
LANDER HOVERS
IN THE B.G.

216-3

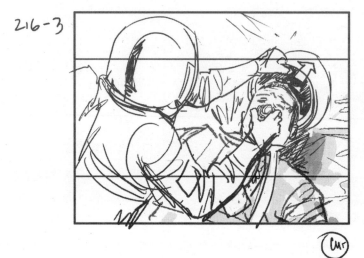

BRAND RIPS OFF
COOPER'S HELMET
AND PUTS AN
OXYGEN MASK
ON HIM.

CUT

216-4

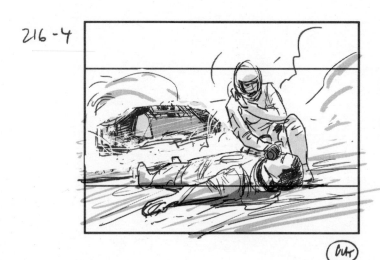

BRAND REACHES
FOR HER LONG
RANGE
TRANSMITTER.

CUT

DR MANN FAILS TO DOCK

EXT. STRATOSPHERE.
RANGER ROCKETS
UPWARD.

INT. RANGER
OVER DR. MANN AS
HE PILOTS THE RANGER
UP INTO THE
STRATOSPHERE

3

LANDER 2 MAKES IT'S
WAY UP THROUGH THE
ICE CLOUDS

4

INT. LANDER 2
COCKPIT.

COOPER: "DR. MANN. ?"
PLEASE RESPOND."

CASE: "HE DOESN'T
KNOW THE ENDURANCE
DOCKING PROCEDURE."

5 A

INT. DR. MANN HEARS
COOPER — IGNORES
HIM. LOOKS AT...

SHOT
CONT'D

5 B

PAN

NAVIGATION COMPUTER.

6A

RANGER IN
ORBIT...

SHOT
CONTD

6B

PAN W/IT ...

SHOT
CONTD

6.1A

INT. RANGER AS THE SHIP ROTATES AROUND MANN...

THERE IS A SECOND CONTROL PANEL WHICH STARTS ABOVE HIS HEAD...

SHOT CONT'D

6.1B

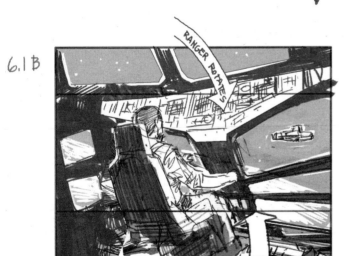

... AS THE SHIP ROTATES AROUND HIM ...

SHOT CONT'D

6.1C

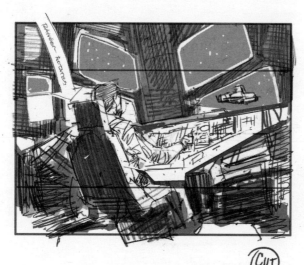

THE SECOND CONTROL
PANEL ENDS UP
IN FRONT OF MANN
AS THE ROTATION
STOPS.

(CUT)

222

7

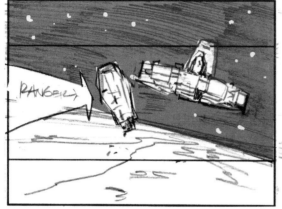

PAN W/ THE RANGER
REVEALING THE
ENDURANCE IN
ORBIT .

8

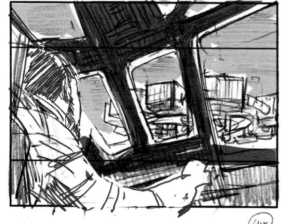

OVER DR. MANN
THROUGH THE
WINDOWS TO
THE ENDURANCE ,

9

A THRUSTER
FIRES ON
THE RANGER.

10A

RANGER ROTATES...

RANGER

SHOT
CONT'D

10 B

THE BACK OF
THE SHIP ROTATES
TOWARD CAMERA ...

SHOT
CONT'D

10 C

LEADING BACK
OF THE SHIP.

CUT

11A

FOLLOWING THE
RANGER AS IT
BACKS TOWARD
THE MODULE.

RANGER

SHOT
CONT'D

11B

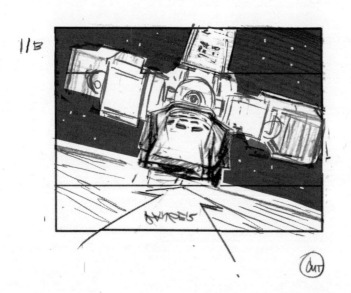

ANGELS

CUT

226

12

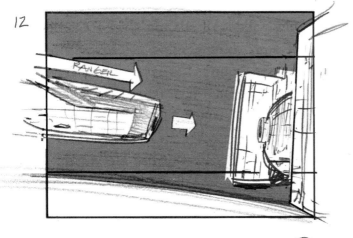

THE RANGER BACKS
TOWARD THE
ENDURANCE AIRLOCK.

13

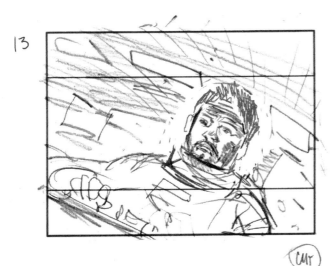

COMPUTER VOICE:

"AUTO DOCKING SEQUENCE
WITHHELD."

DR. MANN:

"OVERRIDE."

COMPUTER VOICE:

"UNAUTHORIZED."

DR. MANN THINKS. LOOKS OVER
AT THE MANUAL DOCKING
CONTROLS.

14 A

INt. LANDER Z
UP THROUGH THE
STRATOSPHERE.

SHOT
CONTD

14 B

INTO ORBIT REVEALING
THE ENDURANCE.

CUT

BRAND

CUT

MANN'S
HANDS WORK ...

PAN

SHOT
CONT'D

15

16

17

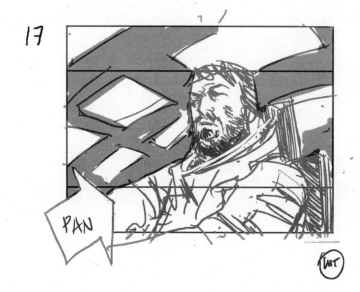

PAN

TO DR. MANN —
FOCUSED.

18

RANGER

EXT. RANGER
INCHES CLOSER
TO THE OUTER
HATCH OF
ENDURANCE

19A

A ROW OF MECHANICAL GRAPPLES TRY TO CONNECT.

SHOT CONTD

19B

GRAPPLES PULL THE RANGER INTO ENDURANCE HATCH.

20

CLANG!

THE SHIPS COME
TOGETHER.

COMPUTER VOICE:
" IMPERFECT CONTACT."

DR. MANN:
" OVERRIDE."

COMPUTER VOICE
" HATCH LOCKOUT
DISENGAGED."

(CUT)

21

MANN FLOATS
BACK TOWARD
CAMERA...

(CUT)

21.1

HE HEADS TOWARD
THE AIRLOCK ..

(CUT)

22

INT. LANDER 2

COOPER: 'IS HE
LOCKED ON?'
CASE: 'IMPERFECTLY'

23

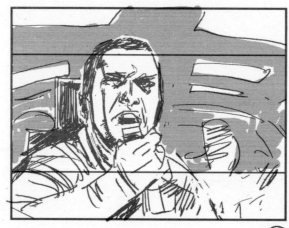

COOPER GRABS
THE TRANSMITTER

"DR. MANN — DR. MANN,
DO NOT OPEN THE
HATCH! IF YOU —-"

24A

INT. RANGER.
DR. MANN WORKS
CONTROLS.
TILT UP ...

SHOT
CONT'D

24B

to A MONITOR
SHOWING THE
INT. OF THE
RANGER'S AIRLOCK
AS THE OUTER
DOOR OPENS

25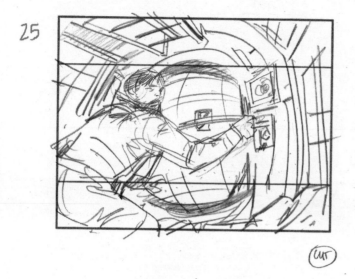

INT. RANGER
WIDER. DR. MANN
WORKS THE AIRLOCK
CONTROLS.

(CUT)

26

EXT. GRAPPLES
OPENING AND
CLOSING BLINDLY,
TRYING TO SEAL
THE JOIN.

(CUT)

27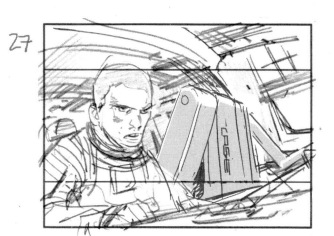

INT. LANDER 2

COOPER: "WHAT HAPPENS IF HE BLOWS THE HATCH?"

CASE: "NOTHING GOOD."

COOPER: "PULL US BACK."

(LNT)

28 A

RETRO THRUSTERS
FIRE ON LANDER 2.

SHOT
CONT'D

28 B

IT BACKS AWAY.

CUT

29

INT. RANGER.
MANN TAKES A
BREATH THEN
REACHES FOR
THE INNER
LEVER.

BRAND. (OVER RADIO)

"— PEAT. DO NOT
OPEN THE INNER
HATCH."

30

MANN HITS HIS
TRANSMITTER.

DR. MANN:

"BRAND, I DON'T
KNOW WHAT
COOPER'S TOLD
YOU.."

31

MANN TURNS BACK
to THE LEVER
AND PULLS IT

32

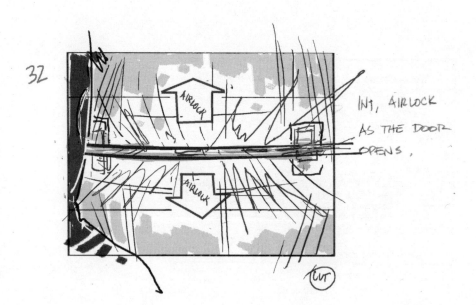

INT, AIRLOCK
AS THE DOOR
OPENS.

33

DR. MANN REACTS

34

DR. MANN
SMASHES INTO
THE AIRLOCK
DOOR AS
IT OPENS.

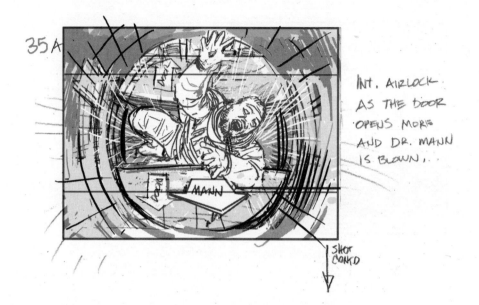

35 A

INT. AIRLOCK.
AS THE DOOR
OPENS MORE
AND DR. MANN
IS BLOWN...

SHOT
CONT'D

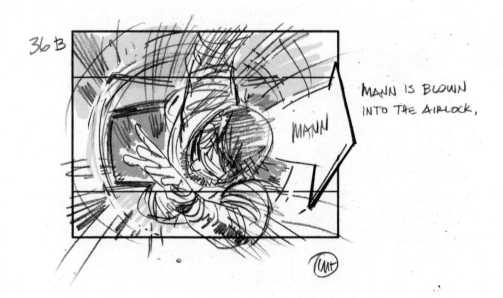

36 B

MANN IS BLOWN
INTO THE AIRLOCK.

37

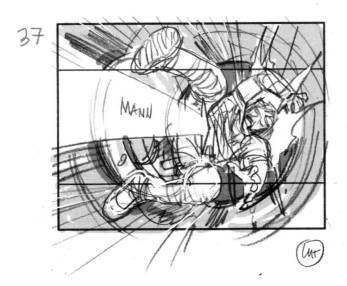

INT. AIRLOCK.
MANN SLAMS
INTO THE
OUTER DOOR.

38

EXT. THE AIRLOCK
SEAL RUPTURES.

EXT. ESCAPING AIR
AND DEBRIS PUSH
ENDURANCE INTO
A SLOW SPIN.

40

INT. AIRLOCK.
MANN IS HAMMERED
BY DEBRIS AS
THE AIRLOCK
STARTS TO RIP
APART.

(cut)

41

EXT. THE AIRLOCK
RIPS APART.

(cut)

42

THE SHIP SPINS
FASTER
THE RANGER
RIPS APART...

(CUT)

43 A

THE RANGER
IS RIPPED AWAY,
FRAGMENTING...

SHOT
CONT'D

43 B

SHREDDING
THE MODULE
NEXT TO IT.

(CUT)

44

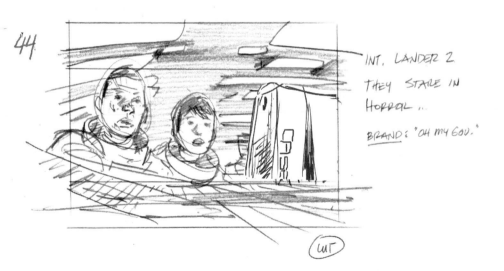

INT. LANDER 2
THEY STARE IN
HORROR...
BRAND: "OH MY GOD."

(CUT)

45 A

THEIR POV FROM
LANDER 2 OF
THE ENDURANCE
AS ...

SHOT
CONT'D

45 B

IT'S SENT SPINNING
OFF IT'S ORBIT
TOWARD THE PLANET.

1

46

COOPER GRABS
THE STICK.

47

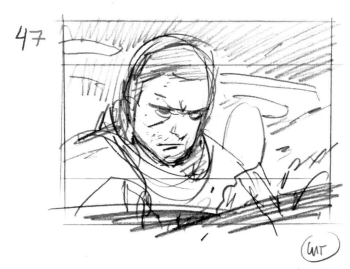

COOPER HITS
THE THRUSTERS

48A

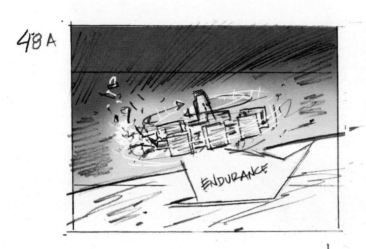

CRIPPLED ENDURANCE IN
A FAST, FLAT SPIN
HEADING DOWN...

SHOT
CONT'D

48B

250

49A

LANDER 2 FOLLOWS
ENDURANCE...

LANDER 2

CAMERA
W/ LANDER

SH
(CU)

49B

DODGING DEBRIS

DEBRIS

LANDS 2

50 A

INT. LANDER 2

CASE: "COOPER,
THERE'S NO
POINT IN USING
OUR FUEL TOO."

SHOT
CONTD

50 B

COOPER: "JUST
ANALIZE THE
ENDURANCE'S SPIN."
BRAND: "WHAT
ARE YOU DOING?"
COOPER: "DOCKING."

51

DOWN ANGLE.
LANDER 2 ROCKETS
AFTER ENDURANCE —
SLOWLY CLOSING.

52

ENDURANCE STARTS
TO ENCOUNTER THE
ATMOSPHERE.

53

INT. LANDER 2
TO THE SPINNING
SHIP.

COOPER CHECKS
SPEED AGAINST
THE ENDURANCE.

CUT

54

LANDER 2

FOLLOWING LANDER 2
AS IT GAINS ON
ENDURANCE.

CUT

55

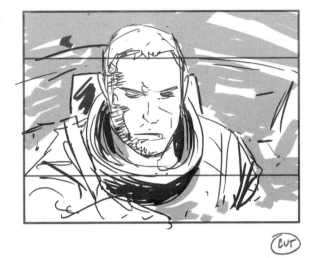

COOPER PILOTS.

CUT

56

LANDER 2
MOVES UNDER
ENDURANCE.

CUT

57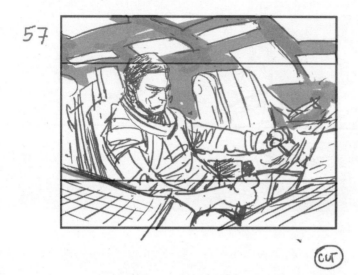

C PULLS BACK
ON THE THROTTLE

(CUT)

58

LANDER 2

SHOT
CONT'D

58B

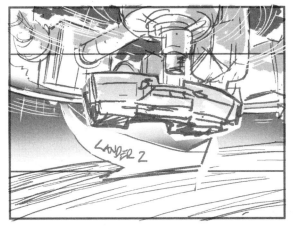

LANDER COMES
INTO POSITION
UNDER ENDURANCE

CUT

59

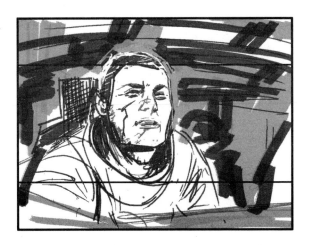

60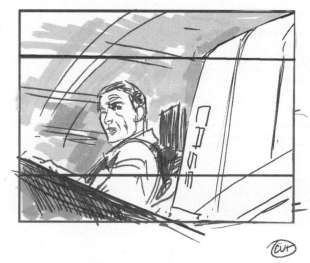

CASE: 'THIS IS
NO TIME FOR
CAUTION."

COOPER: 'IF I BLACK
OUT, TAKE THE STICK.'

61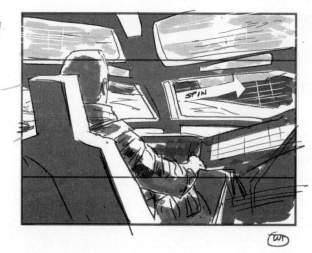

LANDER 2 STARTS
TO SPIN.

62

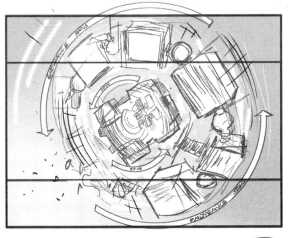

EXT. THE LANDER SPINS FASTER AND FASTER — CATCHING UP WITH ENDURANCE.

(CUT)

63

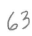

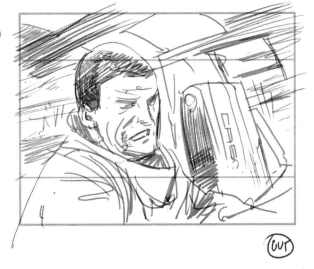

G FORCE OF THE SPIN PULLS THEM IN THEIR RESTRAINTS.

(CUT)

62

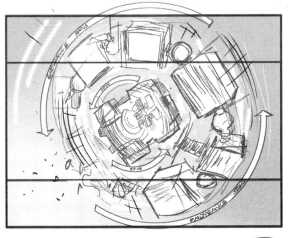

EXT. THE LANDER SPINS FASTER AND FASTER — CATCHING UP WITH ENDURANCE.

(CUT)

63

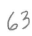
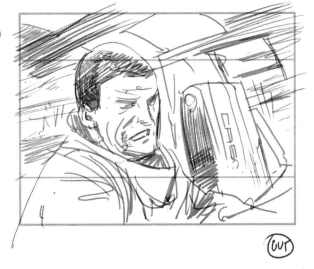

G FORCE OF THE SPIN PULLS THEM IN THEIR RESTRAINTS.

(CUT)

64

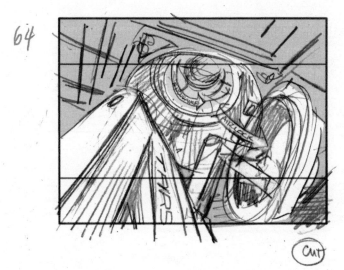

UP ANGLE
PAST TARS AS
HE OPENS THE
INT. AIRLOCK DOOR
THE ENDURANCE
HATCH IS ABOVE
THEM NOW -
SLOWLY ROTATING
RELATIVE TO HIM,

CUT

65 A

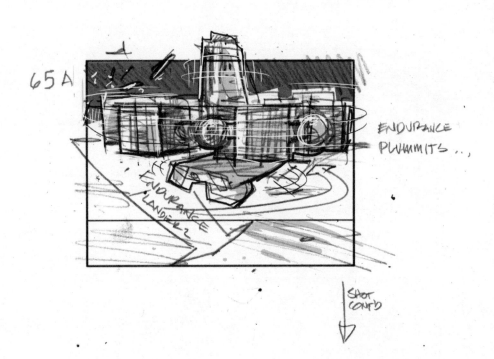

ENDURANCE
PLUMMITS...,

SHOT
CONT'D

65 B

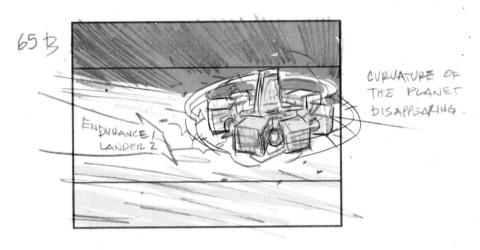

ENDURANCE/
LANDER 2

CURVATURE OF
THE PLANET
DISAPPEARING.

66

ENDURANCE

INT, TARS PEERS
UP AS THE SPIN
SPEEDS MATCH.

67 A

EXT. the
GRAPPLES —

67 B

FIRE BUT MISS
the ENDURANCE
AIRLOCK. —
THE HATCHES
MOVED.

(CUT)

68

COOPER KEEPS HIS
EYES ON THE
CONTROLS, NOT
THE WINDOWS.

69

INT. COCKPIT.
BRAND LOOSES
CONSCIOUSNESS.

70 A

HATCHES ALIGN
AGAIN . . .

70 B

GRAPPLES FIRE —
THEY HOLD.

TARS: "GOT IT!"

(CUT)

46

71

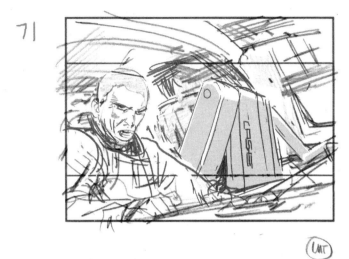

INT. COCKPIT.
COOPER REGISTERS.
CASE FIRE THE
RETRO ROCKETS.

(UNT)

72

EXT. RETRO
ROCKETS FIRE.
TO SLOW SPIN.

(UNT)

73

THE TWO CRAFT
NOW JOINED
SPIN MORE
SLOWLY

CUT

74

COOPER EASES
BACK IN HIS
SEAT AS THE
G-FORCES
LESSEN.

"GET READY TO
PULL US UP,"

CUT

75

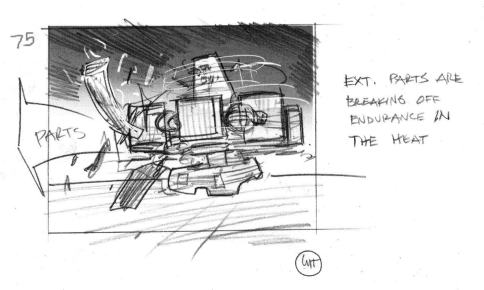

PARTS

EXT. PARTS ARE
BREAKING OFF
ENDURANCE IN
THE HEAT

(Cut)

76

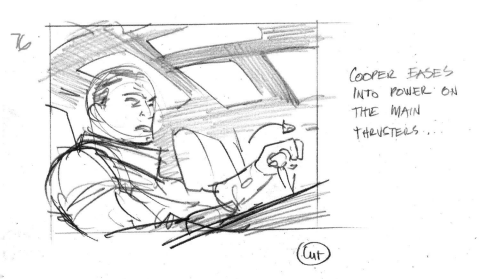

COOPER EASES
INTO POWER ON
THE MAIN
THRUSTERS...

(Cut)

77

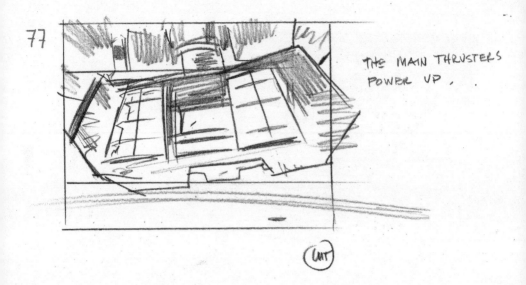

THE MAIN THRUSTERS
POWER UP.

(CUT)

7B A

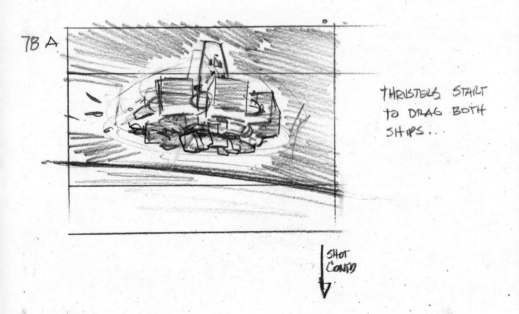

THRUSTERS START
TO DRAG BOTH
SHIPS...

SHOT
CONT'D

78B

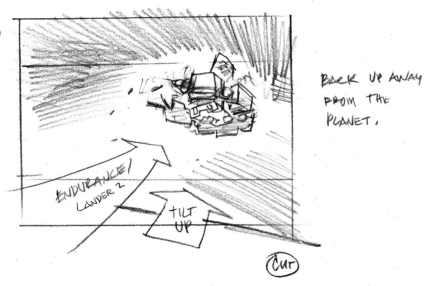

BACK UP AWAY
FROM THE
PLANET.

ENDURANCE/
LANDER 2

TILT
UP

CUT

BLACK HOLE

SCENE # 298

298 - 1

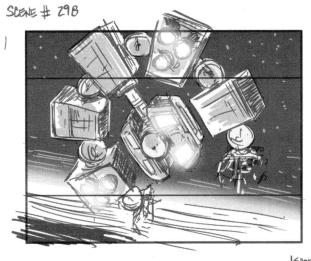

LANDER 1'S ENGINES
FIRE ...

SHOT
CONT'D

298-2

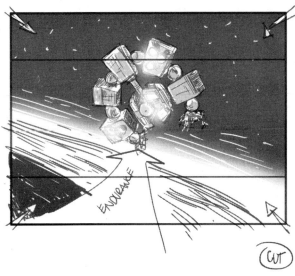

ENDURANCE STARTS
RISING AWAY

ENDURANCE

CUT

SCENE # 29

299-1

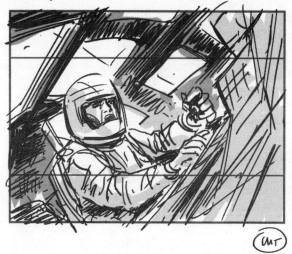

INT, RANGER 2
COOPER HITS A
BUTTON -

COOPER: "FIRE!"

299-2

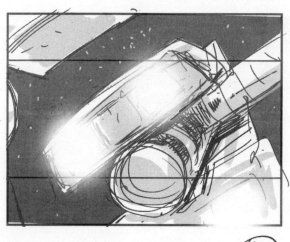

RANGER 2'S ENGINE'S
FIRE.

SCENE # 300

300-1

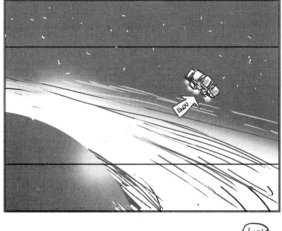

EXT. ENDURANCE
IS PUSHED BACK
UP INTO THE
STARLIGHT.

(CMT)

SCENE # 301

301-1

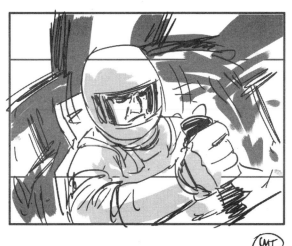

SHAKING WITH
THRUST — LOOKS
AT INSTRUMENTS.

(CMT)

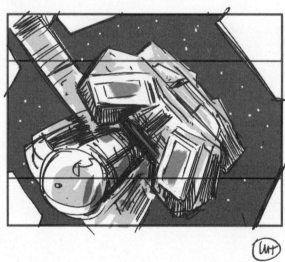

SCENE # 302

302-1

INT. RING MODULE.
BRAND HOLDS ON
TIGHT.

BRAND: "YOU DON'T LOOK
SO BAD FOR 120."

(CUT)

SCENE # 303

303-1

LANDER 1 ENGINES
DIE OUT.

CASE (OVER RADIO):
"LANDER 1, PREPARE
TO DETACH ON MY
MARK."

SCENE # 304

304-1

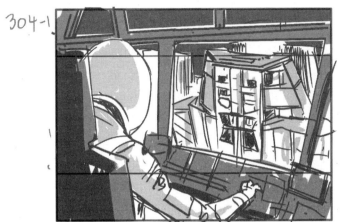

BRAND LOOKS
OVER AT THE
LANDER.

CASE: "TWO..."

CUT

SCENE # 305

305-1

INT. LANDER COCKPIT.
TARS HITS A SWITCH.

TARS: "DETACH."

WT

SCENE # 306

306-1A

BRAND SEES LANDER 1...

SHOT
CONT'D

306-1B

... AS IT DROPS AWAY...

BRAND: "GOODBYE
TARS."

SHOT
CONT'D

306-1C

REVEALING
RANGER 2 AND
COOPER.

COOPER (OVER RADIO):
"SEE YOU ON THE
OTHER SIDE."

SCENE # 307

307-1

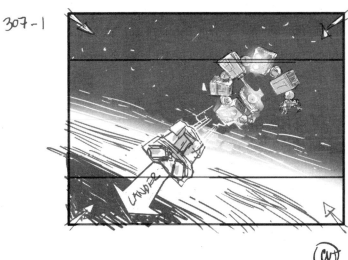

LANDER
LANDER 1
FALLS BEHIND
AS ENDURANCE
CONTINUES TO
RISE.

SCENE # 308

308-1

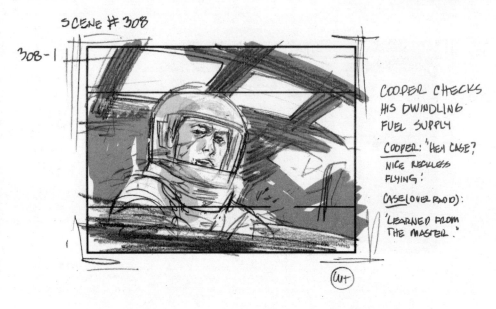

COOPER CHECKS
HIS DWINDLING
FUEL SUPPLY

COOPER: "HEY CASE?
NICE RECKLESS
FLYING!"

CASE (OVER RADIO):
'LEARNED FROM
THE MASTER.'

SCENE # 309

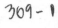

309-1

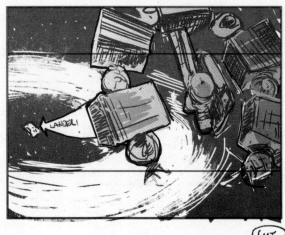

LANDER 1 FALLS
BACK TOWARD
GARGANTUA.

309·2

THE RANGER'S
ENGINES DIE
OUT.

SCENE # 310

310 - 1

INT. RING MODULE
CASE REGISTERS
THE BURNOUT.

CASE: "RANGER 2,
PREPARE TO DETACH."

BRAND LOOKS UP, SHOCKED.

310-2A

SHE UNBUCKLES...

SHOT
CONT'D

310-2B

FLIES TO WINDOW
LOOKING OUT AT
COOPER.
BRAND: "WHAT ARE
YOU DOING?"

SCENE # 311

311-1

COOPER LOOKS AT
BRAND.

COOPER:
" NEWTON SECOND LAW—
YOU HAVE TO LEAVE
SOMETHING BEHIND."

CASE (RADIO): "TWO..."

SCENE # 312

312-1

BRAND PUSHES HER
HELMET AGAINST THE
WINDOW.

BRAND: " YOU TOLD
ME WE HAD ENOUGH
POWER,"

CASE:" ...ONE..."

283

SCENE # 313

313-1

COOPER LOOKS AT
HER FONDLY.

COOPER: "WE AGREED,
90 PERCENT."

CUT

313-2

COOPER REACHES
FOR A BUTTON...

COOPER'S HAND

CUT

313·3

 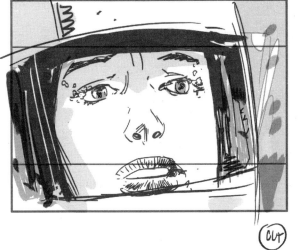

BRAND CRIES
ZERO G TEARS
CATCHING IN
HER EYELASHES.

(CU)

313·4

COOPER HITS THE
BUTTON.

COOPER: "DETACH"

(CUT)

SCENE # 314

34-1A

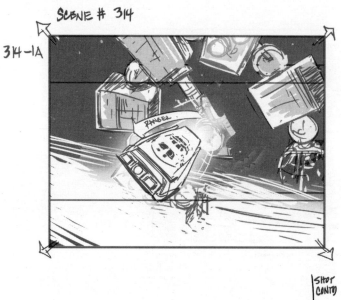

RANGER 2 DROPS
AWAY FROM
ENDURANCE.

SHOT
CONT'D

34-1A

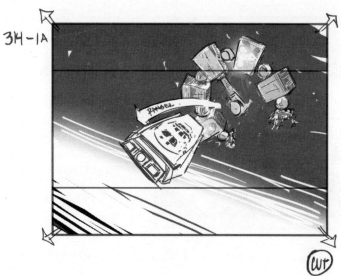

LWT

SCENE # 315

315-1

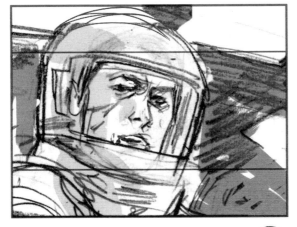

INT, RANGER 2
ON COOPER.

(CUT)

315·2A

COOPER SEES
ENDURANCE...

SHOT
CONT'D

315-2B

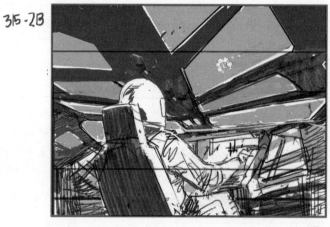

ACCELERATE AWAY
TO A BRIGHT POINT
OF LIGHT.

COOPER STARTS
TO BREATHE
FASTER.

(CUT)

SCENE # 316

316-1A

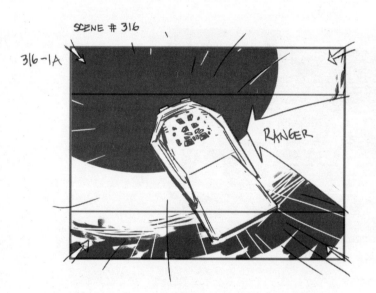

RANGER

LANDER 2 PLUMMETS

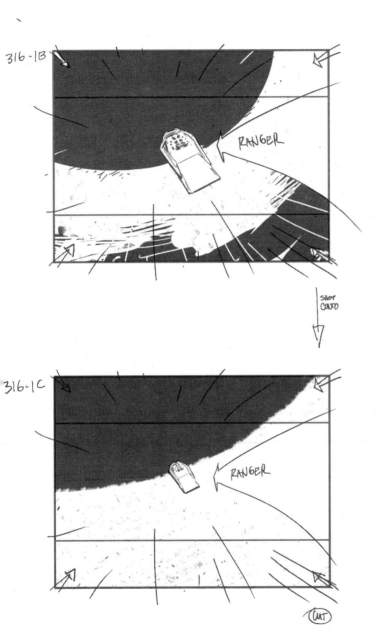

316-1B

RANGER

SHOT
CONTD

316-1C

RANGER

CMT

SCENE # 317

317 - 1

RETRO ROCKETS
FIRE.

CUT

317 · 2

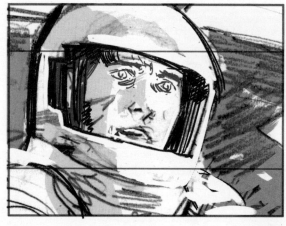

COOPER TRIES TO
CONTROL HIS
BREATHING.

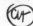

317·3A

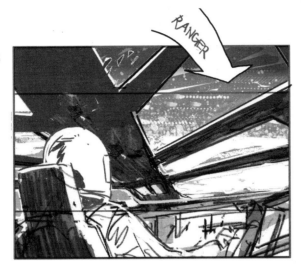

THE NOSE OF
THE LANDER
DIPS DOWN ...

SHOT
CONT'D

317·3B

INKY BLACKNESS
AHEAD.

CUT

SCENE # 318

318-1

BRAND CRYING,
MONITORING COOPER'S
LONELY TRANSMISSIONS.

SCENE # 319

319-1

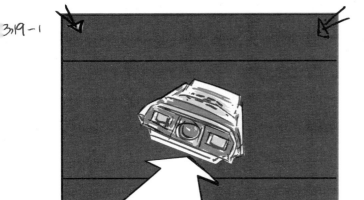

GARGANTUA.
RANGER 2
PLUNGES TOWARD
THE BLACK HOLE ...

319-2A

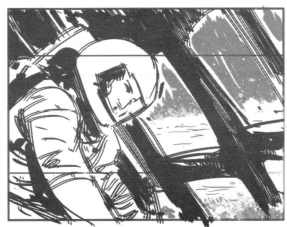

RANGER 2 SHUDDERS
WITH EXPONENTIALLY
RISING GRAVITATIONAL
ENERGY ...

SHOT
CONT'D

319-2B

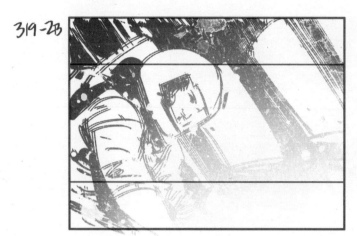

AS IT CROSSES THE
HORIZON, PLUNGING
TOWARD THE
SINGULARITY...

(W+)

319-3

EXT. PROFILE
ON RANGER
AS IT CROSSES
THE HORIZON

(CM.)

319-4A

SHOT
CONTD

3194B

SHOT
CONTD

3194C

CUT

319-4

WE PLUNGE INTO
ABSOLUTE WHITE

COOPER IS
SCREAMING AS
WE CUT TO —

(CUT)

SCENE # 321

321 - 1A

A BLACK DOT
APPEARS —
RUSHING TOWARD
US...

SHOT
CONT'D

321 - 1B

IT BECOMES
A DARK SPHERE

SHOT
CONT'D

321 - 1C

PLUNGE THROUGH
IT INTO SILENT
DARKNESS ...

SHOT
CONT'D

321-1C

A WHITE
SPHERE ...

SHOT
CONT'D

321-1D

... RACES TOWARDS
US ...

(CUT)

321-1E

THE BLACK AND
WHITE SPACES
RACE TOWARD US ...

SHOT
CONTD

321-1F

... FASTER AND
FASTER ...

CUT

321-2

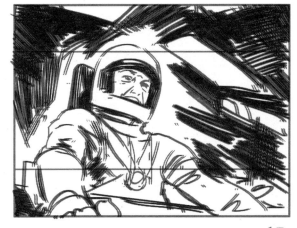

COOPER HOLDS ON FOR
DEAR LIFE.

COMPUTER VOICE:
'FUEL CELL OVERLOAD —
DESTRUCTION
IMMINENT.
INITIATE EJECTION —"

321-3A

ON RANGER 2
AS...

321-3B

A HATCH BLOWS OFF...

321-3C

COOPER IS LAUNCHED OUT OF THE RANGER ...

321-3D

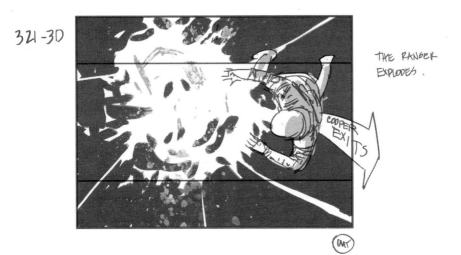

THE RANGER EXPLODES.

COOPER EXITS

(BAT)

321-4A

COOPER FALLS TOWARD A WHITE HOLE...

COOPER

SHOT CHGV

321-4B

COOPER IS PULLED
TO ONE SIDE, MISSING
THE WHITE HOLE.

SHOT
CONT'D

324-4C

INSTEAD PLUNGING
TOWARD A SMALLER
GLASS-LIKE SPHERE ...

SHOT
CONT'D

321-4D

COOPER SLOWS DOWN ...

COOPER

SHOT CONTU

321-4E

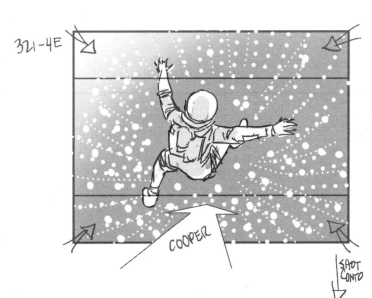

LIGHT WITHIN THE SPHERE IS NOT STARS BUT AN INFINITY OF WORLDLINES ...

COOPER

SHOT CONTD

321-4F

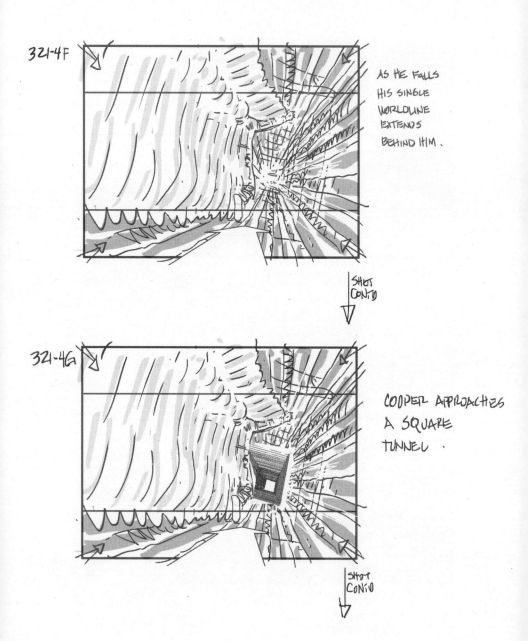

AS HE FALLS
HIS SINGLE
WORLDLINE
EXTENDS
BEHIND HIM.

SHOT
CONT'D

321-4G

COOPER APPROACHES
A SQUARE
TUNNEL.

SHOT
CONT'D

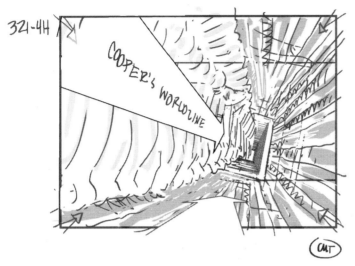

321-4H

COOPER'S WORLDLINE DROPS INTO A SMALL SQUARE TUNNEL

CUT

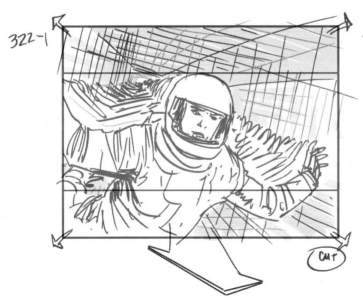

322-1

THE TESSERACT. BLINDINGLY FAST. LEADING COOPER AS HE FALLS.

COOPER AND HIS INFINITE SELVES ARE ACTUALLY SLOWING.

CUT

322-2

COOPER'S POV AS HE FLIES THROUGH THE TESSERACT.

(CUT)

322-3A

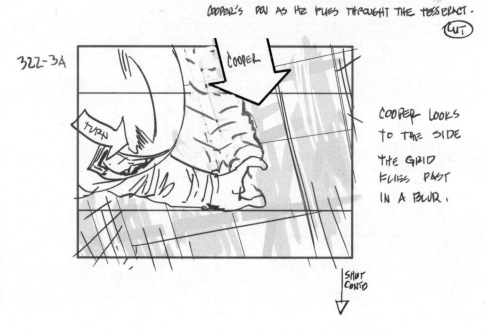

COOPER

TURN

COOPER LOOKS
TO THE SIDE
THE GRID
FLIES PAST
IN A BLUR.

SHOT
CONT'D

322-3B

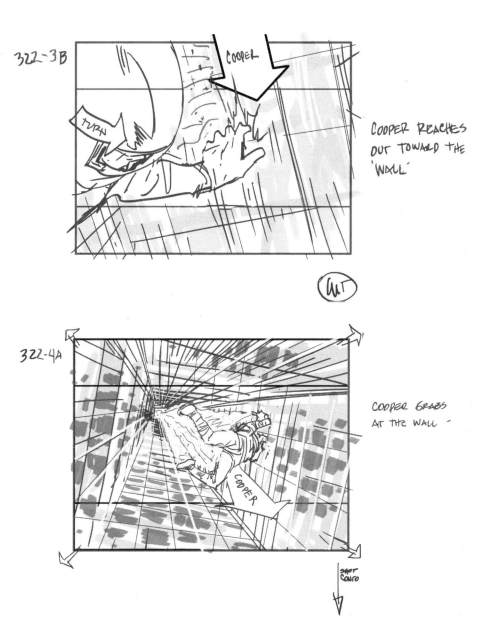

COOPER

TURN

COOPER REACHES
OUT TOWARD THE
'WALL'

322-4A

COOPER

COOPER GRABS
AT THE WALL —

SHOT
CONTD

322-4B

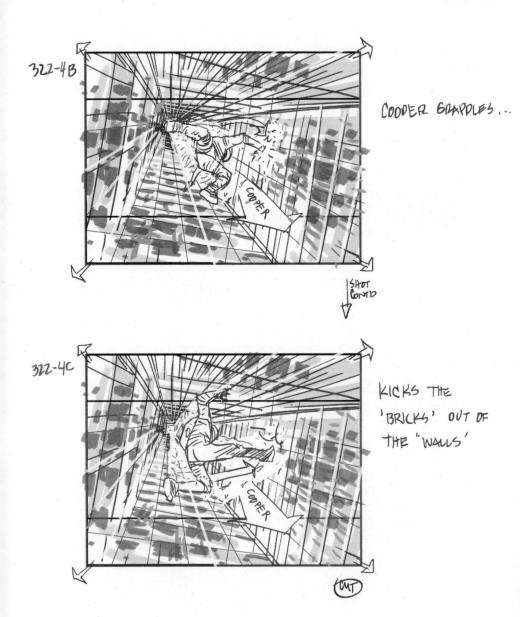

COOPER GRAPPLES...

COOPER

SHOT
CONT'D

322-4C

KICKS THE
'BRICKS' OUT OF
THE 'WALLS'

COOPER

322-5

HE PUNCHES AT
THE 'WALL'
(WHICH ARE ACTUALLY
WORLDLINES).

CUT

322-6

HE KICKS,

CUT

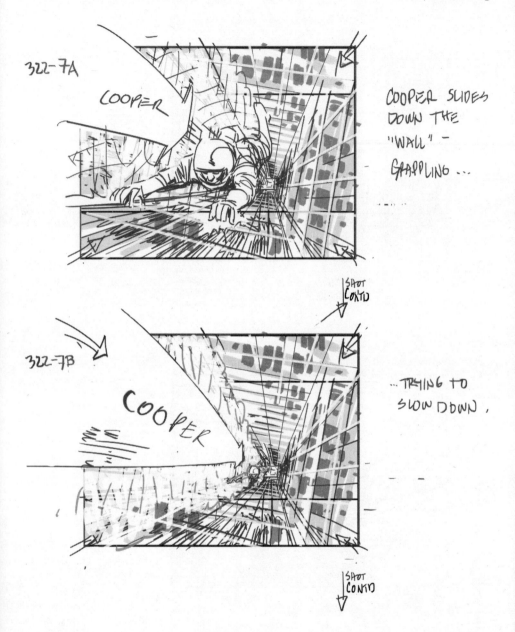

322-7A

COOPER

COOPER SLIDES
DOWN THE
"WALL" -
GRAPPLING ...

SHOT
CONT'D

322-7B

COOPER

... TRYING TO
SLOW DOWN .

SHOT
CONT'D

322-8A

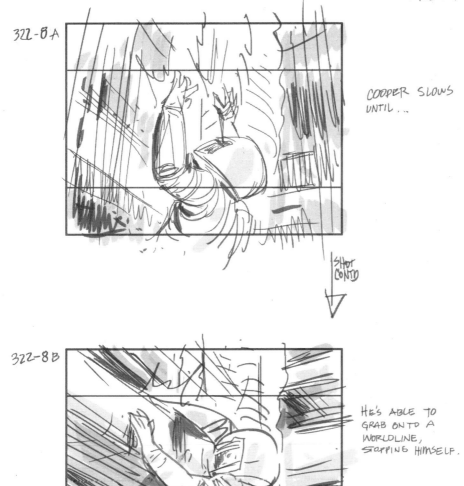

COOPER SLOWS
UNTIL...

SHOT
CONT'D

322-8B

HE'S ABLE TO
GRAB ONTO A
WORLDLINE,
STOPPING HIMSELF.

CUT

322-9A

SUDDEN CALM...
AN INFINTE
GRID OF EXTRUDING
WORLD LINES

SHOT
CONT'D

322-9B

COOPER PULLS
HIMSELF UP.

CUT

322-10

COOPER FLOATS
UP TO THE
VERTICAL
WORLDLINES.

322-11A

COOPER LEANS
ON THE VERTICAL
BOOK WORLDLINES,
CATCHING HIS
BREATH.

CONTD

322-11B

THE WORLD LINE
MOVES.

CUT

322-11C

COOPER MOVES
TOWARD THE
GAP IN THE
WORLDLINES

CUT

322·12B

COOPER LOOKS
THROUGH THE
GAP IN THE
WORLDLINES

SHOT
CONT'D

322-13

COOPER LOOKS
IN...

322-14

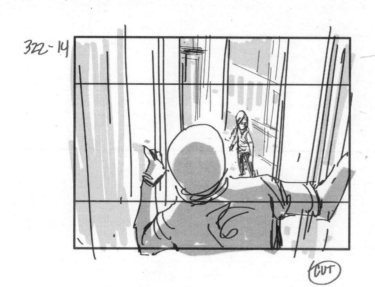

LOOKING INTO
MURPH'S ROOM.

CUT

322-15

COOPER: "MURPH?
MURPH?"

CUT

322-16

COOPER'S POV OF THE
FRONT OF BOOKCASE
AND IT'S WORLDLINES

322-17
A

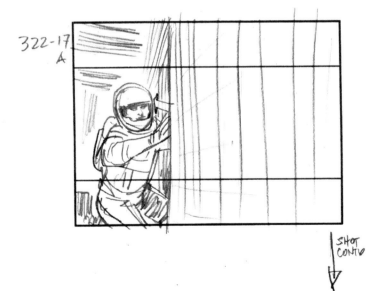

COOPER LOOKS
BACK TO THE
VERTICAL
WORLDLINES...

SHOT
CONT'D

322-19

HE HITS THE
HORIZONTAL
WORLD LINE.

(CUT)

323-1

THE BOOK
FALLS ON THE
FLOOR.

323-2

INT, MURPH'S
BEDROOM.
MURPH (10) LOOKS
AT THE
BOOKSHELF

SCENE # 324

324-1

INT. MURPH'S ROOM
MURPH (40) LOOKS
AT THE SHELVES
REMEMBERING.

(MT)

SCENE # 325

325-1

TESSARACT
COOPER LOOKS
TO MURPH,

(MT)

324-2

COOPER'S POV
MURPH (10) CROUCHES
OUT OF FRAME.

SCENE # 325

325-1

MURPH (40) TURNS
THE LUNAR LANDER
IN HER HANDS —
THINKING.

SCENE # 327

327-1

MURPH (10) STANDS,
HOLDING THE BROKEN
LUNAR LANDER.

SCENE # 328

328-1A

COOPER MOVES

SHOT
CONT'D

328-1B

LOOKING INTO
MURPH'S ROOM.

328-2

COOPER: "MURPH?
MURPH?"

328-3

MURPH EXITS.

COOPER'S POV
OF MURPH AS
SHE TURNS AND
WALKS OUT
THE DOOR,

(CUT)

328-4

COOPER TURNS
LOOKS AROUND
THE TESSARACT,

(CUT)

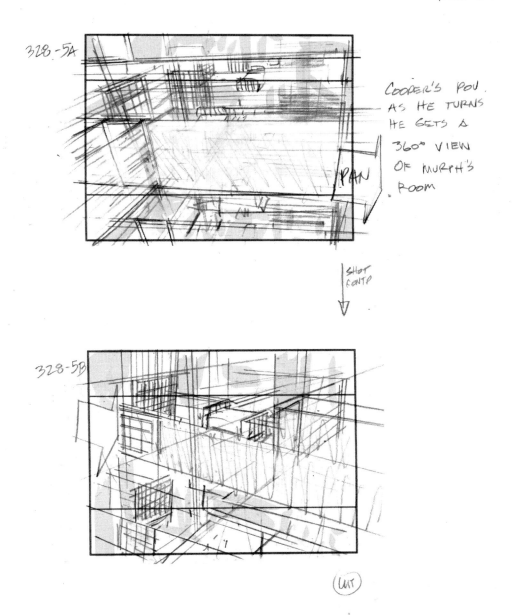

328-5A

COOPER'S POV.
AS HE TURNS
HE GETS A
360° VIEW
OF MURPH'S
ROOM

PAN

SHOT
CONTD

328-5B

(cont)

328-6

COOPER HITS
THE BOOK
WORLDLINES.

328-7

INT. MURPH'S ROOM.
THE BOOK MOVE.

328-8A

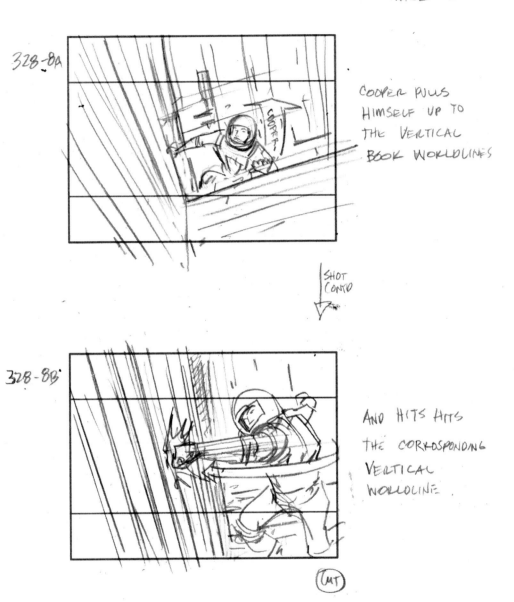

COOPER PULLS
HIMSELF UP TO
THE VERTICAL
BOOK WORLDLINES

SHOT
CONT'D

328-8B

AND HITS HITS
THE CORROSPONDING
VERTICAL
WORLDLINE.

(MT)

328-9

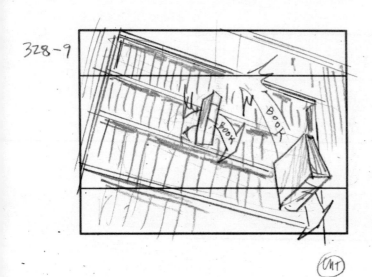

INT. MURPH'S ROOM
2 BOOKS FALL
OF THE SHELF.

(MT)

528-10

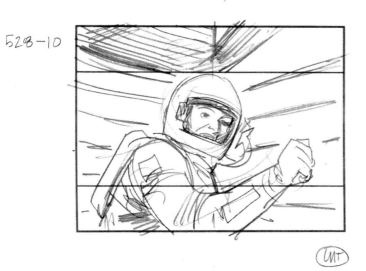

COOPER LOOKS
TOWARD ANOTHER
NODE,

528-11A

COOPER'S POV
OF MURPH'S
ROOM. COOPER'S
EARLIER SELF
WALKS IN —
STANDS, STARING
AT THE ROOM.

528-11B

MURPH (10) FANS
HIM.

528-12

COOPER LASHES
OUT AT THE
BOOK WORLDLINES.

528-13

ANOTHER BOOK
FALLS.

528-14

COOPER'S POV
THROUGH A GAP
IN THE WORLDLINES
OF MURPH (10)
AS SHE MOVES
HER DESK IN
FRONT OF THE
DOOR.

SCENE # 329

329-1

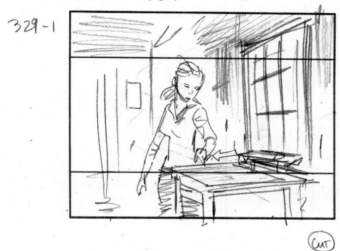

MURPH (40) RUNS HER
FINGERS ALONG
THE DESK —
REMEMBERS.

(CUT)

SCENE # 330

330-1

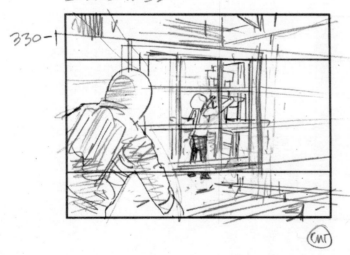

COOPER WATCHES
MURPH (10) PUT
A CHAIR ON TOP
OF THE DESK.

(CUT)

SCENE # 331

331 - 1

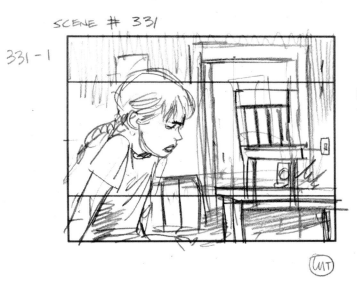

MURPH (10) SEES
THE DOOR NUDGING
AGAINST THE CHAIR.

MURPH: "JUST GO.
IF YOU'RE LEAVING-
JUST LEAVE NOW."

SCENE # 332

332 - 1

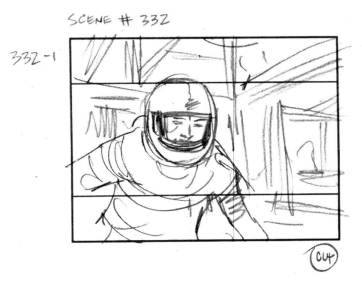

COOPER

335

332-2

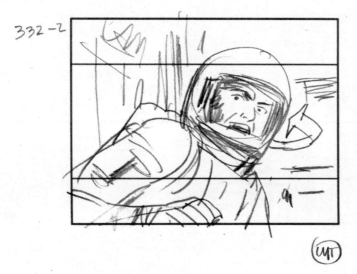

COOPER SPINS...

332-3

...TO SEE HIS
EARLIER SELF
NUDGING THE
DOOR.
COOPER:
"DON'T GO YOU
IDIOT!"

332-4

COOPER MOVES
UP TO THE
VERTICAL BOOK
WORLDLINES - HITTING
COOPER'S..T...

(CUT)

332-5

THE BOOKS
BARELY NUDGE.

(CUT)

3326

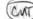

COOPER MOVES
DOWN, HITS THE
HORIZONTAL
BOOK WORLDLINES

COOPER: "A..Y...

(CUT)

332-7

MURPH (10) WATCHES
THE BOOKS FALL -
NO LONGER SCARED -
FASCINATED.

COOPER: "...A..Y.."

(CUT)

332-B

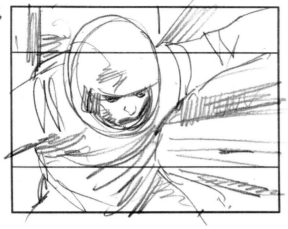

COOPER STOPS—
CATCHING HIS
BREATH — WAITS.

332-9

COOPER'S EARLIER
SELF LIFT THE
CHAIR OFF THE
TABLE. TO ENTER.

332-10

COOPER WATCHES
HIS EARLIER
SELF - FRUSTRATED.

COOPER: "STAY
YOU IDIOT!"

332-11

AS BEFORE,
COOPER GIVES
MURPH THE
WATCH, MURPH
THROWS THE
WATCH AND TURNS
AWAY.

SCENE # 333

333-1

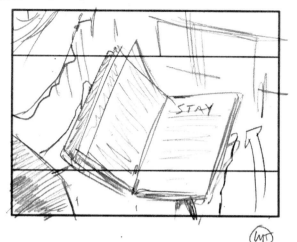

MURPH (40) PICKS
UP THE NOTEBOOK,
FLIPS TO THE
WORD "STAY"

333-2

SHE LOOKS UP
AT THE BOOKSHELF -
REALIZING.

SCENE # 334

334-1

COOPER CRYING
WITH FRUSTRATION

CUT

334-2

COOPER WATCHES
HIS EARLIER SELF
WALK OUT,

COOPER: "STAY!"

LMT

342

334-3A

COOPER TURNS

SHOT
CONTD

334-3B

AND HITS THE
BOOK WORLDLINES

SHOT
CONTD

334-4

THE BOOK FALLS
IN MURPH'S ROOM

(int)

334-5A

COOPER LOOKS
BACK AT THE
BOOK...

SHOT
CONT'D

334-5B

THEN LEAVES.

334-6

COOPER RESTS
HIS HEAD, SOBBING.

SCENE # 335

335-1

MURPH (40) MOVES
TO THE BOOKSHELF.
IN AWE.

MURPH (40):
"DAD... IT WAS YOU.
YOU WERE MY
GHOST."

335-2

MURPH CRYING -
JOYFUL.

346

SCENE # 336

336-1

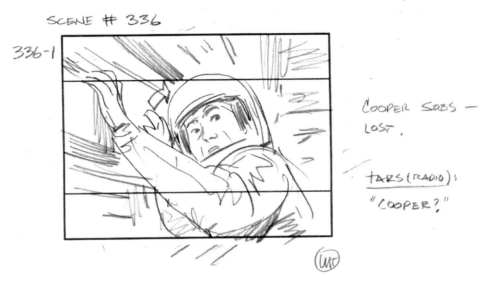

COOPER SOBS —
LOST.

TARS (RADIO):
"COOPER?"

336-2

COOPER TURNS —
TARS ISN'T
THERE.

336-3

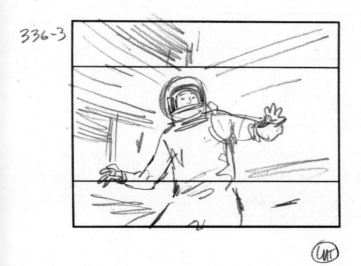

COOPER: "YOU SURVIVED".

TARS: "SOMEWHERE
IN THEIR 5th
DIMENSION. THEY
SAVED US."

COOPER: "WHO'S THEY?"

336-4

COOPER LOOKS
AROUND AT THE
INFINITE TUNNEL —
INFINTE COOPERS.

"GRAVITY CROSSES
THE DIMENSIONS —
EVEN TIME."

36-5A

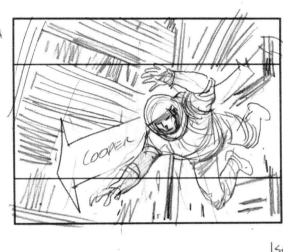

COOPER PULLS
HIMSELF TO
ANOTHER WALL.

COOPER: "AND YOU
HAVE THE QUANTUM
DATA NOW."

SHOT
CONTD
↓

336-5B

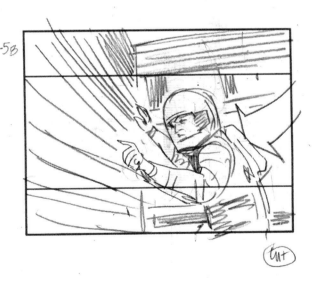

STARTS COUNTING
BOOKS (WORLDLINES).

TARS: "I'M TRANSMITTING
IT ON ALL WAVELENGTHS
BUT NOTHING IS
GETTING OUT."

CUT

.36

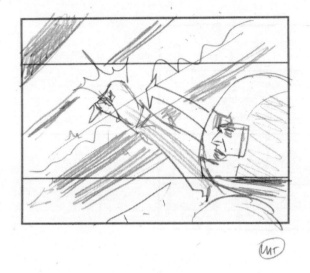

COOPER HITS
A BOOK'S WORLDLINE

SCENE # 337

337-1

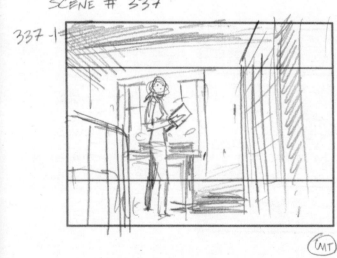

MURPH (40) HOLDS
THE NOTEBOOK
SHE LOOKS AROUND
THE ROOM FOR
AN ANSWER.

SCENE # 338

338-1

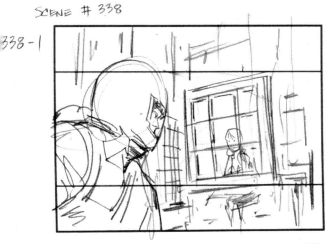

INT. TESSARACT
COOPER WATCHES
MURPH (10) LOOKING
OUT THE WINDOW.

TARS: "EVEN IF
YOU COMMUNICATE
IT HERE .."

338-2

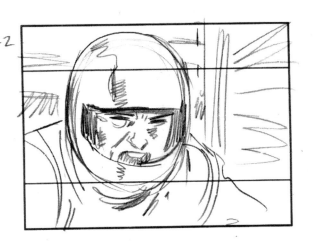

COOPER IS SEIZED
BY SUDDEN ANGER.

COOPER: "THEN
FIGURE SOMETHING
OUT! EVERYBODY
ON EARTH IS
GOING TO DIE!"

338-3A

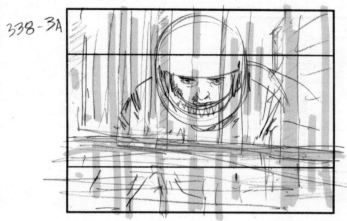

COOPER LOOKS
AT THE DUST
ON THE FLOOR
IN MURPH'S ROOM.

THE WORLD LINES
EXTEND FROM IT.

COOPER: "TARS, FEED
ME THE COORDINATES
OF NASA IN BINARY."

SHOT
CONT'D

338-3B

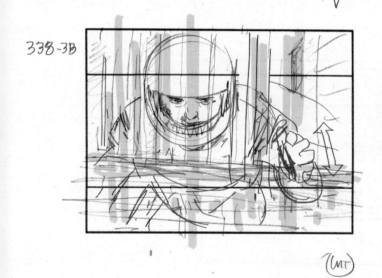

COOPER CUTS
THROUGH THE
HORIZONTAL
WORLDLINE OF
THE DUST.

3386A

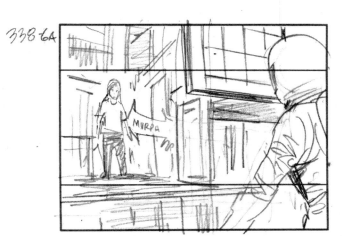

COOPER WATCHES
AS MURPH (10)
BURSTS IN, STOPS
AND STARES AT
THE PATTERN IN
THE DUST...

SHOT
CONT'D

338-6B

THE EARLIER
VERSION OF
COOPER ENTERS

SHOT
CONT'D

338-6C

EARLIER COOPER
SLAMS THE WINDOW.
WAVES OF WINDOW
SLAM MOVE DOWN
THE WORLDLINES

338-7

WIDER. WE SEE
THE WAVES OF THE
WINDOW FROM THE PAST
INTO THE FUTURE.

354

338-6D

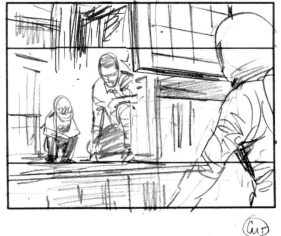

1.. THEN SEES
THE PATTERN.

SCENE # 339

339-1

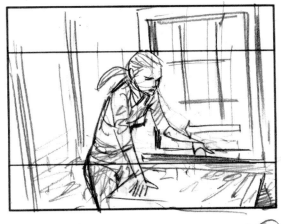

MURPH (40) RUNS HER
FINGER ALONG THE
DUST ON THE
WINDOW SILL.

MURPH (40): "

"COME ON, DAD. IS
THERE SOMETHING
ELSE HERE ?"

SCENE # 340

340-1

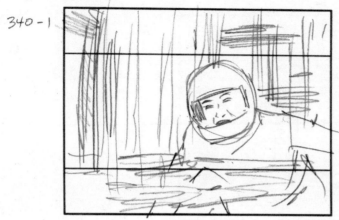

(MT)

PAST THE DUST
TO COOPER.

<u>COOPER</u>: "DON'T
YOU SEE TARS?
I BROUGHT MYSELF
HERE."

340-2

COOPER

(MT)

COOPER MOVES TO
ANOTHER ITERATION
OF MURPH'S ROOM.

SCENE # 341

41-1

MURPH (40) LOOKS
AT THE WATCH —
REMEMBERING.

(cut)

341-2

TIGHT ON THE
WATCH. THE SECOND
HAND TWITCHES.

(cut)

341-3

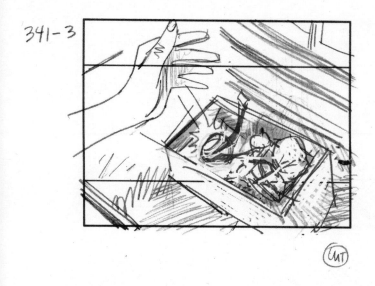

SHE DROPS THE
WATCH IN A
BOX.

(CUT)

SCENE # 342

342-1

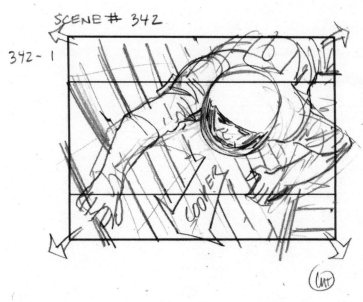

COOPER PUSHES
HIMSELF ALONG
THE WORLDLINES
OF BOOKS.

COOPER : "I THOUGHT
THEY CHOSE ME —
THEY CHOSE MURPH."
TARS : "FOR WHAT?".
COOPER : "TO SAVE
THE WORLD."

(CUT)

SCENE # 343

343-1

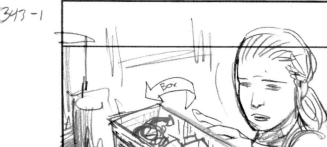

MURPH (40) PUTS THE
BOX BACK UP ON
THE SHELF, SIGHS.

344-1

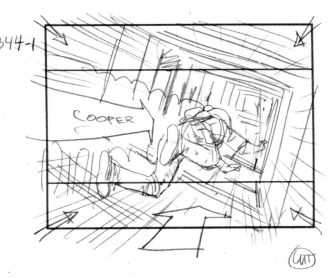

COOPER RACES
FASTER AND
FASTER DOWN
THE WORLDLINES

COOPER: THEY HAVE
ACCESS TO INFINITE
TIME, INFINITE SPACE."

344-2

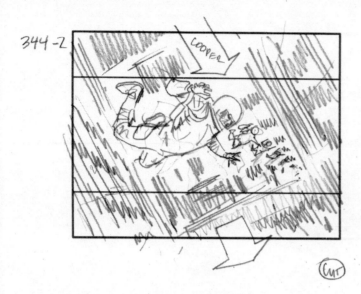

COOPER GESTURES
TO THE INFINITE
IN ALL DIRECTIONS

344-3

COOPER FINDS THE
WATCH.
COOPER: "THE WATCH,
THAT'S IT, SHE'LL
COME BACK FOR IT."

44-4

COOPER CAREFULLY
MANIPULATES THE
WORLD LINES OF
THE WATCH ON
EACH AXIS.
LIKE PLUCKING
STRINGS.

(CUT)

14-5

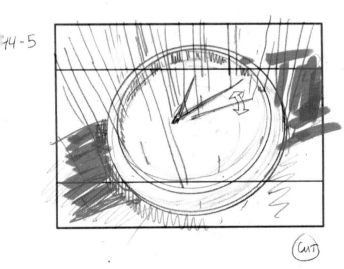

THE SECOND HAND
IS FLICKING BACK
AND FORTH.

(CUT)

SCENE # 345

345-1

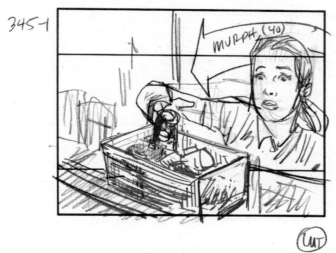

MURPH (40) COMES
BACK. TO THE
BOX, REACHES IN,
PICKS UP THE
WATCH.

345-2

SHE STARES
AT THE WATCH.
WONDERING.

SCENE # 350

350-1

(UMT)

350-2

COOPER LOOKS
AT THE WATCHES
WORLDLINE.

COOPER: "DID IT
WORK?"

TARS: "I THINK IT
MIGHT HAVE."

COOPER: "WHY?"

TARS: "BECAUSE
THE BULK BEINGS
ARE CLOSING THE
TESSARACT."

COOPER LOOKS
OUT INTO THE
DISTANCE, IT
IS RAPIDLY APPROACHING

SHOT
CONT'D

363

350-2B

WORLD LINES
BECOMING WORLD
SHEETS.

SHOT
CONT'D

350-2C

THEN BULK.

SHOT
CONT'D

364

350-3

COOPER BRACES
HIMSELF.

COOPER: "WHAT
HAPPENS NOW?"

CUT

350-4A

SHOT
CONTD

350-4B

BAM!
COOPER IS SWEPT
UP IN THE
EXPANSION LIKE
A TINY LEAF ON
A CHURNING
WAVE.

UNT

350-5A

COOPER FLIES
THROUGH THE
EXPANDING
COSMOS, PAST

SHOT
CONT'D

350-5B

WHICH BECOME
ATOMIC PARTICLES.

SHOT
CONT'D

350-5C

WHICH BECOME
MATTER, BECOMING
STARS.

SHOT
CONT'D

350-5D

TOWARD A
LENS LIKE
SPHERE...

SHOT
CONT'D

350-5E

AN IMAGE
RESOLVES IN
THE SPHERE...

SHOT
CONT'D

350-5F

COOPER

SHOT
CONT'D

INSIDE IS THE
OLD, UNDAMAGED
ENDURANCE.

COOPER MOVES
TOWARD THE
ENDURANCE WHICH
IS IN THE
WORMHOLE
HE APPROACHES
THE BRANE.

350-5G

COOPER PRESSES
UP AGAINST
THE BRANE
TOWARD

350-6

PAST DOYLE TO
BRAND AS SHE
STRAPS IN —
TRAVELING THROUGH
THE WORMHOLE
FOR THE FIRST
TIME.

(CUT)

350-7

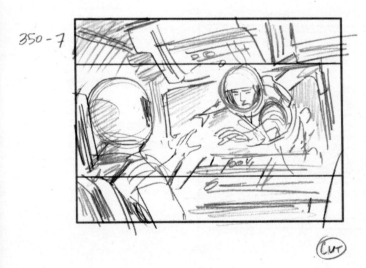

COOPER REACHES
FOR BRAND.

(CUT)

350 - 8

HER FINGERS
DISTORT THE
SPACE OF HIS
FINGERS,

350 - 9.

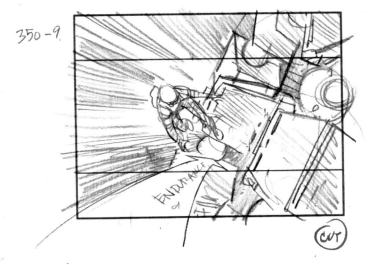

WHAM! SHE AND
THE ENDURANCE
ARE SWEPT AWAY.

350-10

COOPER SCREAMS
AS WE ...

SCENE # 351

351-1

COOPER FLOATS,
DEAD OR UNCONSCIOUS
NEAR SATURN.

A WARNER BROS. PICTURES
and
PARAMOUNT PICTURES
Presentation
In Association with LEGENDARY PICTURES
A SYNCOPY/LYNDA OBST PRODUCTIONS Production

A Film by
CHRISTOPHER NOLAN

INTERSTELLAR

Directed by
CHRISTOPHER NOLAN
Written by
JONATHAN NOLAN *and* CHRISTOPHER NOLAN
Produced by
EMMA THOMAS, p.g.a.
CHRISTOPHER NOLAN, p.g.a.
LYNDA OBST, p.g.a.
Executive Producers
JORDAN GOLDBERG, JAKE MYERS
KIP THORNE, THOMAS TULL
Director of Photography
HOYTE VAN HOYTEMA, F.S.F, N.S.C.
Production Designer
NATHAN CROWLEY
Edited by
LEE SMITH, A.C.E.
Music by
HANS ZIMMER
Visual Effects Supervisor
PAUL FRANKLIN
Costumes Designed by
MARY ZOPHRES
Casting by
JOHN PAPSIDERA, CSA

MATTHEW MCCONAUGHEY
ANNE HATHAWAY
JESSICA CHASTAIN
ELLEN BURSTYN
JOHN LITHGOW
and MICHAEL CAINE

CASEY AFFLECK • WES BENTLEY • BILL IRWIN
MACKENZIE FOY • TOPHER GRACE • DAVID GYASI

Unit Production Manager DANIEL M. STILLMAN
First Assistant Director NILO OTERO
Second Assistant Director BRANDON W. LAMBDIN

Murph (older)	ELLEN BURSTYN
Cooper	MATTHEW McCONAUGHEY
Murph (10 Yrs.)	MACKENZIE FOY
Donald	JOHN LITHGOW
Tom (15 Yrs.)	TIMOTHÉE CHALAMET
School Principal	DAVID OYELOWO
Ms. Hanley	COLLETTE WOLFE
Boots	FRANCIS XAVIER McCARTHY
TARS	BILL IRWIN
Brand	ANNE HATHAWAY
Smith	ANDREW BORBA
Doyle	WES BENTLEY
Williams	WILLIAM DEVANE
Professor Brand	MICHAEL CAINE
Romilly	DAVID GYASI
CASE	JOSH STEWART
Tom	CASEY AFFLECK
Lois	LEAH CAIRNS
Murph	JESSICA CHASTAIN
Coop	LIAM DICKINSON
Getty	TOPHER GRACE
Mann	MATT DAMON
Girl on Truck	FLORA NOLAN
Boy on Truck	GRIFFEN FRASER
Doctor	JEFF HEPHNER
Nurse Practitioner	LENA GEORGAS
Administrator	ELYES GABEL
Nurse	BROOKE SMITH
Crew Chief	RUSS FEGA

Stunt Coordinator	GEORGE COTTLE

Stunts

DIZ SHARPE • MARK FICHERA • MICHAEL P. LI • KEVIN ABERCROMBIE
MARIE FINK • SEAN MORRISSEY • DAN BROWN • GREG HARRIS
MARK NORBY • STEVE DE CASTRO • TERRY JACKSON • AARON TONEY
EDWARD A. DURAN • JESS KING • FRANK TORRES • WADE EASTWOOD • ALICIA VELA-BAILEY

Special Effects Supervisor	SCOTT FISHER

Associate Editor	JOHN LEE
Post Production Supervisor	DAVID E. HALL
Visual Effects Producer	KEVIN ELAM
Sound Designer/Supervising Sound Editor	RICHARD KING
Re-Recording Mixers	GARY A. RIZZO
	GREGG LANDAKER
Production Controller	HELEN MEDRANO
Production Supervisor	MICHELLE BRATTSON MAJORS
Supervising Art Director	DEAN WOLCOTT
Script Supervisor	STEVEN R. GEHRKE
Chief Lighting Technician	HAROLD J. SKINNER
Key Grip	HERB AULT
IMAX Consultant	DAVID KEIGHLEY
Art Directors	JOSHUA LUSBY • ERIC DAVID SUNDAHL
Assistant Art Directors	JENNE LEE • TRAVIS WITKOWSKI

375

Costumers

LAUREN PRATTO • MAUREEN O'HERON • LAURA WONG
MARIA SUNDEEN • SOPHIA CORONADO • LETICIA SANDOVAL

Ager/Dyer	ROB PHILLIPS
Suit Technicians	JAMES SCHEXNAYDRE • GREG FINNIN
	DOMINICK DeRASMO
Location Manager	MANDI DILLIN

Assistant Location Managers

MICHAEL GLASER • KEOMANEE VILAYTHONG • JUSTIN HARROLD
JORGE LUIS ALVAREZ • MANNY PADILLA • LORI RUSSELL

Assistant Chief Lighting Technician	CLIVE RICHARDS
Rigging Gaffer	JOHN MANOCCHIA
Rigging Best Boy	ANTHONY OFRIA
Best Boy Grip	SHANNON DEATS
Dolly Grips	RYAN MONRO • PETER CLEMENCE
Rigging Key Grip	OSCAR GOMEZ
Rigging Best Boy	DUSTIN AULT
Special Effects Technical Consultant	TOM FISHER

Special Effects Foremen

MARIO VANILLO • RONALD GOLDSTEIN • CLARK TEMPLEMAN • MATTHEW DOWNEY
ROLAND LOEW • KIRK BARTON • JAMES ROLLINS • JOHN DOWNEY • JOSEPH E. JUDD

Special Effects Technicians

TERRY HAMBLETON • ROBIN REILLY • RYAN ARNDT • MICHAEL RIFKIN
ARTHUR CLEVER • FRANCIS J. AYRE, JR. • RONALD EPSTEIN • SCOTT ROARK
DARREN McCORMICK • NEAL GARLAND • MARK STANTON • ROBERT SLATER

First Assistant Editors	ERIC A. LEWY • LAURA RINDNER
Assistant Editors	DONALD LIKOVICH • WILLIAM FLETCHER
	PAULA SUHY • JACKSON YU
Post Production Coordinator	ADAM COLE
Post Production Assistants	BOBBIE SHAY • GABRIEL DIAZ • JEREMY NAIL
First Assistant Sound Editors	ANDREW BOCK • LINDA YEANEY
Dialogue Editor	HUGO WENG
ADR/Dialogue Editor	R. J. KIZER
Sound Effects Editors	MICHAEL W. MITCHELL • JEFF SAWYER
Additional Sound Design	KEN J. JOHNSON • AARON GLASCOCK
Sound Effects Recording Mixers	JOHN FASAL • ERIC POTTER
Additional Re-Recording Mixer	MICHAEL BABCOCK
Foley Supervisor	CHRISTOPHER FLICK
Foley Editors	MICHAEL DRESSEL • SCOTT CURTIS
Foley Artists	JOHN ROESCH • ALYSON DEE MOORE
Foley Mixers	MARYJO LANG • KYLE ROCHIN
ADR Mixer	THOMAS J. O'CONNELL
Mix Technician	RYAN MURPHY
Mix Stage Engineer	TONY PILKINGTON
Supervising Music Editor	ALEX GIBSON
Music Editor	RYAN RUBIN
Music Production Services	STEVEN KOFSKY
Sequencer Programming	ANDREW KAWCZYNSKI • STEVE MAZZARO
Technical Score Engineer	CHUCK CHOI
Digital Instrument Design	MARK WHERRY
Supervising Orchestrators	BRUCE FOWLER • WALT FOWLER
Orchestra Conducted by	GAVIN GREENAWAY • RICHARD HARVEY

Organ Soloist	ROGER SAYER	Violin Soloist	ANN MARIE SIMPSON
Steel Guitar Soloist	CHAS SMITH	Tuned Percussion Soloist	FRANK RICOTTI

Orchestra Leader	THOMAS BOWES
Score Recorded at	LYNDHURST HALL, AIR STUDIOS
	TEMPLE CHURCH
Score Recorded and Mixed by	ALAN MEYERSON
Score Recorded by	GEOFF FOSTER
Assistant Engineer	JOHN WITT CHAPMAN
Supervising Score Coordinator	SHALINI SINGH

376

Supervising Score Coordinator	SHALINI SINGH		
Score Coordinators	CYNTHIA PARK • CZARINA RUSSELL		
Visual Effects Editors	STEVE MILLER • TOM BARRETT		
Visual Effects Assistant Editors	SCOTT WESLEY ROSS • CHRISTY RICHMOND		
Visual Effects Production Supervisors	CATHERINE LIU • ELAINE ESSEX THOMPSON		
Visual Effects Coordinators	TYLER OTT • KATIE STETSON		
Visual Effects Data Wrangler	JOE WEHMEYER		
Visual Effects Production Assistant	TIEN NGUYEN		
Construction Coordinator	BRIAN WALKER		
Construction Foremen	WILLIAM DALY, III • DARREL D. BRICKER		

Head Sculptor	GENE COOPER	Head Greensman	STEVE HANKS
Paint Supervisor	LARRY CLARK	Head Plasterer	JEFF HOUSE
Transportation Coordinator	DENNY CAIRA	Welding Foreman	STEVE SALAZAR
Transportation Captain	ROB MORTON	Casting Associate	DEANNA BRIGIDI-STEWART
Set Medic	KEVIN CANAMAR	Casting Assistant	SOPHIE RAGIR
Technical Consultant	MARSHA IVINS	Catering	CHEF ROBERT CATEI
		Craft Service	LAURA BAGANO

ALBERTA UNIT

Unit Production Manager	CASEY GRANT		
Art Directors	KENDELLE ELLIOTT • GARY KOSKO		
Department Coordinator	JOEL TOBMAN	Set Decorator	PAUL HEALY
Art Department Trainee	CRAIG STEPHENS	On Set Dresser	STEVEN KAJORINNE
Property Master	KEN WILLS	Set Dressers	DREW BAKGAARD
Assistant Property Master	KELLY WILLS		JACK CROWELLS
irst Assistant "B" Camera	DOUG LAVENDER	Still Photographer	MICHELLE FAYE
nd Assistant "B" Camera	JEFF SAYLE	Video Technician	JOHN SANDERSON
Loader	ADRIENNE WYSE	Production Sound Mixer	DREW KUNIN
Post Production Assistant	KATRINA CARRASCO	Boom Operator	MURRAY FORWARD
Production Accountant	CHRISTIAN FELDHAUS		

Assistant Accountants

JENNIFER OMOTH • STEFANI ROCKWELL • BRENDA McCLELLAN • VICKI PLATERO

Production Coordinators	JILL CHRISTENSEN • KIM GODDARD-RAINS
Assistant Production Coordinators	KAARI M. AUTRY • STACEY DOUGLAS
Second Assistant Director	GARY HAWES
Third Assistant Director	MEGAN SHANK
Set Production Assistants	GIANNA ISABELLA • SCOTT SIKMA

Production Assistants

EVAN GODFREY • SARAH JANE TROHIMCHUK • MARK LAWS • STEPHEN KIEVIT • ASHLEY MacMILLIA

Costume Supervisor	HEATHER MOORE
Set Costumers	MARY HYDE-KERR • SHARON TEMPLEMAN
Key Hair	JOHN ISAACS
Hair Stylist	DEBORAH KLIEWER
Make-up Artist	PEARL LOUIE

Location Manager	BRUCE BROWNSTEIN	Assistant Location Manager	MATT PALMER
Chief Lighting Technician	MARTIN KEOUGH	Assistant Chief Lighting Technician	COLIN ALLEN
Rigging Gaffer	SEAN OXENBURY	Rigging Best Boy	KURT ZELMER
Key Grip	JOHN KUCHERA	Dolly Grip "B" Cam	TIMOTHY MILLIGAN
Best Boy Grip	KENT OGILVIE	Key Rigging Grip	ROSS LONG
		Best Boy Rigging Grip	IVAN HAWKES

Special Effects Coordinator	JAMES PARADIS

Special Effects

TODD BILAWCHUK • JEFF BUTTERWORTH • STEW DePASS • DON DOLAN • RODNEY DOLAN
KURT JACKSON • AMANDA PALLER • GARY PALLER • DOM SMART

Construction Coordinator	CRAIG HENDERSON
Construction Foremen	JIMMY BRUDER • CHARLIE CAMPBELL
	GARY PATT
Lead Carpenters	PIERRE BARTLETTE • BARRY CAMERON
Lead Painter	RALPH SARABIA
Paint Foremen	JOSE OLIVA • AARON McCULLOUGH

On Set Painter	DAVID CLARK
Greens Supervisor	DAN ONDREJKO
Transportation Coordinator	GRANT McPHEE
Transportation Captain	TYLER MILLER
Medic	AVALINE ADSHEAD

Plaster Foreman	JAMES DENTON
Lead Greens	CORAL TILBURY-DAMBRA
On Set Greens	CHERYL ALLSEN
Stunt Coordinator	LAURA LEE CONNERY
Catering	KEITH CHURCH

ICELAND UNIT

Production Services	SAGAFILM PRODUCTIONS
Line Producer	ARNI BJORN HELGASON
Unit Production Manager	BIRNA PAULINA EINARSDOTTIR
Art Director	EDDI KETILSSON
Assistant Prop Master	OLAFUR JONASSON
Production Accountant	GENE STRANGE
Assistant Production Accountant	LENA SCHMIGALLA
Production Supervisor	DEB SCHWAB
Production Coordinator	INGA BJORK SOLNES
Assistant Production Coordinators	MO STEMEN • GUDLAUG O. THORISDOTTIR

Production Assistants
FINNUR THOR KARLSSON • HEIDRUN T. HARALDSDOTTIR • SIGRIDUR SIGGA MARROW

Second Second Assistant Director VALGEIR GUNNLAUGSSON

Set Production Assistants
JANA MARIA GUDMUNDSDOTTIR • THORUNN GUDLAUGSDOTTIR • HREFNA HAGALIN

Gaffer	NILS WALLIN
Key Grip	ATLI THOR THORGEIRSSON
Special Effects Foremen	GUNNAR KVARAN • R.J. HOHMAN
Special Effects Technicians	JON ANDRI GUDMUNDSSON • DAVID GEIR JONSS
Location Manager	FRIDRIK ASMUNDSSON
Transportation Coordinator	STEINARR LOGI NESHEIM
	Assistant Location Manager SILJA HAUKSDOTTIR
	Transportation Captain EINAR G. EINARSSON
Catering	GUDMUNDUR KOKKUR • ERLINGUR ORN KARLSS
Medic	JOHANNES ANDRI KJARTANSSON

Visual Effects by DOUBLE NEGATIVE LTD.

Visual Effects Supervisor	ANDREW LOCKLEY
CG Supervisors	EUGÉNIE VON TUNZELMANN • DAN NEAL
Compositing Supervisor	JULIA REINHARD NENDICK
Previsualization Supervisor	FARAZ HAMEED
Animation Supervisor	DAVID LOWRY
CG Effects Supervisor	NICHOLAS NEW
Matchmove Supervisors	CHRIS COOPER • SIMON PYNN
CG Lighting Supervisor	LAURENT HAMERY
Software Development Supervisor	OLIVER JAMES
Visual Effects Editors	CRYSTAL HADCROFT • SIMON J WILLIAMS
Visual Effects Digital Color Timers	GARRY MADDISON • SCOTT ANDERSON
Production Supervisor	ALLISON GARDNER

Line Producers

GRAEME PUTTOCK	HARRISON GOLDSTEIN	JENNY BASEN

Visual Effects Coordinators

ENG SZE JIA	GRETEL NG	KIRSTY DAVIES-BHAKAR
LINDA BARSOTTI	MARILUZ NOTO	MAXIMILIAN McNAIR MacEWAN
MONICA ØSTBØ ØSTGÅRD	MONIFA ANDREW	TIMOTHY TRIMMINGS

Compositing Sequence Supervisors

GRAHAM PAGE	ISAAC LAYISH	RAPHAEL HAMM
SEBASTIAN VON OVERHEIDT		TRISTAN MYLES

CG Sequence Supervisors

BRUNO BARON	CHANTELLE WILLIAMS	FABIO ZANGLA
SETH DUBIENIEC		TOM BRACHT

Lead Digital Artists

ALAN STUCCHI	ELHAM BINSENIN	NATHAN GARDNER
	OLIVER ATHERTON	
ADAM GAILEY	ADRIEN FLANQUART	ANDREW SCRASE
ANDY GUEST	BLAKE WINDER	BRUNO EBÉ
CRAIG TONKS	DAVID FERNANDEZ	GAVIN THOMAS

GRAHAM HUDSON	IACOPO DI LUIGI	JOHN SERU
LEANDRO PEDRONI	LUCY SALTER	MARTIN CUTBILL
MASSIMO PASQUETTI	PETE HOWLETT	PETER FARKAS
ANDREW McEVOY	ANGELO STANCO	ANTON NAZARETH
ANTON SMIT	ANTONIO MEAZZINI	AVINASH BHANDARY
BEN HICKS	BENJAMIN KHAN	BENOIT TERMINET SCHUPPON
BUN YUE CHOY	BYUNG GUN JUNG	CALEB CHOO
CAROLINE CHAI	CAROLINE JOURNO	CEDRIC LING
CEDRIC MENARD	CHETAN GAUR	CHEWTENG LIM
CHRISTIAN WAITE	CHRISTINA BRUCE	CHRISTOPHER COUPE
CHRISTOS PARLIAROS	CLAUDIA LECHEN	COJOCARU NICOLAE-GHEORGHE
DANIEL BALDWIN	DANIEL DUWE	DANIEL NICHOLSON
DAVID KIRCHNER	DIONE QUEK	DIRK BECKER
DORIAN KNAPP	ED PULIS	EUNICE ONG
EVA MATTHES	EWOUD HEIDANUS	FAVIAN EE
FELIX TAN	FINELLA FAN	FINLAY SUTTON
FIRDAUS AB LATIF	FRANCESCA DARE	GABRIEL TAN
GENGTONG NEO	GEORGE PLAKIDES	GERALD BLAISE
GIACOMO MATTEUCCI	GIANPIETRO FABRE	GONZALO SANCHEZ
HAYLEY BRAZELTON	HELEN JOHNSON	HENRY HIAH
HUW WHIDDON	IGNACIO CAICOYA	IGOR GONZALEZ VELAR
JACKY TOH	JAMIE HAYDOCK	JAMIE WONG
JEAN-FRANCOIS LEROUX	JEAN-NICOLAS COSTA	JENNI EYNON
JIM STEEL	JOAN NG	JOANNE TAI
JOE ENGELKE	JOHN GRESKO	JOHN O'LONE
JOHN PECK	JOHNNY LEE	JON HUDSON
JONATHAN PEREZ	JULES LISTER	KAMELIA CHABANE
KAMILLA BAK	KANIKA ANDREW	KARL RAPLEY
KEANAN SEAN CANTRELL	KEVIN SAN	KIRSTY CLARK
KOSTAS PANAGIOTOPOULOS	KRIS ANDERSON	KRISTOFER WHITFORD
LAILOK CHAU	LEONGKIT WONG	LOUISE FONTILLAS
LUIS PEREIRA	LUKE BUTLER	LUKE RAWCLIFFE
LYNN TAN	MARCO ENGELMANN SANTOS	MARCUS OLOFSSON
MARIJN EKEN	MARK YOUNG	MARKO RADINKOVIC
MARY STROUMPOULI	MATT SADLER	MATTHEW JACQUES
MELVIN HONG	MICHAEL BRAZELTON	MICHAEL CASHMORE
MICHAEL HOLM NIELSEN	MICHAEL WILBOURN	MICHELE BENIGNA
MICK HARPER	NAFISAH MOHAMED	NAVEEN SHUKLA
NEIL WEST	NGOC HENG	NIC HODGKINSON
NICK VAN DIEM	NIKI TURPIN	NITHIN BABU
OSCAR TORNINCASA	PABLO GIMENEZ	PATRICK MICHAEL BURKE
PATSY YUEN	PEIZHI HUANG	PETTER STEEN
PIERSON LIPPARD	RACHEL GREGSON	RAHUL VENUGOPAL
RAPHAËL GADOT	RASHABH BUTANI	RAYMOND TAN
RICKY CHEUNG	ROBERT SEATON	RODRIGO DORSCH
RYAN SEYMOUR	RYAN WOODWARD	SAM DAWES
SEBASTIAN BECKER	SHAILENDRA PANDEY	SHERMAINE TOH
SHRADDHA UPPU	SHRAMANA HALDAR	SIMON-PIERRE PUECH
STANISLAV KOLEV	STEPHEN PAINTER	SULLIVAN RICHARD
SUSANNE BECKER	TANIA RICHARD	THERESE JOHANSSON
THOMAS SALAMA	TIMOTHY RUSSELL	TITO FERNANDEZ
TOM COLLIER	TRYSTAN JAMES	UPASANA SHANKER
VAIBHAV A MARATHE	WAYNE LIM	WILLIAM FOULSER
WILLIAM VAN DAO	YAK HONG YUNG	YASUNOBU ARAHORI
YUKO KIMOTO	ZELJKO BARCAN	ZOHAIB AHSAN

Research & Development

SYLVAN DIECKMANN	PAUL-GEORGE H. ROBERTS	ROBERT JOHN DAVIES
OLIVER HARDING	GEORGE ZARGIANNAKIS	SIMON PABST

Technical Support

MILES DRAKE	LAURIE PELLARD	KAT TYSOE
PHILLIPS PENDLEBURY	LISA WOOD	CARLOS PEREZ-LOPEZ
ADAM BARNETT	DANNY LING	CHRIS EBORN

Technical Support

MILES DRAKE	LAURIE PELLARD	KAT TYSOE
PHILLIPS PENDLEBURY	LISA WOOD	CARLOS PEREZ-LOPEZ
ADAM BARNETT	DANNY LING	CHRIS EBORN

Visual Effects by NEW DEAL STUDIOS, INC.

Visual Effects Supervisor	IAN HUNTER
Visual Effects Producer	DAVID SANGER
Senior Modelers	BRANDEN W. SEIFERT • CHRIS HAWTHORNE
Senior Workshop Technicians	JONATHAN FABER • BEN RECORD
Senior SFX Technicians	SCOTT BEVERLY • RICHARD O. HELMER
Visual Effects Director of Photography	TIMOTHY E. ANGULO
Motion Control Operator	JOSHUA CUSHNER
Visual Effects Camera	JAMES THIBO • CRAIG SHUMARD
Model Unit Gaffer/Key Grip	TIM McARDLE • OTTO BETANCOURT
Visual Effects Coordinators	KATIE GARCIA • LEAH SARGENT

Opticals by	CUSTOM FILM EFFECTS	Color Timer	MATO DER AVANESSIAN
	MOTION PICTURE IMAGING	Negative Cutters	MO HENRY • ANDREA FICELI
Titles by	SCARLET LETTERS		JIM HALL • CHRISTIE MEYER

'Do Not Go Gentle Into That Good Night' by DYLAN THOMAS

Filmed on location in Los Angeles, U.S.A., Alberta, Canada, and Iceland

The Producers would like to thank:

Ken Burns, Dayton Duncan, Florentine Films, PBS, and those interviewed for
The Dust Bowl who participated in the making of this film:
Sam Arguello, Minnie Louise Forester Briggs, Floyd Coen, Melbourne Headrick, Pauline Heimann Robertson,
Charles Shaw, Don Wells, Lorene Del White, Dorothy Christenson Williamson

Sears Family

County of Lethbridge

U.S. Department of the Interior, Bureau of Land Management, Barstow Field Office
and Inland Empire Film Commission

Filmed partly on location in Alberta, Canada, with the assistance of
the Government of Alberta, Alberta Media Fund

With Support from Atvinnuvega- og Nýsköpunarráðuneytið – Ministry of Industries and Innovation

Soundtrack Album on WATERTOWER MUSIC

Camera and Lenses by PANAVISION® and IMAX®

Kodak
Motion Picture Film

Color and Prints by FOTOKEM

THIS MOTION PICTURE WAS SHOT AND FINISHED ON FILM

DOLBY.
DIGITAL
In Selected Theatres

DATASAT
DIGITAL SOUND
IN SELECTED THEATRES

No person or entity associated with this film received payment or anything of value,
or entered into any agreement, in connection with the depiction of tobacco products.

APPROVED NO. 49218

MOTION PICTURE ASSOCIATION OF AMERICA, INC.

THIS PICTURE MADE UNDER
THE JURISDICTION OF

AFFILIATED WITH
A.F.L.-C.I.O.-C.L.C.